C

PowerShot G11
Digital Field Guide

Brian McLernon

WILEY

Wiley Publishing, Inc.

Canon® PowerShot G11 Digital Field Guide

Published by
Wiley Publishing, Inc.
10475 Crosspoint Boulevard
Indianapolis, IN 46256
www.wiley.com

ISBN: 978-0-470-56508-7

Manufactured in the United States of America

10 9 8 7 6 5 4 3 2 1

For general information on our other products and services or to obtain technical support, please contact our Customer Care Department within the U.S. at (877) 762-2974, outside the U.S. at (317) 572-3993 or fax (317) 572-4002.

Wiley also publishes its books in a variety of electronic formats. Some content that appears in print may not be available in electronic books.

Library of Congress Control Number: 2009943648

WILEY

About the Author

Brian McLernon is a commercial freelance photographer, educator, and writer based in Portland, Oregon. Originally from New Jersey, he was educated in Arizona, Philadelphia, and New York City. Brian shoots primarily for editorial, commercial, corporate, and lifestyle clients: locations, portraits, products, travel, public relations events, weddings, high-school seniors, artworks, sports, special events, and more, capturing moments and telling visual stories.

To share his passion for photography, Brian conducts workshops in photography and lighting for Portland Community College's adult education series. He is often honored to be a guest speaker for several artistic associations, communication groups, and business organizations, and enjoys speaking to student groups as well. When he's not photographing in the studio or on location, Brian spends time with his wife and daughter, family and friends, camping, travelling, white-water rafting, cross-country and downhill skiing, and of course, photographing nature and all kinds of motorsports.

This is his third book for Wiley Publishing, Inc.

Credits

Acquisitions Editor
Courtney Allen

Project Editor
Chris Wolfgang

Technical Editor
Marianne Jensen

Copy Editor
Kim Heusel

Editorial Director
Robyn Siesky

Editorial Manager
Cricket Krengel

Business Manager
Amy Knies

Senior Marketing Manager
Sandy Smith

Vice President and Executive Group Publisher
Richard Swadley

Vice President and Executive Publisher
Barry Pruett

Project Coordinator
Lynsey Stanford

Graphics and Production Specialists
Jennifer Mayberry
Mark Pinto

Proofreading and Indexing
Laura Bowman
Valerie Haynes Perry

To Kevin, Sean, and Charlotte, who were there from the very beginning.

Acknowledgments

Although one name appears on the cover, this project brought an entire team of people together in seemingly unrelated ways that all contributed to the creation of this book. Today we live in an age of community, and I would be remiss if I didn't mention mine — these wonderful folks who answered my calls, spent hours discussing technical details, and volunteered time and suggestions to help me create this book.

To Dean Collins, the master of lighting and Photoshop guru who showed me that photography is all about the light instead of the gear. His knowledge of how to manipulate light and his entertaining teaching style has made a lasting impression on me. Though Dean is no longer with us, I am forever in his debt.

To Bob and Shirley Hunsicker of Pharos Studios, my early mentors in studio photography and business, whose guidance and friendship contribute immeasurably to my photographic career.

To photographers Galen Rowell, Dewitt Jones, George Lepp, and John Shaw who conducted workshops that keyed me in to the technical considerations of natural light and shared concepts and approaches to nature photography that I still use today.

To photographers David Hobby, Joe McNally, Syl Arena, Chase Jarvis, and John Harrington who share their photographic expertise through blogs and Web sites in their selfless desire to see all photographers succeed. I am indebted to them for sharing their experiences that enhance all I attempt to accomplish in photography.

To Mark Fitzgerald of the Digital Darkroom, my local Photoshop guru, who was never too busy to answer my calls and e-mails with answers to my questions and for providing his invaluable insight into the book-writing process.

To Courtney Allen, my acquisitions editor for this edition and first contact at Wiley, for taking me under her wing and providing friendship and encouragement and bringing me into the Wiley fold — may you rock to the metal always.

To Chris Wolfgang, my project editor, for her attention to every detail of this book, including her advice on image selection, captions, and sentence structure. Her contributions never failed to make this book better.

To Kim Heusel and Marianne Jensen, my copy and technical editors, whose comments and suggestions I thoroughly enjoyed. So glad to have them on the team.

To the fine team at Wiley Publishing for their skillful editing, marketing insight, and constant support and encouragement.

Finally, to my wife Gayle and daughter Brenna, who allowed me to disappear into my studio cave to shoot and write and make my deadlines, all the while providing those smiles, support, and laughter that make my life a joy.

Contents

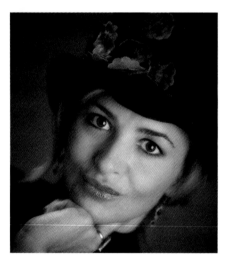

CHAPTER 2
Using the PowerShot G11 Menus 35

CHAPTER 3
Choosing Settings
on the Canon PowerShot G11 65

CHAPTER 4
Light and Color 105

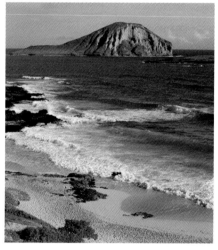

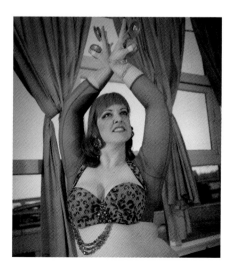

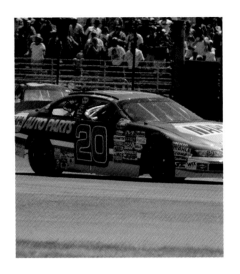

CHAPTER 5
Making Movies with Your
PowerShot G11 127

CHAPTER 6
Everyday Picture-taking Situations
with Your PowerShot G11 141

Introduction

Welcome to the new Digital Field Guide for the Canon PowerShot G11. Whether you are holding this book or your new G11 digital camera in your hands, you are holding a fantastic tool that will assist you in creating awesome photographs that you will be proud to display and share with your family and friends.

When the PowerShot G series was introduced almost ten years ago with the G1, many photographers were overjoyed at the prospect of being able to shoot with an affordable, full-featured digital camera in a lightweight, compact design.

Canon now ups the ante with the PowerShot G11 and a host of fantastic improvements, including a new 10-megapixel sensor, new DiG!C 4 processor, improved and expanded ISO sensitivity and range, Auto ISO, Image Stabilization, enhanced iContrast to deliver better coverage from low light shadow details to highlights with minimized blow out, special face recognition and self-timer modes, and probably the most impressive to many, the return of the beautiful 2.8 inch flip-out adjustable TFT LCD Monitor, last seen on the PowerShot G6 in 2004.

Learning how to properly use your new G11 is only the beginning to creating great photographs. You'll also learn about the subtleties of light and some compositional aids, and the how, when, and why you should use them. I cover camera placement and styles of lighting for different and creative effects. *Canon PowerShot G11 Digital Field Guide* will take you beyond the everyday use of your camera and start you on the path to creating truly dazzling images.

This book seeks to help you to better understand and use your new Canon PowerShot G11 and provides a handy compilation of tips on the capabilities of photography and your G11 in particular.

Short History of Canon's PowerShot Cameras

The first Canon PowerShot digital cameras debuted in July 1996 with the PowerShot 600. Although considered inadequate by today's standards, the 600 was a breakthrough camera that offered digital capture in a small compact unit and featured JPEG, TIFF, RAW, and audio-capture WAVE files. This camera was limited by its single ISO setting of 100, small memory capabilities (1MB on board, Type II and III PC card), tiny 1/3-inch image sensor, and total pixel count of only 570,000.

The PowerShot A series was introduced with the A5 in April 1998 followed by the A5 Zoom, released in October the same year. Their compact design featured a special duralumin alloy metal casing and a motorized retracting lens system, that permitted the camera to fit easily into a shirt pocket or briefcase for go-anywhere digital capture of images.

The Canon PowerShot S-series was introduced in October 1999 and included improvements that PowerShot users had requested, such as five new Shooting modes and advanced functions that included Spot Metering, AE Lock, and ISO sensitivity settings from 100 to 400, a Compact Flash (CF) card, and Red-eye reduction, all in a lightweight, highly mobile compact-camera-sized package.

The first PowerShot digital ELPH camera was the S100, and it was released in May of 2000. This model combined convenience, ease of use, and a look that made a distinct fashion statement. It also offered broad appeal to a wide range of users that positioned the ELPH to create an entirely new digital-camera market for the active user who wanted the smallest high-performance digital camera available at the time.

Hot on the heels of the ELPH S100 was the first of the G-series cameras, the G1, which debuted in October 2000. This feature-rich camera was a welcome addition to many professional photographers as a small back-up solution to their dSLRs. The G1 included a mechanical and electronic shutter system, digital zoom functions, expanded ISO settings from 50 to 400, along with a new Auto ISO mode from 50 to 100. The G1 also included a hot shoe with sync-terminals that communicated directly with the Canon Speedlites 220EX, 380EX, 420EX and 550EX.

Canon improved the G-series by releasing a new model nearly every year and upping the designation by one for each new release. The G-series became the top-tier cameras in Canon's digital compact lineup, often referred to as point-and-shoot cameras.

Pros were attracted to their retro design and external controls, such as the exposure compensation, ISO, and shooting mode dials. The G-series continued to improve with the G2, G3, G5, G6, G7, G9, and G10.

 There were no G-series cameras with a 4 or 8 designation.

Industry buzz on the G11 has been swift, and many believe this new PowerShot has retired, or at least stalled, the megapixel wars by dropping the pixel count on the G11 and including a faster processor to handle images. Canon reduced the megapixel resolution to 10 from 14.5 and kept the same lens as the G10. Canon says its new Dual Anti-Noise System combines a high sensitivity 10.0 megapixel image sensor with Canon's enhanced DiG!C 4 image processing technology to increase image quality and greatly improve noise performance by up to 2 stops (compared to the PowerShot G10).

Further G11 improvements over the G10 include a higher 1/2000-second flash synchronization speed and an HDMI port for reviewing images on a high-definition TV. The flash sync is impressive, especially when you consider that the PowerShot G11 is fully compatible with the 270EX, 430EX II, and 580EX II Speedlites plus the ST-E2 Speedlite transmitter. Even the MT-24EX macro twin-lite and MR-14EX macro ring-lite can be used for macro photography with the PowerShot G11.

What You'll Learn from This Book

This book is written for those Canon PowerShot G11 owners who may be new to photography and seeking professional results with their new camera. *Canon PowerShot G11 Digital Field Guide* also strives to be a great resource to learning about all the exciting new features of the PowerShot G11; and as a digital field guide, it is small enough to fit conveniently in your camera bag. Take it along with you and let it assist you in understanding the technical data, as well as offer up creative ideas to make your photography a fun and rewarding endeavor.

This book offers you a solid foundation of photographic fundamentals along with fun tips, tricks, and advice based on the real-world experiences of a working commercial photographer who has been using digital cameras for many years. I am excited to be a part of your journey — a tour guide, if you will — on your path to producing fantastic images with your Canon PowerShot G11.

Quick Tour

Many photographers, both amateur and professional, relish that special joy of bringing new camera equipment home, opening the boxes, and taking the gear out for a test drive to see what it can do, whether it's a camera, lens, or special accessory.

As a professional photographer, that excitement has not diminished in the least, but I do take a bit of time now to check out all the buttons, menus, and external camera controls before making photographs with the new gear. I want to learn to see as the camera sees.

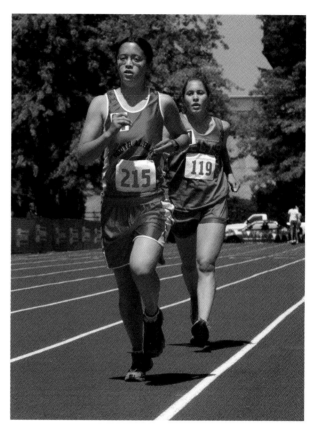

The PowerShot G11 is speedy enough to capture these long-distance runners at a recent track meet. Taken in Aperture Priority at ISO 800, f/11, 1/800 second with a 21.7mm lens setting.

Getting Up and Running Quickly

This Quick Tour assumes you have read the PowerShot G11 manual and gets you up to speed by providing brief explanations of some of the controls and settings you need to use to make your first photographs with your new equipment.

At the end of this Quick Tour, you should feel comfortable making images with your new G11. By then, you should be ready to move on to the subsequent chapters, where you learn more detailed explanations of the camera's controls, dials, and buttons; some rules for basic photo compositions; and advice on how to get the most out of your camera in different types of shooting situations and scenes.

If you have previously owned a Canon G-series or other PowerShot camera, many of the controls may already be familiar to you as you explore your new G11. New users, though, may be confused by the fact that while some controls are single-function only, other controls may serve double duty, handling several functions or even functions that can be set more than one way.

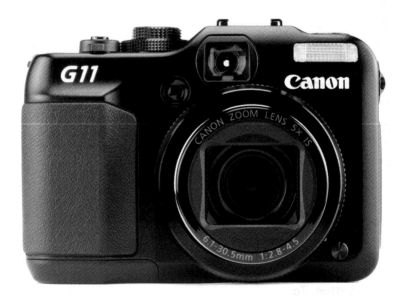

QT.1 **The PowerShot G11 is a feature-rich, compact digital camera that offers complete creative control and automatic modes for every type of photographer.**

At first glance, you should be able to identify and locate the following controls you will need to be aware of as you begin to use your new PowerShot G11:

▶ **Power button.** Located on the top of the camera, directly behind the Shutter Release button and indicated by On/Off labeling and the power lamp that glows green when the camera is turned on. The Power button sits flush with the top panel of the camera so that you don't mistake it for the Shutter Release button and inadvertently turn the camera off instead of taking a picture.

▶ **Shutter Release button.** Pressing the Shutter Release button halfway down activates the autofocusing system, and pressing it all the way down takes the picture. The Shutter Release button is surrounded by the Zoom lever.

▶ **Zoom lever.** Identified by the magnifying glass, trees, and checker icons, the Zoom lever has a tab that extends toward the front of the camera that you use to activate its functions.

▶ **Indicator lamps.** To the right of the viewfinder are two indicator lamps that glow either of two colors that alert you to various states of the camera's readiness, such as inability to focus; flash on; camera shake warning; or reading, recording, or transmitting images.

▶ **ISO dial.** Surrounding the Mode dial, the ISO dial has a lamp that indicates it can be actively adjusted in certain Shooting modes, and it has a range of ISO 80 to 3200 along with Auto ISO.

▶ **Mode dial.** The Mode dial is where you set all the Shooting modes such as Movies, Low Light, and Scene modes, along with two user-customized Shooting modes.

▶ **4-Way Controller.** This control is actually several controls in one. The Control dial is the outside ring that rotates, with different functions controlled by pressing the top, bottom, right, and left side sections of the dial.

▶ **Function/Set button.** Located in the center of the 4-Way Controller, this button is similar to Enter on a computer keyboard. Use this button to adjust, change, and confirm certain camera functions.

▶ **Menu button.** Located on the bottom right of the camera, you press this button to access the on-screen menus for shooting, setup, and My Menu settings.

▶ **Display button.** To the left of the Menu button is the Display button, which allows you to switch between viewing modes during normal shooting and controls other functions while shooting in Scene modes.

Several other buttons on the back of the camera are explained in Chapters 1 and 2, but getting acclimated to the previous list of controls allows you to quickly start shooting with the PowerShot G11.

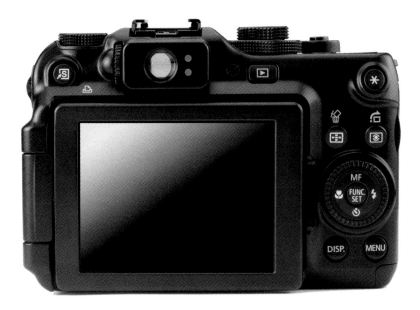

QT.2 The photographer's side of the PowerShot G11 has numerous camera controls that offer complete creative control and become entirely intuitive after a very short time.

Charging the battery

Now that you know where all the main controls are located, it's time to charge the battery and get the camera ready to make some cool images. The Canon G11 comes with a 7.4 V NB-7L Battery Pack and Battery Charger CB-2LZ. The battery ships with only a very low charge and must be charged before using the camera for the first time.

Although quite pricey for a proprietary camera battery (about $55), I opted for an additional battery at the time of purchase knowing I would eventually run out of battery power at the most inopportune moment.

 It's always good insurance to have a spare battery along for any electronic component.

Opinions vary about camera battery memory, but all agree it is a good idea to fully exhaust your camera's battery so that when you recharge it, the battery gets a complete charge. Under normal conditions, recharging from the beginning takes about 2 1/2 hours.

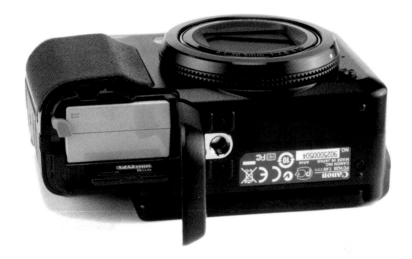

QT.3 The bottom of the G11 houses the memory card slot and battery compartment.

Setting the display language

If you want to change the language setting of your G11 camera, you have 26 choices. To set the language, follow these steps:

1. **Press the Playback button.** The next step may be a little tricky to get right.

2. **Press and hold the Function/Set button, then immediately press the Menu button to display the language list.**

3. **Use the Control dial to select the correct language and then press the Function/Set button.** As often as you'll ever do this, use both thumbs to press the buttons at the same time. I eventually managed to do this with just my right thumb, but it took a bit of practice.

Setting the date and time

When you power up the camera for the very first time, you will see a prompt to set the date, time, and time zone. The camera displays the month with adjustment arrows both above and below the value that can be adjusted. To set the date and time, follow these steps:

1. **Rotate the Control dial to select the current month.**

2. **Press the right control to select the date.**

3. **Rotate the Control dial to select today's date.** Repeat these steps to continue setting the current year, time, display format, and time zone. After setting the date and time, you set the order of the month, day, and year.

> **NOTE** The time is set using a 24-hour system, or military time for short. When you set the time, seconds are reset to zero when you press the Function/Set button. To easily figure out the correct time in a 24-hour system, if it is past noon simply add 12 to the current hour. So for example, 7:00 p.m. is 12:00 + 7:00, so it is then 19:00.

4. **Choose from the U.S. standard of month/day/year (mm/dd/yy), the European setting of day/month/year, or the chronological setting of year/ month/day.** A sun icon to the far right of the date/time display indicates the daylight saving time status.

5. **Use the up and down controls on the 4-Way Controller to switch between standard and daylight saving time.**

6. **When you have completed setting the date, time, date format, and daylight saving mode, press the Function/Set button to confirm your settings.**

Your PowerShot G11 allows you to set and choose between two time zones. This feature is great if you travel and want to know exactly when you took certain photos. You can set the camera to track two different time zones, one for home and one for travel, indicated by house and airplane icons, respectively. To set the time zones, follow these steps:

1. **Turn the camera on and press the Menu button.** The menu appears on the LCD.

2. **Use the 4-Way Controller to select the Set-up menu.** The Set-up menu is identified by the wrench/hammer tool icon.

3. **Use the down side of the 4-Way Controller to select the Time Zone setting.**

4. **Press the Function/Set button.** The display shows two time zones. Home is indicated by a house icon and Travel is indicated by an airplane icon.

5. **Use the 4-Way Controller to scroll down to the time zone indicated by a house icon.** This is your local time.

6. **Press the Function/Set button to display a world map.** The map will show a red box to indicate a city and a time zone highlighted in yellow.

7. **Use the right and left sides of the 4-Way Controller to select your time zone.**

8. **Press the Function/Set button to confirm your time zone.**

9. **Use the down side of the 4-Way Controller to select the Travel time zone setting.** Repeat Steps 6, 7, and 8 to complete the time zone setup.

 When you finish setting the time zones, check to make sure that the time is correct. More discussion on why this can be important is included in Chapter 2.

Formatting the memory card

The PowerShot G11 uses Secure Digital (SD) and Secure Digital High-Capacity (SDHC) solid-state memory cards. The memory card slides into the camera with the gold contacts facing the rear of the camera. When inserting a memory card into the G11 for the first time, it's always a good idea to format it first. Formatting sets the card up to receive organized data from the camera and erases any file data on the card. To format the memory card, follow these steps:

1. **Turn the camera on and press the Menu button.** The menu appears on the LCD.

2. **Use the 4-Way Controller to select the Set-up menu.** The Set-up menu is identified by the wrench/hammer tool icon.

3. **Use the down side of the 4-Way Controller to select the Format setting.** Format is deep into the Set-up menu, so you'll need to press the down side to go past other settings to locate it.

4. **Press the Function/Set button.** The display shows the size of the card, how much is used, a low level format option, and asks if you want to format the card. Chose to perform a low level format by navigating to it and placing a check mark in the box to the left with the left or right area of the 4-Way Controller or select OK to perform a normal format of the card.

5. **Use the 4-Way Controller to select OK and press the Function/Set button.** A progress bar and message appear as the card is being formatted.

Formatting erases any data on the memory card including any images that have been protected. However, there may be a way to find them again. See Chapter 2 for more details.

Setting the image quality

The file format you choose determines whether the images are stored on the memory card in JPEG, RAW, or both formats, and the quality level you choose determines the number of images you can store on the card, as well as the overall image quality and the sizes at which you can enlarge and print those images. To quickly set the image quality, follow these steps:

1. **Press the Function/Set button.**

2. **Use the down side of the 4-Way Controller to select the Image Quality setting in the bottom-left corner of the LCD.**

3. **Use the right/left sides of the 4-Way Controller to select various sizes and formats for JPEG or RAW files.**

4. **Press the Function/Set button to confirm your selection.**

Setting the ISO

ISO is a setting that adjusts how your digital camera's image sensor perceives and interprets the light that strikes it. Increasing the ISO from 100 to 400 quadruples the relative sensitivity of the camera making it easier to take photographs in low light. Lowering the ISO value in brightly lit shooting situations provides better exposures or allows you to shoot with longer shutter speeds.

The ISO settings of the camera control the light-gathering sensitivities of the image sensor, and by doing so affect exposure. You can manually set the ISO dial on the PowerShot G11 to Auto or a range from ISO 80 to 3200 in many shooting modes.

 If ISO adjustment is available in the Shooting mode you are in, a lamp illuminates near the ISO dial to alert you.

Setting the ISO correctly to suit the scene affords much flexibility during the image-processing phase later on by allowing greater latitude and a wider range of possible exposure adjustments.

 See Chapter 1 for more information about the top camera controls such as the Exposure Compensation dial.

Setting Auto White Balance

Before you begin taking pictures, it's always a good idea to check the white balance setting on your camera. White balance settings tell the camera how to interpret the scene depending on the color temperature of the ambient light or flash being used. Different types of lighting have different color temperatures that all affect getting accurate color in your images. The G11 has a sophisticated Auto White Balance setting that reads all the light entering a scene and sets an average that is extremely accurate.

AWB is the default setting in a few Shooting modes and is not adjustable. To check the white balance setting and adjust it to Auto White Balance (AWB), follow these steps:

1. **Turn the camera on and press the Function/Set button.**

2. **White Balance setting will be the top choice on the left side of the LCD.** At the bottom of the LCD screen you will see your white balance choices.

3. **Turn the Control dial to select AWB.**

4. **Press the Function/Set button to confirm.**

You get more detail about white balance and color temperature in Chapter 4.

Taking Your First Photos with Your PowerShot G11

The PowerShot G11 comes with powerful advanced controls that rival those of its older-sibling dSLRs. Creative shooting modes enable you to set the camera for different biases depending on the characteristics of the picture you want to take. Special Scene modes set the camera up for you in certain situations so all you have to do is shoot and not worry about camera settings. Reviewing and editing in-camera are a snap with two conveniently located Playback and AF Frame/Erase buttons.

Detailed explanations of all the Shooting modes can be found in Chapter 3.

Choosing a Shooting mode

Shooting modes afford the photographer as much or as little input into the exposure calculations and settings as needed, and they can really speed up the process of getting the desired shot. You can adjust Shooting modes by using the Mode dial on the top of the camera, in the center of the ISO dial. Modes such as Aperture Priority and Shutter Priority allow you to select the f-stop or shutter speed values, and the camera picks a proper shutter speed or aperture to complement it.

Auto is a Shooting mode that allows you to just shoot, and the camera takes over almost all the decisions regarding ISO, white balance, shutter speed, aperture, and flash so you can just compose the image and make the shot.

The PowerShot G11 does an amazing job at estimating all of the camera settings in a millisecond when photographing a large assortment of subjects. When you're just getting started using your camera, I suggest leaving it on the Auto setting while you familiarize yourself with some of the other important camera controls. Even on Auto mode, you still have some control over the image by way of telling the camera if you want to use the flash, Red-eye reduction flash, Self-timer, or Macro setting.

Choosing a Scene mode

Special Scene modes have become huge favorites of past G-series owners for their flexibility and awesome results. In addition to Auto, Scene modes help you capture certain types of subjects and scenes in the most appropriate way. Each Scene mode optimizes various camera settings according to typical situations to help you capture better images.

The special Scene modes are easily accessed by turning the Mode dial to SCN, right next to the Movie mode icon. Scene modes available on the PowerShot G11 include:

▶ Portrait

▶ Landscape

▶ Night Snapshot

▶ Kids & Pets

▶ Indoor

▶ Sports

▶ Sunsets

▶ Night Scene

- ▶ Fireworks

- ▶ Beach

- ▶ Underwater

- ▶ Aquarium

- ▶ Foliage

- ▶ Snow

- ▶ Color Accent

- ▶ Color Swap

- ▶ Stitch Assist

 Chapter 3 has more detail and explanations of all the individual special Scene modes.

Reviewing images

Once you've taken a few images, you'll want to see what they look like. The ability to quickly review the image you just shot is one of the greatest joys of digital photography. Once the image file is successfully written to the storage card, the image can be displayed on the LCD monitor for a user-defined amount of time.

 Chapter 2 explains how to change the standard image reviewing time.

To review your images after the shoot, enter Playback mode by pushing the Playback button on the back of the camera below the ISO dial. In Playback mode, the first picture displayed is the most recent image you took. You can scroll through all of your images by turning the Control dial.

You can also use the Zoom lever on the camera to zoom in to the photo and magnify the image so you can see the details. If you zoom out, you can create grids of all your images that get progressively smaller as you zoom out, similar to a contact sheet of negatives that allow you to quickly review large groups of images.

Deleting images

You can delete images you do not like during image playback by pressing the button just to the top left of the 4-Way Controller, identified by a blue trash can icon. When

you press the Delete button while reviewing images on the LCD monitor, a dialog box appears asking you if you want to erase the current image. If you are absolutely sure you want to delete it, turn the Control dial to select Erase then press the Function/Set button and the image is deleted from the storage card.

 Be totally sure you want to delete the image(s) from the storage card. There is no undo for deleted images!

Anatomy of the PowerShot G11

Now that you've covered the Quick Tour and probably have had some fun test driving your new camera in a variety of shooting situations, it's time to move on and explore the key features and components of your PowerShot G11. This first chapter brings you up to speed with the most readily accessible controls of the G11 that are located on the outside of the camera: the buttons, dials, and 4-Way Controller.

Many of you may be upgrading from a previous G-series camera, but there are plenty of new features on the G11 that require a more detailed look. Bear in mind, this info comes to you from a professional photographer who has been using digital cameras for several years and is impressed with the wide array of convenient features and shooting modes that the G11 offers.

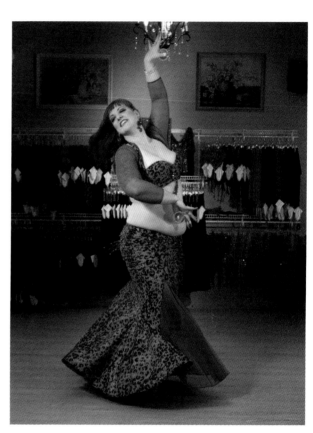

Magidah Sa'id, belly dancer, instructor, and entrepreneur, photographed in her studio for INUR Magazine. Taken in Manual mode at ISO 320, f/8, 1/30 second with a 9.8mm lens setting.

Camera Controls

In the Quick Tour, I briefly told you where some of the controls were located and out-lined some simple settings to start taking pictures right away. You should be pretty familiar with the basic buttons and dials you need to use to make your initial settings. This section covers the camera from all sides so you can fully understand the layout of all the controls available to you on the outside of the camera.

One of the really cool features of the G11 is its retro design with several exposed dials that harks back to the look of film cameras, and I'm happy to accept the extra bulk of the G11 in order to afford those exterior functions. The great thing about these exter-nal controls is that they give you quick access to important settings you will use over and over again. Searching through menus to find the option you want can get old very quickly and can increase the likelihood of missing important shots.

4-Way Controller

Before getting into detail about the buttons and dials, you need to under-stand the function and navigation of the 4-Way Controller, usually referred to by one or more of its parts. You will use this control more than any other with the exception of the Shutter Release button. It functions very simi-lar to the arrow keys on your computer keyboard and is used to move up, down, left, and right as you scroll through selections on the LCD moni-tor. Those same up, down, left, and right area movements also give you access to several core groups of func-tions. Some of these options may be inaccessible depending on your Shooting or Scene mode.

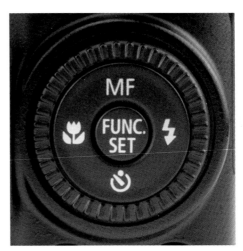

1.1 The layout and option areas of the 4-Way Controller

The 4-Way Controller on the PowerShot G11 includes the following functions:

▶ **Control dial.** This textured ring that surrounds the 4-Way Controller is used to make selections, adjust settings, adjust focus, and navigate the menus. It mim-ics the function of other controls, too, so give it a try first to change a selection.

▶ **Manual focus.** When you press this icon the G11 switches to Manual focus mode and displays a magnified area of the scene when you turn the Control dial. It also displays a focusing scale on the right-hand side of the LCD. You turn the Control dial to focus the magnified area and thus the photo to make sure it's sharp.

▶ **Flash control.** Pressing this icon displays the flash mode options available to you in the particular Shooting mode setting you've chosen. Flash options include Auto, On, Slow Synchro, and Off.

▶ **Self-Timer.** You access the five Self-timer modes by pressing the clock icon at the bottom of the 4-Way Controller. The Self-timer allows delaying the camera's firing by 2 or 10 seconds, usually to allow the photographer to be in the shot, or when a new face enters the scene, or when using a special custom mode that allows you to set the delay time and the number of shots to be taken.

▶ **Macro mode.** Pressing the flower icon on the left side of the 4-Way Controller switches the camera lens between normal and Macro modes. Macro mode allows the lens to focus on objects that are very close; so close, in fact, that care must be taken not to bump the object with the front element of the lens.

 Instead of zooming in to frame the subject when you are shooting in Macro mode, keep your lens zoomed to the Landscape setting and move the camera closer or farther away from the object to compose the shot. The G11 will be unable to focus on macro subjects using a telephoto lens setting in Macro mode.

Top camera controls

Figure 1.2 shows the top camera controls, which provide ease of use so the thumbs and index fingers of both the right and left hands control common adjustments quickly without taking the camera away from the shooting position. The top camera controls are:

▶ **Exposure Compensation dial.** In Shooting modes, use this dial to adjust exposure anywhere between +2 to –2 stops off of the base exposure.

▶ **Exposure Compensation lamp.** This handy lamp illuminates in particular Shooting modes when adjusting Exposure Compensation is possible.

Chapter 3 explains how to use the Exposure Compensation dial in more detail.

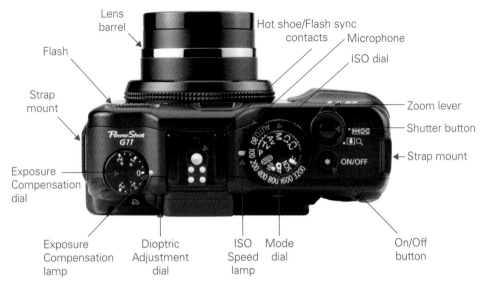

1.2 The G11 top camera controls

▶ **Dioptric Adjustment dial.** This small dial nestled to the left of the viewfinder is used to make adjustments for viewfinder clarity to suit your eyesight. It has no effect on the LCD monitor. The range of dioptric adjustment is –3 to +1. To set the dioptric adjustment, focus the lens by pressing the Shutter Release button halfway down, and then turn the knob until the image in the viewfinder is sharp. If you wear eyeglasses when shooting, like I do, be sure to wear them when setting the dioptric adjustment. Adjusting this dial to suit your eyes makes it very easy to review images on the LCD and go right back to looking through the viewfinder.

▶ **Flash sync contacts.** The hot shoe contains the standard flash sync contacts for mounting an external Canon EX-series Speedlite or the ST-E2 wireless transmitter to fire remote flashes.

▶ **Microphone.** When shooting movies, the mono microphone picks up the voices and sounds in your scene and is the only audio input on the G11. Due to its close proximity to the camera controls, it also may pick up operational control sounds like zooming in and out or active camera handling, so be sure to keep these actions to a minimum when shooting video.

▶ **ISO speed dial.** In Shooting modes that allow it, this dial controls the ISO setting from Auto to ISO 3200. Use this dial in low light or overly bright situations to manually set the ISO.

▶ **ISO Speed lamp.** At the 9 o'clock position outside the ISO speed dial, the ISO Speed lamp lights to indicate manual ISO adjustment is possible in certain Shooting modes.

▶ **Mode dial.** Turning this dial changes the Shooting modes. Shooting modes determine how much control you have over the final exposure. The dial provides fully automatic shooting with Auto, and includes Program, Shutter Priority, Aperture Priority, Manual, Quick Shot, Movie, and Low Light modes, a complete selection of Special Scene modes, and two user-customizable C1 and C2 modes.

▶ **Zoom lever.** The zoom lever allows adjusting the focal length of the lens during shooting to aid in composition. When reviewing images, it is used to magnify an image, show the full image, or display a grid of images on the memory card, similar to a contact sheet.

▶ **Shutter Release button.** Pressing this button halfway down activates autofocusing, auto white balance, and automatic exposure metering that then sets the shutter speed and aperture. Pressing down completely releases the shutter and captures the image.

▶ **On/Off button.** This button is used to turn the G11 on and off, and a green LED at the center of the button indicates the camera's status.

Rear camera controls

Figure 1.3 shows the rear camera controls, which provide quick access to the LCD monitor, menus, various playback and image deletion controls, display options, and exposure information:

▶ **LCD monitor screen.** The LCD monitor screen is where you compose the image prior to shooting, make menu selections, and review the images after you have taken them. Part of the excitement of the new G11 is the added function with a new 2.8-inch vari-angle PureColor II VA LCD, a feature introduced as a direct result of customer feedback.

The adaptable screen makes the PowerShot G11 ideal for shooting in all situations, such as shooting when using the optical viewfinder may not be practical. Perfect for creative and macro photography, the vari-angle lens has a wide viewing angle and 461K dot resolution with natural color accuracy, giving photographers a detailed view of their subjects — both before and after the shoot. It rotates a full 180 degrees to also protect the LCD monitor when the camera is not in use.

▶ **Shortcut/Direct Print button.** Once a control is registered, pressing this button allows you quick access to a camera function of your choosing from a prescribed list. Some registered controls may not be available in all Shooting modes.

In addition, when a camera is connected with a PictBridge, Canon CP Direct, or Canon Bubble Jet Direct–enabled printer and the camera is set to Print/PTP, this button in conjunction with the Playback button can also display JPEG-only images for cropping, layout, and direct printing. When connected to a computer via the USB digital terminal, use this button to begin downloading images to the computer.

▶ **Viewfinder.** The viewfinder is used to compose the image the same way you would in dSLR and many other cameras. The viewfinder only shows 77 percent of the actual picture taken, so there will be more image in the file than what you saw through the viewfinder.

▶ **Indicator lamps.** The indicator lamps to the right of the viewfinder illuminate or blink to alert you to various camera states.

▶ **Playback button.** This button displays or turns off the playback display of the images or movies on the LCD. Press the Playback button to enter the Playback mode and review still images or videos. The image shown will be the last picture or video the camera captured. It also turns the camera on when it is connected to a television set for viewing images.

▶ **AE Lock/FE Lock button.** Auto-exposure lock and Flash-exposure lock can be activated by pressing this button.

Chapter 3 explains why you might want to use AE Lock and FE Lock.

▶ **AF frame selector/single image erase button.** When the AF frame is set to FlexiZone mode, pressing this button will turn the AF frame orange to indicate it can be moved or resized to an area of your choosing. If you hold it down, it returns the AF frame to the original center position. If the AF frame mode is set to Face AiAF, pressing the Menu button repeatedly will move the AF frame from face to face allowing you to choose which one to focus on. Pressing this button during Playback mode will delete the image shown on the LCD from the memory card.

Chapter 2 explains more about focus modes and FlexiZone and Face Detect.

▶ **Metering light/Jump button.** Use this button to choose between Evaluative, Center-Weighted Evaluative, or Spot metering modes when in the Shooting modes. During Playback mode, use this button to jump among different amounts of photos or to sort between still images and videos for playback.

▶ **Menu button.** The Menu button displays groups of camera functions organized under three tabs, Shooting settings, Camera settings, and My Menu, an area where you can register settings from the Shooting and Camera menus to tailor the menu to contain the controls that you use most often. The Menu button is also used during other camera functions to change settings.

 Chapter 2 explains the entire menu system of the G11.

▶ **Display button.** Pressing the Display button enters the mode where you can change the display on the LCD monitor between Off and two user-configurable display modes. You use this button to switch between display modes that can show shooting info, grid lines, a brightness histogram, or a 3:3 ratio guide.

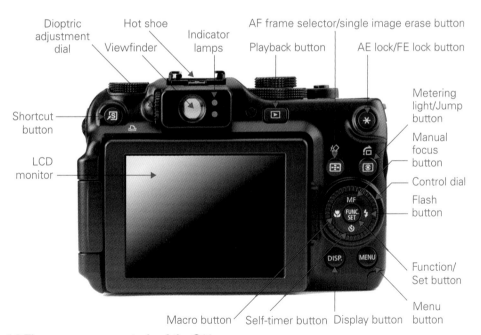

1.3 The rear camera controls of the G11

Front camera controls

Figure 1.4 shows the front of the camera, which is one view that photographers usually see only in camera ads. But there are lamps and features located there that you use often. Front features of the PowerShot G11 include the following:

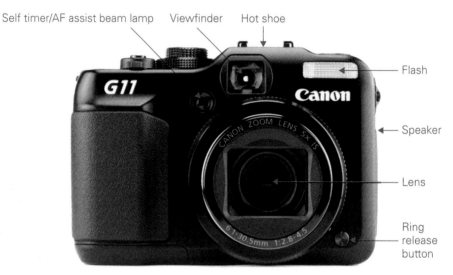

Self timer/AF assist beam lamp Viewfinder Hot shoe

Flash

Speaker

Lens

Ring release button

1.4 The front camera controls of the G11

▶ **Lens.** The lens of the PowerShot G11 allows both wide-angle and telephoto pictures and any setting in between. The lens is 6.1mm at its wide angle setting and 30.5mm at its telephoto setting, the equivalent of a 28-140mm lens on a 35mm camera, and also includes optical Image Stabilization (IS), a feature found on more expensive dSLR lenses.

▶ **Flash.** The built-in flash has a range of 50cm/1.6 feet to 5 meters/16 feet when shooting wide-angle photos and 50cm/1.6 feet to 5 meters/16 feet when shooting telephoto pictures.

 Chapter 4 explains the on-board flash in more detail.

▶ **AF-assist beam/Self-timer lamp.** This lamp flashes to count down the seconds to shutter release when the camera is set to one of the Self-timer modes. This lamp also illuminates in low-light shooting situations to aid operation of the auto-focus system.

▶ **Ring.** A bezel that surrounds the lens, this ring is removed to attach accessory lenses or to switch to different color accessory rings.

▶ **Ring release button.** Pressing this button disengages the ring from around the lens mount to facilitate mounting the optional conversion lens and teleconverter or to change the color of the ring with the optional RAK-DC-2 Accessory Kit.

Camera terminals

Figure 1.5 shows the interface terminals, which are located on the right side of the PowerShot G11 under the spring-loaded terminal door. The cover door is embossed with icons that identify the terminals underneath. The terminals include the following:

▶ **HDMI mini OUT terminal.** Located at the top of the terminal compartment is the HDMI mini OUT terminal. It connects the Type 2 HDMI HTC-100 cable to any high-definition television, monitor, or DVR unit with an HDMI input port.

▶ **Remote switch terminal.** This terminal, in the middle of the terminal compartment, connects with a remote control switch to fire the camera to avoid camera shake when shooting in telephoto and macro modes as well as when shooting time exposures. The optional Remote Switch RS-60E3 replicates the functionality of the Shutter Release button, providing half and full depression of the Shutter

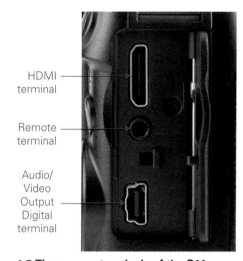

HDMI terminal

Remote terminal

Audio/ Video Output Digital terminal

1.5 The camera terminals of the G11

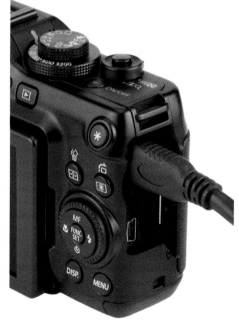

1.6 The G11 with the HDMI HTC-100 cable attached for viewing images and videos on a high-definition TV

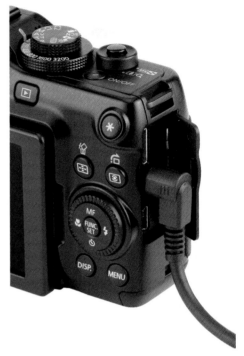

Release button as well as the shutter-release lock to keep the shutter open for longer periods of time up to 15 seconds when shooting time exposures.

▶ **A/V Output Digital terminal.** Located on the bottom of the terminal panel, the digital terminal connects the camera to a standard television for viewing images, for downloading images to a computer, or for printing to a compatible printer. The cable for direct printing comes with the printer, and printer cables must support PictBridge, PictBridge and CP Direct, PictBridge and Bubble Jet Direct, CP Direct only, or Bubble Jet Direct only.

Side and bottom camera features

Figure 1.9 shows the bottom features of the PowerShot G11, which includes the release latch and cover for the battery and memory card compartment, and the tripod socket used when securing the camera to a tripod or tripod quick-release plate.

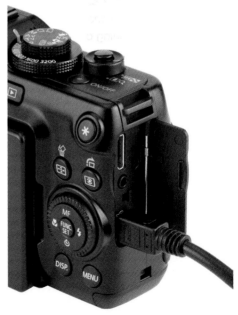

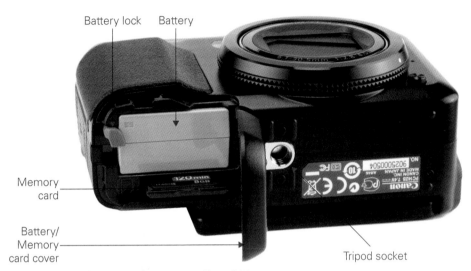

Battery lock Battery

Memory card

Battery/ Memory card cover

Tripod socket

1.9 The bottom features of the PowerShot G11

The side panels of the G11 also include:

▶ **Speaker.** A speaker is included on the left-hand side of the G11 to listen to audio after recording movies.

▶ **DC coupler cable cover.** When using the optional AC Adapter Kit ACK-DC50, the coupler cable that connects the camera to household power exits the camera via this opening on the right side that is closed by the cover when the camera uses a standard NB-7L battery.

LCD Monitor Screen

A big part of the excitement of the new G11 is the new high-resolution 2.8-inch vari- angle PureColor II VA LCD. Although slightly smaller than the 3.0 inch LCD monitor on the previous G10, it includes the same number of pixels, and the smaller size allows the LCD to be positioned for shooting comfort and functionality, or completely flipped around to protect the face of the LCD when the camera is not in use.

You use the LCD to compose images while shooting, review images and videos dur- ing Playback mode, and operate the menus. As an added feature, the LCD monitor brightness level can be set over a five-step range, convenient when shooting in brightly lit situations or when shooting in low-light locations where the glow of the LCD may be distracting to others.

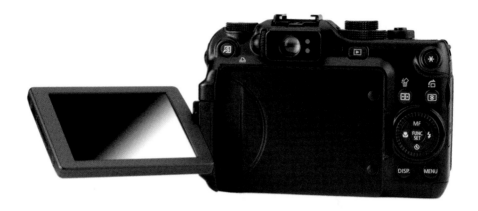

1.10 The new 2.8-inch vari-angle PureColor II VA LCD of the PowerShot G11

Positioning

From its closed position, the vari-angle LCD monitor is positioned for shooting by flip-ping it out to the left, away from the camera body, rotating the top edge of the LCD 180 degrees away from you, and then flipping it back to the right, filling the indenta-tion on the back of the camera for a streamlined fit.

You can position the LCD to allow full view of the lens coverage area from a conve-nient shooting angle, such as when holding the camera above your head in event or concert situations, or low to the ground when photographing children, wildlife, flow-ers, or pets.

Another cool feature of the vari-angle LCD monitor is the mirror-image display the LCD switches to when the monitor is positioned facing the front of the camera as when composing a shot with you in it. This way you can see exactly what the picture will look like when holding the camera away from you. You can compose the shot with you and your family or friends and see what the background looks like before you make the exposure.

To change the display when the LCD monitor is positioned towards the front of the camera, follow these steps:

1. **Press the Menu button.**

2. **Press the up area of the 4-Way Controller to select Reverse Display.** You can turn this feature on or off.

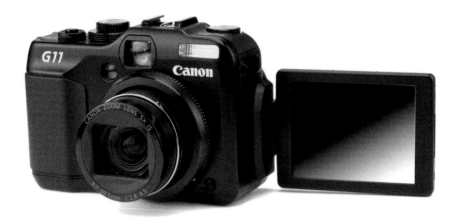

1.11 The LCD monitor can display a mirror image when oriented toward the front of the camera.

Quick Shot mode

When you need to shoot quickly because the action in front of your lens is happening fast and you want to see all the pertinent camera settings on one screen, switch to the Quick Shot mode on the Mode dial. The Quick Shot mode is ideal for those run-and-gun situations where you will not be reviewing images on the LCD until after you finish shooting. In Quick Shot mode, you compose images while looking through the viewfinder so you never have to take your eye away from the action.

Several camera controls are accessible and fully adjustable from the new Quick Shot mode screen on the LCD. To see what your options are, follow these steps:

1. **Turn the Mode dial to the flying camera icon and then press the Function/ Set button.** The last value changed will be highlighted.

2. **Press the 4-Way Controller right, left, up, or down to scroll through the available functions.**

3. **Once you highlight something you want to change, turn the Control dial to make the change.** You do not need to press the Function/Set button to apply the change. A message at the bottom of the LCD screen will show you the options you've selected for that particular function.

4. **From this control screen, use the 4-Way Controller and Control dials to make your selections.**

The LCD monitor displays the status of the following shooting functions in Quick Shot mode:

▶ Shutter Speed

▶ Aperture Value

▶ AE Lock/FE Lock

▶ ISO Speed

▶ Exposure Compensation

▶ My Colors

▶ Flash Exposure Compensation

▶ Flash mode

▶ White balance

▶ Image quality

▶ Drive mode

▶ Self-Timer

▶ Histogram

▶ Camera orientation

▶ Image Stabilization

▶ Battery charge indicator

▶ Recordable shots

Depending which of these functions you have turned on, the Quick Shot screen will also indicate the status of the following:

▶ i-Contrast

▶ Red-Eye Correction

▶ Date Stamp

The interface is elegant, the type and symbols are large and easy to see, and

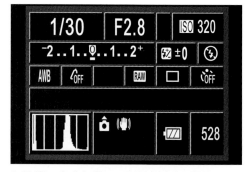

1.12 The Quick Shot screen of the G11

the 4-Way Controller response is fast and accurate. I must say that I was very impressed with this new display on my first few outings with the PowerShot G11 — not only for its

ability to quickly change settings but for its ability to pick one mode and see an illuminated, adjustable readout of those settings in the midst of a fast-paced shooting session.

Face Detection modes

The PowerShot G11 was designed first and foremost to take great shots of people. Several features built in to the G11 support this objective, but probably none more so than the Face Detection modes. The G11 comes loaded with not just one but three Face Detection features for different types of shooting scenarios.

 Face Detection is a sophisticated technology that can detect and track numerous faces within the frame to ensure the correct exposure and focus for them. If that is not enough, the G11 also features Blink Detection that alerts you if someone in your shot blinked so you can retake the photo. This feature can also be turned off in the Shooting menu. See Chapter 2 for more information on setting Face Detection modes.

The Face Detection features of the G11 include the following:

▶ **Face AiAF.** In Face AiAF mode, the G11 adjusts exposure and white balance to optimize exposure for people's faces. This is a great setting to use in most situations for photos with people in them. In rare occasions, the camera may blow out a few highlights attempting to get proper exposure on the face, but it does a much better job in difficult lighting situations, resulting in faces that are bright and clear.

This feature also works extremely well in strong backlit scenarios where your subject's face may be in a shadow, resulting in underexposure, or it counteracts overexposing faces that appear against darker backgrounds, which is common with digital cameras that don't include this technology. The G11 displays a white frame around the face it detects as the main subject and gray frames around the other faces in the scene.

▶ **Face Selection.** With the G11 set to Face AiAF in the Shooting menu, you also have the ability to choose which face to focus on when your shot includes more than one face. This is desirable in group shots where one face is more important to you than the others. Face Select mode displays an orange frame around the face it detects as the main subject, and the orange face frame follows this person's face, even if that person moves around in the scene. You are then free to move the face frame to a different face using the 4-Way Controller areas and the Control dial, and then shoot the picture.

▶ **Face Self-timer.** With the Face Self-timer mode, gone are the days of having to run to get in the picture when shooting images with you in them. Previous G-series cameras gave you the option of a 2- or 10-second delay before the camera took the picture. Often, this wasn't enough time for the photographer to get into the group, resulting in poorly timed group photos. When the Shutter Release button is pressed, Face Self-timer waits until the G11 detects a new face entering the scene, indicated by the Self-timer beep and warning light speeding up, and after 2 seconds, the camera takes a series of three shots. If your face or the added face is not recognized by the camera, the camera takes the three pictures after approximately 30 seconds.

▶ **Blink Detection.** Although not actually a Face Detection mode, this new feature is related and bears mentioning here. As an added safeguard, Blink Detection alerts you via the LCD monitor anytime it detects what it perceives to be closed eyes in the picture. The camera displays a face icon with greater than/less than symbols for the eyes, allowing you to reframe and take an additional picture to make sure everyone's eyes are open. Blink Detection can be turned on or off in the Shooting menu.

Grid Display

As an added feature, the PowerShot G11 includes a display option for Grid Display, which overlays the LCD monitor with a nine-box Rule-of-Thirds grid. This grid is an ideal compositional aid when shooting architecture, landscapes, and scenics, and helps you follow the Rule of Thirds by showing where you might place your subject for more interesting images.

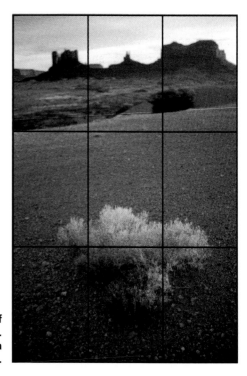

 The Rule-of-Thirds and other compositional aids are explained in more detail in Appendix A.

1.13 Grid lines help you follow the Rule of Thirds when composing your images. Taken at ISO 100, f/4, 1/60 second with a 6.1mm lens setting.

Clock Display

In the Quick Tour, I described how to set the Clock Display when you first set up the camera. This is an important setting for those shooting situations like weddings or vacations where you may be generating lots of images over several memory cards. By having the clock set properly, you can organize your images later in the included Canon Zoom Browser software in chronological order that sets all the images in the order they were captured.

1.14 The standard Clock Display on the G11 in horizontal orientation

 See the Quick Tour for **CROSS REF** instructions on how to set the clock.

You can access the Clock Display at any time by pressing and holding down the Function/Set button. The Clock Display also shows the date (mm/dd/yy) when the camera is turned to a vertical position.

Lens Controls

The Canon lens of the PowerShot G11 delivers high performance, offering a 5x wide-angle (28mm) zoom with optical Image Stabilizer (IS). This enables you to take handheld shots at shutter speeds 4 stops slower than conventional non-IS models, allowing perfect shooting in darker conditions or at lower ISO settings.

1.15 The Clock Display when the PowerShot G11 is held in a vertical orientation. The time is displayed vertically on the left, while the date is on the right.

Image Stabilization

Image Stabilization (IS) is a technology that counteracts motion blur from handholding the camera. Canon has built the same Image Stabilization technology used in its premium lenses into the G11 for sharper pictures of moving subjects and handholding the camera in low light. The IS needs to be fluid because different shooting scenarios have different stabilization needs. The IS of the G11 enables you to gain from 1 to 4 f-stops of stability — and that means that you may be able to leave the tripod or monopod at home.

Canon's inclusion of optical Image Stabilization (IS) technology in the PowerShot G11 makes handholding the camera at slow shutter speeds and in low-light scenes more likely to produce a sharp image.

The rule of thumb for handholding a camera has always been 1/shutter speed to [focal length]. For example, the slowest shutter speed at which you can handhold a 140mm lens and avoid motion blur is 1/140 second. If the handholding limit is pushed, then shake from handholding the camera bends light rays coming from the subject into the lens relative to the optical axis, and the result is a blurry image.

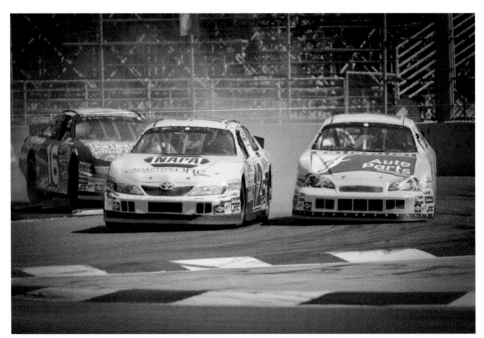

1.16 For fast-paced action like this NASCAR race, Image Stabilization (IS) assures sharp images. Taken in Aperture Priority mode at ISO 400, f/5.6, 1/4000 second with a 30.5mm lens setting.

IS Lenses and Panning

IS detects *panning* (moving the camera with the motion of a subject) as camera shake, and the stabilization then interferes with framing the subject. To correct this, Canon offers four settings on the G11 for IS: Off, Continuous, Shoot Only, and Panning. Continuous and Shoot Only are designed for stationary subjects, whereas Panning shuts off IS in the direction of movement when the lens detects large movements for a preset amount of time. So, when panning horizontally, horizontal IS stops, but vertical IS continues to correct any vertical shake during the panning movement.

With an IS lens, the built-in miniature sensors and a high-speed microcomputer analyze vibrations and apply corrections via a stabilizing lens group that shifts the image parallel to the focal plane to cancel camera shake. The lens detects camera motion via two gyro sensors — one for yaw and one for pitch. The sensors detect the angle and speed of shake. Then the lens shifts the OIS lens group to suit the degree of shake to steady the light rays reaching the focal plane.

Stabilization is particularly important with long lens settings and macro shooting where the effect of shake is more pronounced as the focal length increases. As a result, the correction needed to cancel motion shake increases proportionately.

Image Stabilization can be a lifesaver, particularly in low-light situations such as weddings, music concerts, or sporting events where tripods are impractical.

Optical zoom

The 5x optical zoom extends the camera's telephoto capabilities by way of optics only with no digital enhancement. I prefer to stay in this smaller zoom range because of the better quality images the G11 attains, because some image degradation can occur when employing the higher-powered digital zoom.

The zoom range on the optical zoom of the G11 is more than adequate for most subjects. I nearly always choose a telephoto lens setting, not only when shooting portraits of people and pets but also to capture distant subjects such as race cars, landscapes, wildlife, and close-ups. It's simply a must for shooting sports. Telephoto lens settings allow you to photograph distant birds, wildlife, and most sporting events. When photographing wildlife, these lens settings also allow you to maintain a safe working distance from the subject, whether it's snakes in the desert or elk in the mountains.

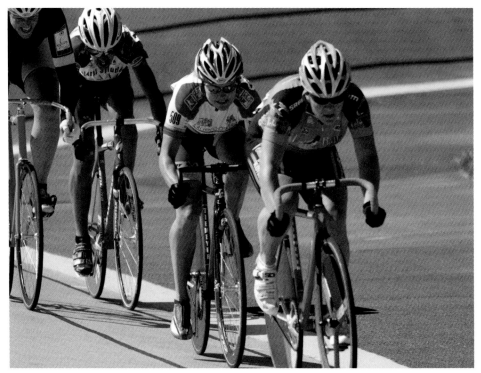

1.17 Bicycle racers at Alpenrose Velodrome. A telephoto lens setting is required for shooting action scenes such as this. Taken in Manual mode at ISO 100, f/8, 1/250 second with a 30.5mm lens setting.

When you shoot with a telephoto lens, keep these lens characteristics in mind:

▶ **Shallow depth of field.** Telephoto lenses magnify subjects, yield a smaller field of view, and provide a limited range of acceptably sharp focus. At large apertures, such as f/4, you can render the background to a soft blur, but with an extremely shallow depth of field, it's important to get tack-sharp focus somewhere in the frame.

▶ **Narrow coverage of a scene.** Because the angle of view is narrow with a telephoto lens, much less of the scene is included in the image. You can use this characteristic to exclude distracting scene elements from the image.

▶ **Perspective.** Telephoto lens settings tend to compress perspective, making objects in the scene appear stacked together. You can sometimes offset this by changing your shooting or lighting angle.

Digital zoom

The 4x digital zoom extends the camera's telephoto capabilities to a total zoom capability of 20x. This function allows you to shoot distant subjects such as wildlife at a much greater focal length than the standard zoom settings, providing a larger subject that fills the frame.

You enter the Digital Zoom range by zooming out all the way in Standard zoom using the Zoom lever, then moving the lever again toward the single tree icon to activate Digital Zoom. Digital Zoom is a handy feature when shooting sports events or wildlife or scenic landscapes, or in any situation where you may not be able to get physically closer to your subject or when doing so might be dangerous or not allowed.

Digital Tele-Converter

Similar to adding a teleconverter between a conventional lens and a dSLR camera body, the G11's Digital Tele-Converter increases the focal length of the lens by 1.4x or 2.3x digitally. These digital teleconverter settings allow you to shoot with faster shutter speeds than with standard zoom at the same focal lengths. The digital camera allows you to adjust the zoom among four settings:

▶ **Off.** Turning the zoom off enables shooting without digital zoom with a focal length of 28mm to 140mm (35mm equivalent).

▶ **Standard.** Selecting standard zoom enables shooting at zoom factors of up to 20x with digital and optical zooms combined at a focal length of 28mm to 560mm.

▶ **1.4x.** Digital zoom is fixed at the select zoom factor of 1.4x for a focal length of 39.2mm to 196mm (35mm equivalent) enabling faster shutter speed and less chance of blurry pictures.

▶ **2.3x.** Digital zoom is fixed at the select zoom factor of 2.3x for a focal length of 64.4mm to 322mm (35mm equivalent) enabling faster shutter speed and less chance of camera shake affecting the image.

These settings may produce some image degradation depending on image quality settings and cannot be engaged when shooting in RAW capture or Wide (panoramic) file size mode.

Canon CCD Sensor

The PowerShot G11 utilizes a 1/1.7-inch CCD (charged coupled device) sensor with an approximate pixel count of over 10 million pixels and is manufactured by Sony. This

small device, usually referred to as the image sensor, captures the light entering the camera as an electrical signal then sends it to the DiG!C 4 for processing.

Compact digital cameras like the PowerShot G11 typically have much smaller sensors than standard digital SLR cameras and are thus less sensitive to light and inherently more prone to noise, which can degrade picture quality, especially in the dark areas.

PowerShot users cite Canon's decision to go with the CCD sensor for the G11 instead of a CMOS sensor as the main reason the camera doesn't feature a high-definition video capability because the CCD sensor can't handle it. CCD sensors cost less to manufacture than the CMOS sensors used in dSLRs, which is why the price of the G11 stays at an affordable level.

DiG!C Image Processor

Between the capture and recording stages is the image processing that determines how the signals from the sensor are translated into a viewable image. The PowerShot G11 employs a newly developed, 10.0 megapixel High Sensitivity System by combining a powerful CCD sensor and Canon's new DiG!C 4 Image Processor with iSAPS technology. Major advances responsible for the incredible speed, advanced image-processing capabilities, and lower power consumption over the processor found in older PowerShots include lower-noise image development at all ISOs, higher-speed image processing, improved highlight and shadow details, extended dynamic range, more accurate saturated colors that maintain fine details, and improved performance.

In addition, a new Low Light mode lets you capture images in an astonishing range of conditions. The camera automatically adjusts the ISO speed from ISO 320 to ISO 12,800 in relation to ambient brightness, subject movement, and camera movement.

The new DiG!C 4 image processor significantly raises the bar with increased ISO ranges in normal and expanded modes and adds an Auto ISO range feature to select from a range of 100–3200 ISO.

Using the PowerShot G11 Menus

By now, you've spent some time with your G11 and perhaps tried it out in a number of different shooting situations. The external buttons, dials, and controls discussed in the previous two chapters are the ones you'll use most when shooting pictures, and their easy accessibility keeps this in mind.

This chapter describes in detail the menu system of the PowerShot G11, breaks down each menu setting and the options for it, and provides some tips on when and why to use those settings. Previous PowerShot users should have no difficulty feeling comfortable with the menu layout and should also really enjoy the ability to position the beautiful new 2.8-inch (diagonal) LCD for comfort and ease of use.

Dyed eggs are on the menu, photographed by setting a Daylight white balance and then shooting with a tiny amount of onboard flash. Taken at ISO 250, f/2.8, 1/40 second with a 10.8mm lens setting.

Camera and Shooting Functions

The G11 keeps the same groupings as the older G10, but has added a few settings within those sections and a My Menu area for registering up to five frequently used menu items for quick recall in fast-paced shooting situations. There's also a setting to register your favorite options and save them as Custom Shooting Modes (C1 and C2 on the Mode dial).

Once you have a clear idea of where each setting is located and have developed some methods of shooting for yourself, you may want to save those settings so you can quickly return to them at a moment's notice.

Access the menus on the G11 by pressing the Menu button on the back of the camera. You then use the 4-Way Controller and Control dial to scroll through the options and make your selections. Some menu items only have a few choices, and the current setting displays to the right of the item. You only have to use the 4-Way Controller to make your selections. Once they are set you can move on to change other settings.

Some menu items open even more detailed menus, so be on the lookout to customize functions as much as possible. When the desired menu item is highlighted, press the Function/Set button to enter the larger menu area. Make your selections from the list of options, and then press the Menu button when finished. Pressing the Menu button again or tapping the Shutter button exits the Menu mode screen and readies the camera for shooting.

When you press the Menu button on your G11, the main menu categories appear on your LCD screen as tabs across the top. While the category tabs and menu items that appear below them depend on the mode the camera is in, the menu system can be broken down into five main categories:

▶ **Shooting.** Symbolized by a camera icon, the Shooting menu contains detailed camera setting functions you set up once for the particular way you like to shoot. These functions need not be addressed every time you shoot but should be thought of as a way to customize the camera to suit your shooting style and overall preferences.

2.1 In Shooting mode, this is the menu you see on your screen when you press the Menu button.

▶ **Set-up.** Identified by its wrench and hammer tools icon, this menu offers setup features like Date & Time and several options on camera functionality. The Set-up menu can be accessed from either Shooting mode or Playback mode.

▶ **My Menu.** Under the star icon tab are the menu items listed that you have registered as your favorites. You build this list by selecting your top 5 menu items from a list of 24 items. You can also set My Menu to appear first whenever you press the Menu button.

▶ **Playback.** The Playback menu only appears when you press the Menu button while in the Playback mode; its icon is a right-pointing triangle inside a square. This menu offers playback options like slide shows and various playback display selections.

2.2 In Playback mode, the menu tabs change to these options.

▶ **Print.** Identified by an icon that resembles a page coming out of a printer, the Print menu is only visible when the menus are accessed while in Playback mode. Under this tab are a variety of printing and output options.

 When deep into a menu, use the Metering light/Jump button to quickly switch between menu tabs at the top of the LCD display.

Be aware that not all Menu tabs and items are available at all times. If you can't locate a Menu tab or item, try putting the camera into another Shooting mode by turning the Mode dial or pressing the Playback button.

Shooting Menu

You can change different options for different shooting scenarios in the Shooting menu. As you begin to get more accustomed to your PowerShot G11, you will probably enter this menu fairly often to change settings or try different ones. I encourage you to explore all of the creative possibilities your camera has to offer.

AF Frame

The AF Frame options control how the G11 achieves autofocus. The AF Frame offers two choices:

- ▶ Face AiAF
- ▶ FlexiZone

When FlexiZone is selected, you can move the focus frame around after pressing the AF Frame/Erase button or hold this button down for a few seconds to return the AF Frame to its normal center position.

Face AiAF is an intelligent autofocus system that detects and prioritizes faces in the scene. It automatically switches the G11 between a nine-area AF system and face detection. It's great to have the two most common AF modes on a single option rather than having to manually select face detection as users of the earlier G10 had to do.

Digital Zoom

Digital Zoom crops the center section of the frame and magnifies it to simulate the effect of zooming in on a scene with your lens. The options are:

- ▶ Standard
- ▶ Off
- ▶ 1.4x
- ▶ 2.3x

The last two options turn on the Digital Tele-Converter mode described in Chapter 1. These settings are fine if you are shooting in the low-resolution Image Quality settings, but they can degrade image quality in high-resolution settings and are not available when shooting RAW capture.

AF-point Zoom

AF-point Zoom aids you by displaying a magnified image of the autofocused area superimposed over the original composition. Your choices are On or Off.

The AF-point Zoom feature is handy for making sure your image is focused after pressing the Shutter Release button to achieve autofocus when it's difficult to do so. Turn AF-point Zoom on so you can see small details magnified and then adjust focus.

 AF-point Zoom can be distracting when you compose your shot, so if you use **CAUTION** this setting, remember that your image will be the entire composition on the LCD monitor, not just the magnified area displayed.

Servo AF

With Servo AF on, the G11 continues to set focus and exposure when the Shutter Release button is pressed halfway down. Servo AF is a good mode to use when shooting sports or action where subjects may be moving closer or farther away from you as you try to take the picture.

In Servo AF, focus and exposure are continuously adjusted inside the blue AF frame while you continue to hold the Shutter Release button halfway down. This option is not available in the Self-timer modes.

Continuous AF

With Continuous AF turned on, the G11 continually focuses until focus is achieved even when the Shutter Release button is not pressed halfway down. Although it is a slight distinction from the Servo AF option, this setting allows the camera to focus as you track a moving or active subject and locks focus once the Shutter Release button is pressed so you don't miss an important shot.

 I turn Continuous AF off in situations where I want to prolong battery life to **NOTE** extend my shooting time.

AF-assist beam

The G11's autofocus system cannot read detail if your scene is too dark. When this happens, the Red-eye reduction LED in the front of the camera turns on and activates as an AF-assist beam to provide enough illumination to the area so the autofocus system can do its job. You can turn this feature either on or off. I set this feature to Off to conserve battery power when I am in bright shooting locations and do not need this focusing aid.

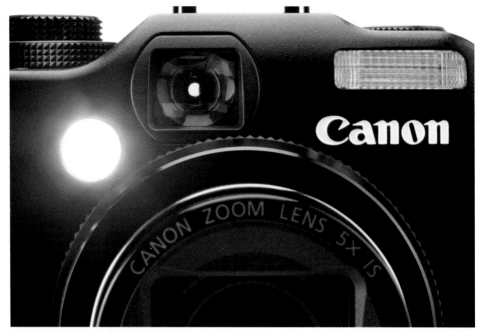

2.3 The Red-Eye Reduction LED does double duty as an AF-assist beam for attaining accurate focus in low light scenes.

MF-point Zoom

MF-Point Zoom is similar to AF-point Zoom in that it displays a magnified image of the focused area superimposed over the original composition when shooting in Manual Focus mode. Your choices are On or Off.

This is a great feature to use if you have trouble making sure your image is focused before taking manually focused pictures. Turn this feature on so you can see the magnified view to check small details and adjust focus. Use the Control dial to focus the image. A distance scale appears on the right side of the LCD. You can fine-tune the focus even further (Safety MF) by pressing the Shutter Release button halfway, but I find it easier to press the AF frame/erase button to accomplish the same task.

2.4 As you scroll down the Shooting menu, this is the second set of options.

Safety MF

Safety MF is a focusing aid to employ when you are in Manual focus mode. Safety MF fine-tunes your Manual focus adjustment. It's often difficult to see enough details on the LCD when you check your focus, even if your G11 has MF-Point Zoom turned on. Safety MF helps sharpen the focus for you automatically once you get it close manually and is indicated by a beep and a white focus frame.

Wind Filter

Available in Movie mode, the Wind Filter reduces ambient audible noise caused by wind or transportation sounds by approximately –20db that may degrade audio recording quality. Be sure to only use this filter when necessary because the resulting audio may sound unnatural if you are in a nonwindy location.

Flash Control

Selecting Flash Control from the Shooting menu opens another menu of five options that affect the performance of the G11's onboard flash. If you have attached an external Speedlite to the camera's hot shoe, selecting Flash Control displays a similar menu affecting the flash accessory's performance.

All Canon PowerShot cameras have two moving curtains in the shutter mechanism. The front curtain opens the shutter, and the rear curtain closes it. The normal operation of the shutter and flash causes the flash to fire immediately when the front curtain opens. This is 1st-curtain sync, and it's fine for most general flash applications.

But let's say your subject is moving, and you're panning the camera using a slow shutter speed to pick up some ambient light. Flash photography in this mode produces motion trails in front of the object you're tracking to make it look like it's moving backward. The trick is to get the flash to fire right before the shutter closes, thereby showing the motion trails behind the object, and this is exactly what 2nd-curtain sync does. You can set this feature either on the G11 or on the Speedlite, but note that the Speedlite takes precedence over the camera's settings.

2.5 The Flash Control settings menu for the built-in flash with the G11 in Program mode

In various Shooting modes, these are the options that you can set in the G11's Built-in Flash Settings menu:

▶ **Flash Mode.** Your Flash mode choices are Auto or Manual. Set this function to how you want to control the flash firing, either automatically by the camera or manually by your settings. When set to Manual, the next item on the menu switches to Good in situations where you are attempting to light very small or very large areas with the built-in flash.

▶ **Flash Output.** This function allows you to set the flash power output to Minimum, Medium, or Maximum for the built-in flash. Helpful for shooting situations of large or small areas that may be beyond the range or capability of the built-in flash. The choices switch from a range of 1/1 to 1/64 power in 1/3-stop increments when an external Speedlite is attached.

▶ **Flash Exposure Compensation.** Similar in function to the Exposure Compensation dial, this control allows you to vary the flash output from +2 to −2 in 1/3-stop increments. Perfect for those situations where you only want a small amount of light from the flash or need to fill in harsh sunlight.

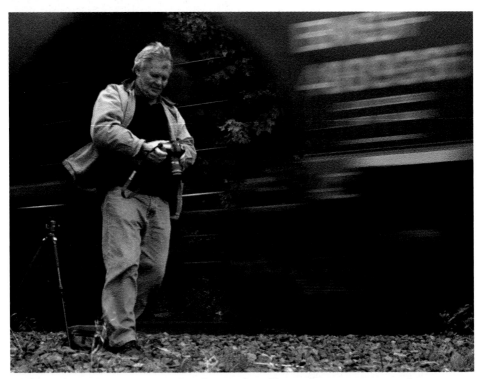

2.6 Second-curtain sync can produce interesting effects when you use a stationary camera as in this shot of David Lutz, photographer, and a passing freight train. Taken in Manual mode at ISO 1600, f/6.3, 1/60 second with a 6.1mm lens setting.

▶ **Shutter Sync.** The shutter sync on the G11 can be set to the 1st-curtain or the 2nd-curtain. As described previously, set this to your preference as to when the flash fires: either when the shutter opens or when it starts to close.

▶ **Red-Eye Correction.** You can set the G11 camera to automatically correct the effect of red eye in pictures taken with flash if red develops in the eyes of your subjects. Be aware that this correction takes a fairly global approach in correcting any red it finds near the eyes and may produce unintended results.

▶ **Red-Eye Lamp.** Turn this control on to have the G11 emit a bright light from the LED on the front of the camera. This light is usually enough to shrink the pupils of your subjects resulting in more natural shots and reducing the red-eye effect. Turn this feature off for theater or event photography where this light could be distracting to others.

▶ **Safety FE.** With Safety FE (flash exposure) turned on, the camera takes control of the shutter speed or aperture to avoid overexposing the image. It's called Safety because it only engages if the camera meter detects overexposure and as such is only available during flash photography.

2.7 The External Flash Settings menu when an external Speedlite flash is attached.

i-Contrast

i-Contrast stands for Intelligent Contrast control, Canon's answer to the vexing problem of losing detail in the shadow areas in high-contrast lighting scenes. The camera detects dark areas, determines them to be shadows, and applies a slight adjustment to the tonal curve. This lowers the overall contrast of the image for a more natural look.

Spot AE Point

Spot AE Point further refines how the Spot metering system achieves an accurate reading. You can choose between the default setting, Center, or AF Point. When AF Point is selected, the exposure reading taken from the focus frame is locked. This is especially helpful when you have moved the focus point around in your frame; AF Point mimics the strengths of Evaluative and Spot metering by basing its reading on the information within the focus frame. When Spot AE Point is selected, a set of brackets displays within the focus frame.

Safety Shift

Safety Shift adjusts the shutter speed in conjunction with an acceptable aperture so that you get the best possible exposure for your shot. You can turn this control on or off. Safety Shift kicks in when your desired exposure would go off the scales and either underexpose or overexpose the shot, and it automatically shifts the shutter speed to a higher or lower value to attain an acceptable exposure.

Review

In Review options, you set the amount of time you want the image displayed on the LCD monitor immediately after capture. This menu option sets the time the review is held on the LCD before reverting back to a live image. The default Review time is 2 seconds. Your Review options are:

▶ **Off.** The camera does not display a review image. Use this option when you are shooting quickly and have no time to review images immediately after shooting or are confident you're getting the shots you want.

▶ **2–10 seconds.** You can choose to display the last image taken for any number of seconds in this range.

▶ **Hold.** This setting keeps the image displayed on the LCD until you change modes or go back to shooting. Leaving the image displayed indefinitely taxes the battery life, so be sure to use this option sparingly.

You can exit the review of the image at any time by pressing the Shutter Release button halfway down and return to shooting.

Review Info

Review Info provides you with options to determine how much shooting information displays along with the image immediately after taking it. Choose from:

▶ **Off.** The camera does not show shooting information when displaying a review image. Use this option when you are shooting and only want to see the full image on the LCD monitor.

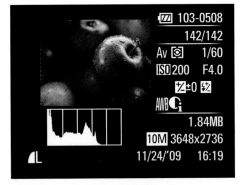

2.8 The Review Info menu is where you set the amount of information that is displayed immediately after taking the picture. This figure shows the Detailed option.

▶ **Detailed.** You can choose to display the last image taken with shooting informa-
tion shown alongside the image.

▶ **Focus Check.** This setting keeps the image displayed on the LCD until you
change modes or go back to shooting.

 Leaving the image displayed definitely taxes the battery life, so be sure to use
the Focus Check option sparingly.

Blink Detection

One of the many features on the PowerShot G11 to improve your pictures of people,
setting Blink Detection On alerts you to the possibility that one of your subjects may
have blinked during the exposure. This gives you the opportunity to retake a picture
with all eyes open. Blink Detection displays a face icon with greater-than and less-than
symbols for eyes when it notices closed eyes in your photo. This feature is helpful for
group shots in low light where you can't see everyone to make sure they are looking
in the direction of the camera.

Custom Display

Custom Display allows you to custom-
ize your LCD screen while composing
through a live display. This is one of my
favorite features of the G11. You can
choose to display any of the four items
listed below, in any combination, over
two modes. This allows you to set cus-
tom shooting screens for special shoot-
ing situations, such as displaying the
histogram when shooting in low light
or extremely bright locations, or dis-
playing the grid when shooting archi-
tecture. A third mode is reserved for
no display, totally disabling the LCD
monitor for times when its brightness
would be distracting to others.

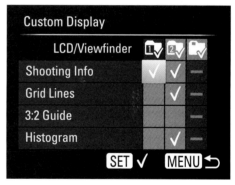

2.9 The Custom Display menu is where
you set the amount of information that is
displayed when reviewing the picture in
Playback mode. This figure shows the
default display view.

The Custom Display options are:

▶ **Shooting Info.** Shows select shooting info such as ISO speed, Shooting mode,
battery life indicator, Image Quality setting, flash status, aperture, shutter speed,
histogram, and more.

▶ **Grid Lines.** Overlays a nine-box Rule of Thirds grid over the LCD live display, allowing you to compose more accurate architectural and landscape photographs and creatively place the subject off-center using these guides.

▶ **3:2 Guide.** This setting applies transparent gray masks on the top and bottom of the LCD display to approximate the cropping to a 3:2 ratio, useful when making 4 x 6 prints. The sensor inside the G11 has a 4:3 ratio and is a little less rectangular than the 3:2 ratio, which is the standard for dSLR cameras.

▶ **Histogram.** A brightness histogram as an exposure indicator is displayed on the top left of the display to show the distribution of tones over the digital scale.

Reverse Display

One of the truly fun things about the small size of PowerShot cameras is that it's easy to take your own picture, often with another friend or friends, in front of famous landmarks. Usually this is a hit-or-miss endeavor because it's hard to tell the framing when you are just holding the camera in front of you. Sure, it's a snapshot, but you still want it to look good. Reverse Display switches the view to mirror-image and solves this problem by allowing you to rotate the LCD around to face the front of the camera and see exactly what the camera sees, enabling better composition of photos with you in them.

IS mode

IS mode sets the Image Stabilization control for the lens of the G11. As previously described, image stabilization is a technology that helps your lens achieve sharp photos of moving subjects or when shooting in low-light situations. To speed up shooting and focusing time, always remember to set this option to Off when using a tripod. Options for the IS mode are:

▶ **Continuous.** IS is fully engaged at all times. This allows you to see sharp images on the LCD monitor to check focus or composition qualities.

▶ **Shoot Only.** IS is turned on only at the moment of shooting. This may be desirable if shooting quickly and you only want IS on at the moment you take the picture.

▶ **Panning.** A great mode for sports and action shooting, the Panning option turns off the horizontal sensors of IS and only corrects any up or down movement of the camera or subjects it detects. Because the horizontal sensors are off in this mode, holding the camera in vertical orientation and panning will not engage the IS system.

Converter

This setting tells the G11 to adjust focus when using the optional TC-DC58D Tele-Converter lens attachment. Unless doing so, leave this option off.

Date/Time Stamp

Popular for snapshots in the 1980s, this control adds date or date and time information directly to the image file so that it appears in the lower-right corner of the image when shot in either vertical or horizontal mode. Useful for environmental or construction projects, this mode displays a date icon on the live LCD while shooting to alert you this feature is on. Be sure the date and time are set correctly before using this feature because once inserted into the image they cannot be removed by the camera. This feature does not work when shooting in RAW capture mode.

Record RAW +JPEG

Often when I need to capture RAW and JPEG images simultaneously, I set this control to On. This is convenient when I want to shoot in RAW but also have a JPEG file that I can quickly e-mail or use in a layout. This feature creates both types of files that yield high-quality RAW files and JPEG files for portability and ease of use.

RAW capture yields the highest file size the G11 is capable of. At 10MB per photo, raw files can sure use up memory card space quickly, so you may want to consider the Large JPEG setting if you are concerned about storage space.

Set Shortcut button

Canon wisely added new functionality to the PowerShot G11 by including a Shortcut button on the back-left side of the camera that you can assign from a list of options by calling up the Set Shortcut button menu. You can set the Shortcut button to operate any one of these functions when pressed:

▶ **Not Assigned.** The default setting. The Shortcut button has no function.

▶ **ND Filter.** Turns on the Neutral Density filter.

▶ **White Balance.** Displays the White Balance menu so you can quickly change white balance settings.

▶ **Custom White Balance 1.** Each press of the Shortcut button takes a custom white balance reading and assigns it Custom 1 or Custom 2 white balance settings.

▶ **Custom White Balance 2.** Same as Custom White Balance 1.

▶ **Servo AF.** Switches the autofocus system to Servo AF to track fast-moving actions or subjects.

▶ **Digital Tele-Converter.** Applies the Digital Tele-Converter so you can quickly get to the maximum telephoto power the G11 has to offer.

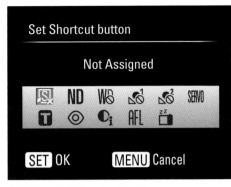

2.10 The Set Shortcut button menu

▶ **Red-Eye Correction.** Engages Red-Eye Correction when you suspect it might occur in your photos.

▶ **i-Contrast.** Turns on i-Contrast to improve the tonal range and detail in the shadowed areas of the picture.

▶ **AF Lock.** Locks the focus in the Focus Frame.

▶ **Display Off.** Turns the LCD monitor display off quickly when its glow might be distracting to others.

Save Settings

You can tweak all the options and settings in the PowerShot G11's menus and save those settings as a group of custom settings, designated 1 and 2. When you find that you have favorite settings for shooting portraits or landscapes and you want to retain them for later use, assign them to a custom setting. To overwrite, you simply create a new collection of settings and save them to a previous C1 or C2 setting.

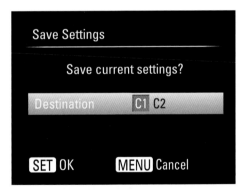

2.11 The Save Settings menu. You can create custom settings and save them as a group to the C1 and C1 modes.

Set-up Menu

The Set-up menu is where you control the hardware and the operational and administrative aspects of the PowerShot G11. The options selected in this menu don't affect

the visual image per se, but they handle some of the more mundane yet important features involved in digital photography. Setting up the G11 correctly in this menu grouping can save time later when you organize your images on a computer. These functions are applied in all camera modes.

Mute

You can choose to turn the operational sounds your camera makes on or off whenever you change a setting.

 Chapter 6 highlights several shooting situations where muting the camera makes sense.

Volume

Rather than muting the camera entirely, you can choose to adjust the volume of some specific camera sounds the G11 makes. You can set volume levels for Start-up, Operation, Selftimer, and the Shutter. Choose from Off, 1, 2, 3, 4, or 5.

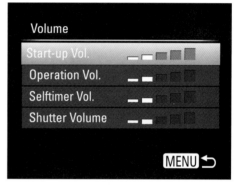

2.12 The Volume menu choices of the G11

 It may be helpful to increase the Selftimer Volume level when doing group shots so everyone in the picture can hear the G11 counting down.

Sound Options

The Sound Options menu allows you to change the sounds the G11 makes for Start-up, Operation, Selftimer, and the Shutter. For each setting, you can choose from three included sounds or you can register and use a sound of your own using the supplied software.

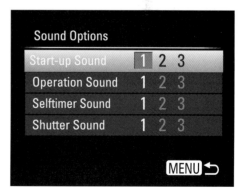

2.13 The Sound Options menu choices of the G11

Hints and Tips

Hints and Tips appears as scrolling messages at the bottom of the Function and Menu options screen to give you more info about a particular control. These handy notes can be turned on or off.

LCD Brightness

You can create better images when you can see the results properly on the LCD monitor. The default setting on the PowerShot G11 works well in most situations, but try dialing the brightness down a bit to go easier on your eyes in nighttime shooting situations. Conversely, you may want to increase the brightness when shooting in bright sun situations, such as at a beach. You can change the brightness level over a five-step range from –2 to 0 to +2.

Start-up Image

The Start-up Image options allow you to personalize your G11 to display any one of three included Canon graphics or none at all. Or if you want, you can register and select an image from your computer to use as the start-up image using the supplied software.

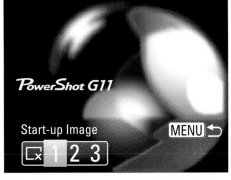

Format

Format is arguably the most important item on the Set-up menu. It is always a good idea to format your SD cards in the camera they will be used in before

2.14 A Start-up Image menu choice of the G11

each shooting session. Be sure that any images on the card are backed up to a storage device before formatting, however. From the Format menu you can perform either a regular format or a low-level (or deep) format. Low-level formatting rebuilds the entire file structure of the memory card and marks off any bad sectors. When you select Format from the Set-up menu, the Format options appear on the LCD.

While low-level formatting takes a little longer to perform than regular formatting, you should do a low-level format every once in a while to keep your cards performing their best.

▶ **Regular.** Select regular format-
ting for a quick rebuild of your
memory card's directory struc-
ture.

▶ **Low level.** Make sure you back
up any images from the card on
some other storage device
before performing a low-level
format. Use the 4-Way Controller
to select Low Level Format and
to place a check mark in the box
next to it. Navigate to OK then
press the Function/Set button to
confirm.

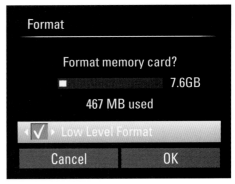

**2.15 Be sure there is a check mark next to
Low Level Format for that type of
formatting.**

 If you perform a regular format without backing up your images, you still might
be able to retrieve them from the memory card. Datarescue makes Photo
Rescue, a software program that can recover images from your card. Find out more at
www.datarescue.com.

 Low-level formatting resets both the directory and the file areas of the memory
card. A professional data recovery company would find it difficult to retrieve
any data from the card once a low-level format is performed. Just remember, there is
no "undo" when you perform a low-level format.

File Numbering

File Numbering allows you some flexibility in the way files are labeled when they are
written to the memory card. When you first turn on your PowerShot G11 and take a
picture, that file is 0001. You can choose from these two options:

▶ **Continuous.** Continuous numbering starts with 0001 and numbers consecu-
tively until you have taken 9999 images, even if you change the memory card.

▶ **Auto Reset.** With Auto Reset, every time you change the memory card, the file
numbering reverts back to 0001.

Even with a capture date embedded in the metadata of the file, importing can be con-
fusing and images can be lost if you have several files with the same name being
downloaded into the computer. I set my cameras to Continuous to avoid duplicate
filenames for my images.

Create Folder

This menu selection helps you organize your images into folders you'll easily be able to remember and find on your computer. Your choices are Monthly folders or Daily folders. If you are viewing the card's contents on a computer or through a card reader, the first folder that you see is named DCIM. Within the DCIM folder you find at least one folder, but possibly more, named 100, 101, 102, 103, and so on, followed by an underscore and then the number of the month, or if you have selected Daily, the month and day.

 DCIM is an acronym for Digital Camera Images and is a standard initial folder for many digital cameras.

Lens Retract

In default mode, the G11 retracts its lens after 1 minute in Playback mode to protect the lens. You can set this control to retract the lens immediately when switching from Shooting to Playback mode.

Power Saving

The Power Saving menu offers two ways to save battery power by powering down the camera or LCD screen after timed intervals. When you select this icon, you can choose between camera and LCD settings:

▶ **Auto Power Down.** The G11 powers down approximately 2 minutes after the last control is accessed on the camera. The LCD monitor automatically turns off 1 minute after the last control is accessed even if Auto Power Down is set to off.

▶ **Display Off.** The Display Off setting turns off your LCD monitor after a predetermined amount of time to save power. Choose from 10, 20, or 30 seconds or 1, 2, or 3 minutes.

 Remember to not mistake the LCD being powered down with the camera being off. This will drain critical battery power when you're not using the camera, so it's a good idea to extend the Display Off feature a little longer.

Time Zone

The Time Zone feature allows you to set your G11 to time stamp your photos with either a Home or World setting, indicated by a house or airplane icon.

Use the 4-Way Controller to select the Home or World icon. Select your time zone from the map that is displayed, then press the Function/Set button. Pressing the Menu button twice returns you to Shooting mode.

Date/Time

This option displays a Date/Time screen where you can set the current date, time, and daylight saving status. The daylight saving adjustment is indicated by the sun icon to the right of the display.

 The Quick Tour describes how to set the date and time.

Distance Units

This menu setting changes the way focus distance is displayed on the LCD when shooting Manual Focus images from meters to feet. Choose m/cm or ft/in.

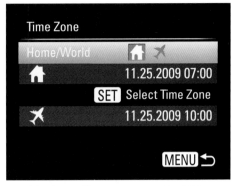

2.16 The Time Zone menu on the G11

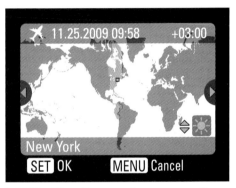

2.17 The Time Zone settings map on the G11. You can select and store your home time zone and the time zone of any location you are travelling to.

Video System

If you travel outside of North America and want to play back images or movies on a video or TV monitor, you may have to change your Video System setting. Choose between the following two settings:

▶ **NTSC.** NTSC is the video system or standard used in North America and most of South America. In NTSC, 30 frames are transmitted each second. Each frame is composed of 525 individual scan lines.

▶ **PAL.** PAL is the predominant video system or standard mostly used overseas. In PAL, 25 frames are transmitted each second. Each frame is made up of 625 individual scan lines.

Language

As discussed in the Quick Tour, you can change the language of the G11 from English, which is the default setting, to any one of 25 other languages, including Spanish, French, Italian, Polish, and Portuguese.

Reset All

If you have made lots of settings and your camera just isn't performing as you know it should, you may want to try resetting all the functions back to the default factory settings. This is convenient if you just want to start over with all the settings as you are learning the camera and have made some settings that disallow other features. My Menu items are also removed from the G11, but, Date, Time, Language, and Video System settings remain.

English	Svenska	Türkçe
Deutsch	Español	繁體中文
Français	简体中文	한국어
Nederlands	Русский	ภาษาไทย
Dansk	Português	العربية
Suomi	Ελληνικά	Română
Italiano	Polski	فارسی
Norsk	Čeština	日本語
Українська	Magyar	

2.18 The Language menu of the PowerShot G11. Choose from 26 languages for your camera.

 You can't reset the camera's functions when the G11 is connected to a computer.

Playback Menu

The Playback menu is only accessible when the G11 is in Playback mode. Some of the menu items are used to set parameters for image playback and others actually perform camera functions.

Slideshow

The Slideshow menu presents three options for controlling the way your slide show plays back. Use the 4-Way Controller's area buttons to navigate these settings.

▶ **Repeat.** Sometimes called *loop*, with this control you can set the G11 to replay the slide show once the camera has shown all the images, or you can set it to stop with the last photo.

▶ **Play Time.** This setting determines how long each image is displayed. Choose from 3, 4, 5, 6, 7, 8, 9, 10, 15, or 30 seconds.

▶ **Effect.** This setting changes the transition effect between images as the slide show advances. Choose from:

- Off
- Fade
- Bubble
- Cross
- Letterbox
- Scroll
- Slide

▶ **Start.** Navigate and select this button to start your slide show.

Erase

The PowerShot G11 allows you to erase images immediately after capture if you have set your camera to display them after being taken. In addition, the G11 includes this menu when you can refine or expand the Erase function. In this menu selection, choose from the following:

▶ **Select.** This setting allows you to go through all the images on the memory card by turning the Control dial and adding a check mark to the box in the upper-left corner with the Function/Set button, marking them for deletion. A counter displays how many images are marked. When finished, press the Menu button and select OK to remove the images from the card.

▶ **Select range.** This function allows you to select a range of consecutive images to remove from the card by using the 4-Way Controller.

▶ **All Images.** Select this option to erase all image and video files from the memory card.

Selecting Erase does not delete images marked as Protected. Remember, there is no undo for Erase Images!

Protect

Protecting your images on the memory card prevents them from being accidentally deleted. Use this function as a good choice for those once-in-a-lifetime captures or images that you just don't want to lose if a viewer accidentally presses a wrong button

while viewing the images on your G11's LCD. When reviewing images, a key icon lets you know that the image is protected. The same three file options as Erase are available here, also.

> Use Protect Images to quickly delete a large batch of images as well. Instead of marking 90 out of 100 images for deletion, save time by marking the 10 you want to keep as protected and then select All Images to delete all the unprotected images from the card.

Rotate

The G11 has a sensor to automatically detect images shot in a vertical orientation. Sometimes, due to image characteristics, you may have to rotate the image yourself by using this setting. The image is not actually rotated, but simply noted in the image file that the image should be rotated to your specifications when displayed. Some image-editing software may not understand this notation and the image will not appear rotated when viewed on the computer.

My Category

This powerful control is where your G11 really shines. You can add or remove category designations manually with the My Category option. Once categorized, you can select groups of images by category for printing, protecting, erasing, and playing slide shows. Chose from:

▶ People

▶ Scenery

▶ Events

▶ Category 1, 2, or 3

▶ To Do

Each image can be tagged to multiple categories.

The G11 automatically categorizes images taken in certain shooting modes into their proper category. Images with faces detected or taken in Portrait mode are tagged *people*, Events mode photos are tagged *sports*, Scenic mode photos are tagged as *landscape*, and so on.

To attach a category to your images, follow these steps:

1. **Place your camera in Playback mode.**

2. **Press the Menu button and use the 4-Way Controller to navigate to My Category.**

3. **Press the Function/Set button.**

4. **Use the right and left areas of the 4-Way Controller to scroll through your images and find one you want to categorize.**

5. **Use the up and down areas of the 4-Way Controller to scroll through the categories displayed on the left side of the LCD.**

6. **Press the Function/Set button to place a check mark next to the image's category designation.**

7. **Repeat Steps 4 to 6 to categorize more images.**

 Remember that you can assign more than one category to an image. Try using Categories 1, 2, and 3 to mark images for printing, deletion, or slide shows.

i-Contrast

Canon's i-Contrast (Intelligent Contrast) control helps to maintain good contrast and boosts brightness in areas of the picture or in faces it detects as too dark. You can shoot with i-Contrast applied via the Shortcut button or from the Shooting menu, or choose four levels of correction to apply to images after they have been taken. Choose from Auto, Low, Medium, or High contrast correction.

 If you're not satisfied with the results in Auto, you can manually apply more correction via the Playback mode menu. i-Contrast cannot be used with RAW images.

Red-Eye Correction

Red-Eye Correction can be applied to eyes that were at an angle or did not receive the full benefit from the Red-Eye Reduction Lamp after the image has been taken. Red-Eye Correction uses Face Detection to remove the red reflected from eyes in flash photography.

To use the Red-Eye Correction fea-
ture, follow these steps:

1. **Place the camera in Playback mode.**

2. **Press the Menu button and use the 4-Way Controller to navigate to Red-Eye Correction.**

3. **Press the Function/Set button.**

4. **Scroll through your images to find one that requires red-eye correction and press the Function/Set button again.** A Busy icon appears while the G11 makes the correction. If the camera detects a face, a box appears around the eyes that were corrected. If no face is detected, a "Cannot modify" message appears at the bottom of the LCD.

2.19 The G11 automatically recognizes the eyes that need correction and allows you to apply the correction after the image has been taken.

5. **Repeat Step 4 to remove red-eye from any other photos you want.**

> If you feel there's room on the memory card, choose to save the file as a new file rather than overwrite the original. This allows you flexibility to go back to the original file in post-production should you ever need to.

Trimming

The Trimming feature allows you to crop parts of an image and save it as a new image file. This is a great adjustment you can make in-camera before e-mailing without the need of a computer and image-processing software.

RAW, Wide, or Stitch-Assist images cannot be trimmed. To trim an image on the G11, follow these steps:

1. **Place the camera in Playback mode.**

2. **Press the Menu button and use the 4-Way Controller to navigate to Trimming.**

3. **Press the Function/Set button.**

4. **Scroll through your images to find one you'd like to trim and press the Function/Set button again.** The Trimming screen appears with a yellow box around the area being trimmed.

5. **Use the Zoom lever and 4-Way Controller to resize and move the yellow box to adjust the trimming area.** If there are faces in the photo you want to crop, turn the Control dial to jump to the face.

6. **Press the Display button to change the orientation of the trimming box from horizontal to vertical if desired.**

7. **When you are pleased with the trimmed image, press the Function/Set button to save it as a new image.**

8. **Select OK to save as a new image file.**

Resize

The G11 allows you to resize images to any smaller resolution size than the one it was taken in for easier portability when attaching them to e-mails or uploading to Web sites, blogs, or sharing sites on the Internet.

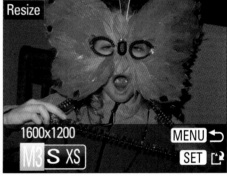

2.20 Choose any smaller resolution size to resize your image.

To quickly resize images to a lower resolution, follow these steps:

1. **Place the camera in Playback mode.**

2. **Press the Menu button and use the 4-Way Controller to navigate to Resize.**

3. **Press the Function/Set button.**

4. **Scroll through your images to find one you want to resize and press the Function/Set button again.** The Resize screen appears showing you the available resizing resolutions.

5. **Use the 4-Way Controller to select a new resolution.**

6. **Press the Function/Set button to save it as a new image.**

7. **Select OK to save it as a new image file.**

My Colors

The My Colors selections allow to you to change the effect of an image after it is taken. Some settings change the entire look of the image, such as B/W or Sepia, while others alter the photo in more subtle ways by making only certain colors stand out.

My Colors adjustments are available in the Program AE, Shutter Priority, Aperture Priority, Manual, Movie, and Quick Shot modes and cannot be used in the Auto, Low Light, or Special Scenes modes. Following is the list of options available in the My Colors settings. In the My Colors menu while in Playback mode, use the 4-Way Controller to choose from the following options:

▶ **Vivid.** Boosts contrast and color saturation to make the colors and crispness of your images pop. A good setting to use in flat light or low-contrast situations where colors may be muted.

▶ **Neutral.** Reduces contrast and softly mutes the colors of your scene. Ideal for bright sunny days with lots of contrast or when you want a less intense look to the colors in a scene. The opposite of Vivid.

▶ **Sepia.** Converts your scene to black and white and adds a warm brown, nostalgic tint to the image.

▶ **B/W.** De-saturates your image colors completely and creates a black-and-white or *monotone* image.

▶ **Positive Film.** Mixes the effects of Vivid Red, Vivid Green, and Vivid Blue to create realistic intense colors reminiscent of high-saturation slide (positive) films like Fujichrome and Ecktachrome. If you miss the look of your old slide films when shooting digitally, you can change the images you shoot to this look.

▶ **Lighter Skin Tone.** Lightens up most skin tones to make them appear brighter, but may have trouble with certain skin types and can also affect other areas of a scene besides skin. Experiment to see the differences for yourself.

▶ **Darker Skin Tone.** Darkens skin tones slightly to produce a normal skin tone look with subjects that have pale or washed-out skin. Can make certain skin tones too dark and may not provide the desired effect, and can also affect other areas of the image besides skin.

▶ **Vivid Blue.** Punches up the blues in your photographs. Works great on oceans, skies, and any other blue objects in the photo by adding saturation and intensity to only the blue areas in the image.

▶ **Vivid Green.** Intensifies the green areas in your photograph such as grass, foliage, mountains, and any other green objects included in the frame. Fun to use on landscape photos or forest shots.

▶ **Vivid Red.** Adds depth and saturation to any red objects or areas in your photo such as lips, berries, and fall leaves. Be careful using this one on portraits as it may call attention to any reds in the face, especially the cheek areas.

Scroll Display

With Scroll Display turned on, the images display at a smaller size when the Control dial is turned quickly, allowing them to load faster when reviewing images. This is a good option when you have a lot of images on the card and you want to find the one you want to view or adjust quickly. By pressing the up and down areas of the 4-Way Controller you can search images by shooting date.

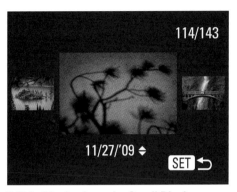

2.21 In Playback mode, Scroll Display reduces the size of the images for faster loading and review when the Control dial is turned quickly.

Resume

Resume is a further tweak the G11 offers to change the image that appears first when you press the Playback button. Choose Last image for the last image reviewed while in Playback mode or Last shot for the last shot taken by the camera.

Transition

When you advance your images using the left and right areas of the 4-Way Controller while in Playback mode, Transition effects provide several options for how those images move on the LCD screen. Choose from:

▶ **Off.** Provides no effect.

▶ **Fade.** One image fades out before the next image fades in.

▶ **Scroll.** Images appear to move diagonally as they transition.

▶ **Slide.** A new image appears to move in front of the previous image.

Print Menu

The Print menu offers options for controlling which images print when the camera is connected to a printer. The Canon PowerShot G11 supports the DPOF (Digital Print

Order Format) industry standard developed for use among digital camera manufacturers and printers. When you use the G11's DPOF features, you can select the images or range of images to be printed, the number of copies, whether to include the date and filename of each image, and whether to print an index print of the selected images from the memory card.

 Although you may use DPOF with many home photo printers, some retail **NOTE** photo processors support the standard, too. DPOF support among photo kiosk printers is limited.

Your options on the Print menu include:

▶ **Print.** The Print option is dimmed unless the G11 is connected to a printer. When the camera is connected to a printer using the supplied USB cable, this option is available and allows you to access the Print menu.

▶ **Select Images & Quantity.** Before printing your images, you must select which images and how many of each to print by choosing Select Images & Quantity. In this option, you scroll through your images and add them to the print queue by pressing the Function/Set button when they are displayed. Once the image has been selected, use the up and down areas of the 4-Way Controller to choose how many prints from each image you want to print.

▶ **Select Range.** Selects a range of consecutive images to print. Use the Control dial to select the first image in the range, then press the Function/Set button. Scroll through the images using the Control dial and select the last image in the range by pressing the Function/Set button when that image displays.

▶ **Select All Images.** Choosing this selects all images on the memory card for printing. Select OK to mark each image to print one print of each.

▶ **Clear All Selections.** This setting allows you to deselect all images and quantities marked for printing. There is no undo for this selection once you unmark images.

▶ **Print Settings.** Choosing this selection opens the Print Settings menu and allows you to control several printing options:

• **Print Type.** Choose from Standard print, Index print, or Both.

• **Date.** You can embed the date the image was taken on the print. Turn this on if you want the date to appear on the print, or off to prevent the date from printing.

 If you embed the date for printing on an image where the date was recorded in the image file, the two may overlap and be difficult to read on the print.

- **File Number.** This option allows you to print the file number on the print by choosing On; no file number prints when this option is set to Off.

- **Clear DPOF data.** Once the images have been printed, when this option is set to On, all DPOF information, such as image selection and number of copies, is deleted. The default setting is On.

My Menu Settings

The My Menu settings screen is designated by a star and can be set to open first whenever you push the Menu button. This fully user-customizable menu screen allows you to include up to five menu items that you use most frequently from a list of over 20 controls, allowing you to register, sort, and swap out any menu option you want.

▶ **Register.** Register up to five camera setting menus that you use most frequently.

▶ **Sort.** Allows you to change the order of the registered items in My Menu. To unregister an item from the list, simply uncheck it in My Menu settings.

▶ **Display from My Menu.** Choose Enable or Disable to set the G11 to display the My Menu screen first when the Menu button is pressed.

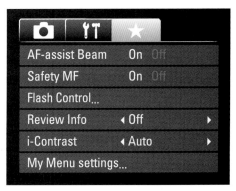

2.22 The My Menu screen allows you to select five of your favorite camera settings from a list of 24 options if they are available in your shooting mode.

Choosing Settings on the Canon PowerShot G11

From Shooting modes and function choices to tweaking exposure and color settings, the Canon PowerShot G11 has all your image-making options covered.

Setting the camera to retain your personal shooting preferences allows you the flexibility and convenience of being able to grab the camera and jump into shooting without having to worry about all the important details of camera functionality because you have already set them. Having the camera perform your way speeds up camera operation and allows for a much more enjoyable shoot. As you become familiar with this incredible tool, spend

The PowerShot G11 handles macro shots, such as this desert lizard on a broken branch in Arizona, with ease. Taken in Macro mode at ISO 100, f/3.5, 1/60 second with a 21.8mm lens setting.

some time investigating all the shooting and menu modes and the different white balance and My Colors settings. They offer convenience and provide the photographer with control over every aspect of the digital capture process.

Creating Folders on the Memory Card

The PowerShot G11 helps you organize your images into folders on your SD card so that you can easily remember and find your images on your computer. Your choices are Monthly folders or Daily folders. If you are viewing the card's contents on a computer or through a card reader, the first folder that you see is named DCIM.

Within the DCIM folder you find at least one folder, but possibly more, named 100, 101, 102, 103, and so on, followed by an underscore and then the number of the month, or if you have selected Daily, the month and day. DCIM is an acronym for Digital Camera Images and is a standard initial folder for many digital cameras.

Setting File Numbering

File Numbering allows you some flexibility in the way files are labeled when they are written to the memory card. When you first turn on your PowerShot G11 and take a picture, that file is 0001. You can choose from these two options:

▶ **Continuous.** With Continuous numbering, images are numbered sequentially using a unique four-digit number from 0001 to 9999. With unique filenames, managing and organizing images on the computer is easy because you don't have to worry about images having duplicate filenames. If you insert a memory card that already has images on it taken with the G11, the camera then starts numbering with the highest number either that was used on the stored images on the card or that was last captured. This happens even if you switch to cards from another PowerShot camera. Continuous file numbering is the default setting on the G11.

▶ **Auto Reset.** If you use Auto Reset, both file and folder numbering restarts when you insert another memory card. If you prefer to organize images by memory card, then Auto Reset is a useful option. Folder numbers begin with 100, and file numbering begins with 0001, unless the card contains a previous image, in which case numbering begins with the highest file number in the highest numbered folder on the memory card. However, multiple images on your computer will have the same filename but will be stored in different folders. Because of this, you should create separate folders on the computer and other devices for each download and otherwise follow careful folder organization to avoid filename conflicts and the potential overwriting of special images on the computer.

Even with a capture date embedded in the metadata of the file, it can be confusing and images can be lost if you have several files with the same name being imported

into the computer. I set my cameras to Continuous to avoid duplicate filenames for my images.

 Filenames begin with the designation IMG_ followed by the four-digit image number and file extension: .jpg for JPEG files, or .cr2 for RAW images.

Choosing the File Format and Quality

The last item on the Function menu is file quality, and here you're offered five options of JPEG, a Wide panoramic-style capture, RAW, or you can shoot and combine RAW and JPEG in separate files. You turn the 4-Way Controller to select the image quality. If you choose the JPEG format, you can then choose between different image and file sizes:

▶ L Large JPEG at 10MB (3648 pixels by 2736 pixels)

▶ M1 Medium JPEG at 6MB (2816 pixels by 2112 pixels)

▶ M2 Medium JPEG at 4MB (2272 pixels by 1704 pixels)

▶ M3 Medium JPEG at 2MB (1600 pixels by 1200 pixels)

▶ S Small JPEG at 0.3MB (640 pixels by 480 pixels)

▶ Wide JPEG at 8MB (3648 pixels by 2048 pixels)

▶ RAW at 10MB (3648 pixels by 2736 pixels)

The file format you choose determines whether the images are stored on the memory card in JPEG or RAW format, and the quality level you choose determines the number of images you can store on the card, as well as the overall image quality and the sizes at which you can enlarge and print images.

Your choice of file format and quality will usually be event- or output-specific. For example, I shoot RAW images during vacations, hiking excursions, interiors with mixed lighting, and so on, but then I might switch to Large JPEG format for a wedding or luncheon outing where I'm a guest, because I know that these images will likely be printed no larger than 5 x 7 inches. But for most other shooting situations, especially the ones I mentioned earlier, I shoot only RAW images to get the highest image quality and to have the widest latitude for converting and editing images.

It took me a while to work out storage and workflow issues and to see the differences in image quality and file management between the two. If you've always shot JPEG images, you might want to reconsider the differences between JPEG and RAW capture.

JPEG settings

JPEG, which stands for Joint Photographic Experts Group, is considered a *lossy* form of compression but is a highly portable file format that enables you and your clients to view the images on any computer platform. The lossy file format means that some image data is discarded during compression to reduce file size for storing images on the memory card. Because JPEG images are compressed to a smaller file size, you can store more images on the card.

However, as the compression ratio increases, more image data is discarded and the image quality degrades accordingly. Additional image data is discarded each time you save the file after you edit JPEG images on the computer.

As a result of the low-bit depth and preprocessing, color in general and skin tones in particular suffer, as do subtle tonal gradations. By the time you get the JPEG image on the computer, you have less latitude for editing with moves in tones and color becoming exaggerated by the lower-bit depth.

However, the JPEG format enjoys universal acceptance, which means that the images can be displayed on any computer, opened in any image-editing program, and printed directly from the camera or the computer.

RAW settings

RAW files are stored in a proprietary format that doesn't discard image data to save space on the memory card. Because the images are stored in a proprietary format, they can be viewed only in programs that support the Canon CR2 file format. RAW files save the data that comes off the image sensor with little internal camera processing. Because many of the camera settings have been noted in an embedded file within the image file but have not been applied to the data in the camera, you have the opportunity to make changes to key settings, such as exposure, white balance, contrast, and saturation when you convert the RAW files on the computer. The only camera settings that the camera applies to RAW files are ISO, shutter speed, aperture, and Shooting mode.

This means that during RAW image conversion, you control the image rendering, including the colorimetric rendering, tonal response, sharpening, and noise reduction. Plus, you can take advantage of saving images in 16 bits per channel when you convert RAW images, versus the low, 8-bit depth of JPEG images. Simply put, the higher the bit depth, the finer the detail, the smoother the transition between tones, and the higher the *dynamic range* (the ability of the camera to hold detail in both highlight and shadow areas) in the image.

In short, with JPEG capture, the camera processes the image according to the exposure and image parameters set in the camera, converts the image from 12 bits to

8 bits per channel, and then compresses the file as a JPEG — a process that discards image data and introduces unwanted artifacts to the file. The result is a preedited and much less robust file than a RAW file. In the process of converting files to 8 bits per channel, image data — such as levels of brightness that you may need and want during image editing — is permanently discarded.

Choosing an Exposure Mode

The G11's Mode dial offers a Full Auto mode, as well as the traditional Shooting modes that you may have grown accustomed to in other PowerShot cameras, including Program AE (P), Shutter Priority (Tv), Aperture Priority (Av), Manual (M), Movie, Low Light, and Quick Shot. In addition, the G11 features Special Scene modes and adds two user settings, denoted as C1 and C2 on the Mode dial.

Full Auto, labeled as a green AUTO on the Mode dial, offers camera-controlled automatic exposure, color, and focusing. P, Tv, and Av modes offer semiautomatic exposure control. As the name implies, Manual mode (M) offers full manual control over exposures.

To use any of the shooting modes, follow these steps:

1. **Turn the Mode dial and line up the mode you want with the ISO Speed lamp on the camera body next to the dial.**

2. **Set any other camera controls depending on the Shooting mode you choose, other than Full Auto mode.**

Full Auto

In Full Auto mode, the G11 automatically sets the ISO, exposure, drive mode, autofocus mode, AF point(s), and white balance. The only menu item you can change from the Function menu in Full Auto is Image Quality. In short, Full Auto mode provides full point-and-shoot functionality. In this mode, the camera settings are as follows:

- ▶ **Color space: sRGB**
- ▶ **ISO: Auto**
- ▶ **White Balance: Auto (AWB)**
- ▶ **Drive mode: Single Shot**
- ▶ **Metering mode: Evaluative**

▶ **Focus mode: AI Focus.** In automatic focus mode, the camera focuses on the closest subject with readable contrast. If the subject is large enough to cover more than one AF point, it may choose multiple AF points for autofocusing.

▶ **Face Detection: On.** Face Detection turns off automatically if it cannot find a readable face in the scene.

The other options that you can select in Full Auto mode are all the Self-timer modes, flash settings, Macro, and Manual focus.

At first, Full Auto mode would appear to be a handy mode for snapshots. But my experience shows that it's not foolproof in that capacity for a few reasons. First, autofocus is controlled entirely by the camera. Automatic AF-point(s) selection ranges from the camera choosing a single AF point on an area of the subject closest to the lens, to selecting multiple AF points. I always want to control the point of focus, and this mode prevents that. This usually means that in a standard portrait, the subject's nose, which is closest to the lens and has readable contrast, is tack sharp, whereas the eyes are a bit soft. This, of course, is opposite what I want and is my main reason against using Full Auto mode.

3.1 In Full Auto mode, the PowerShot G11 automatically selects the AF points, white balance, and all exposure settings in this shot of schoolroom scissors. The camera detects the closest object and bases its exposure on that. Taken in Auto mode at ISO 400, f/2.8, 1/80 second with an 11.9mm lens setting.

Program AE

Program AE mode, denoted as P on the Mode dial, is also an automatic mode. This shooting mode allows you to use Exposure Compensation by dialing it in, and it is very handy when you want to shoot Auto but still retain some control over the exposure.

This mode allows you to quickly control the ISO and exposure compensation with a minimum of manual adjustments. The advantage of Program AE mode over Full Auto mode is that you have more control over the camera settings so that you can shoot JPEG or RAW, or set the camera to record both RAW+JPEG images; set My Colors, ISO, white balance, and the drive, metering, and autofocus modes, along with bracketing, Flash Exposure Compensation (FEC), and the choice of adding a Neutral Density filter from the Function menu.

If the G11 cannot attain a proper exposure, the exposure values of aperture and shutter speed will display at the bottom of the LCD in orange. You can manually adjust the ISO Speed or Exposure Compensation values to obtain a better exposure. They will appear in white when a proper exposure is achieved.

Program AE mode is the mode that makes sense for quick shots at a party or for family snapshots. You might already have the camera set to your preferred drive and metering modes, My Colors, image quality, and so on, so switching to P mode offers the advantage of semi-automated shooting. With a quick turn of the ISO Speed or Exposure Compensation dials, you can shift to a more desirable shutter speed or aperture combination and keep shooting.

3.2 Taken in P mode at ISO 1600, f/8, 1/10 second with an 11.9mm lens setting.

Shutter Priority AE

Shutter Priority AE mode, or Tv (Time-variable) on the Mode dial, is the semiautomatic mode that offers you control over the shutter speed. The PowerShot G11 features electronically controlled shutter speeds from 1/4000 second to 15 seconds. In Tv mode, you control the shutter speed by turning the Control dial; the camera then automatically calculates the appropriate aperture based on the light meter reading, the metering mode, and the ISO Speed setting. The G11 then displays the aperture on the LCD monitor only when you press the Shutter Release button halfway down. If the shutter speed you have chosen allows a proper aperture to be selected, it appears in white. If your selection will cause the camera to over- or underexpose the image, the aperture value appears in orange.

In either case, adjust the shutter speed slower or faster, respectively, until the aperture value turns white on the LCD, or you can set a lower or higher ISO Speed, or add or subtract Exposure Compensation.

In Shutter Priority mode, you can set the white balance, My Colors, bracketing, Flash Exposure Compensation (FEC), Neutral Density, and the drive, metering, and Image Quality modes from the Function menu.

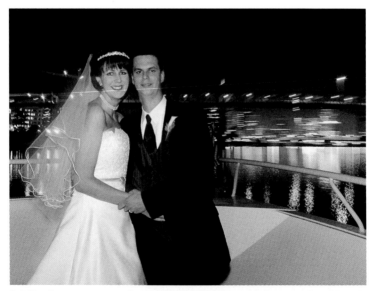

3.3 To show some motion in the background nightscape for this wedding portrait, I switched to Shutter Priority mode and then set the shutter speed to 1/13 second. Taken at ISO 400, f/8, 1/13 second with a 6.1mm lens setting.

 You can change shutter speed increments in 1/3-stop settings.

Aperture Priority AE

Aperture Priority AE mode, denoted as Av on the Mode dial, is the semiautomatic mode of preference for everyday shooting because it offers quick control over the aperture, and, thus, control over one factor that determines depth of field. In this mode, you control the aperture by turning the Control dial, and the camera automatically calculates the appropriate shutter speed based on the light meter reading, the metering mode, and the ISO Speed setting. The PowerShot G11 displays the selected aperture on the LCD monitor in white.

3.4 Aperture Priority mode is great for controlling the rendering of the foliage for this outdoor flower shot. Taken at ISO 400, f/8, 1/1600 second with a 30.5mm lens setting.

Pressing the Shutter button halfway down initiates the camera's exposure calculation based on the aperture you select. If the exposure is outside the camera's exposure range, the shutter speed value turns orange on the LCD panel. If 4000 appears in orange, the image will be overexposed. If 15″ appears in orange, the image will be underexposed. In either case, adjust to a smaller or larger aperture, respectively, until the shutter speed value appears in white or you can set a lower or higher ISO Speed.

In Aperture Priority mode, you can set the white balance, My Colors, bracketing, Flash Exposure Compensation (FEC), Neutral Density, and the drive, metering, and Image Quality modes from the Function menu.

Manual

Manual mode, denoted as M on the Mode dial, is, as the name says, fully manual. This mode gives you complete control over aperture and shutter speed. Manual mode is useful in a variety of shooting scenarios, including shooting fireworks, interiors when you want to intentionally underexpose or overexpose a part of the scene, or when you want a consistent exposure across a series of photos, such as for a panoramic series.

In Manual mode, you turn the Control dial to select the shutter speed and the aperture. To switch between values, press the Metering Light/Jump button. Pressing the Metering Light/Jump button cycles through the shutter speed value, aperture value, and metering mode and displays curved green arrows around them when they can be changed.

Pressing the Shutter Release button halfway down initiates the metering based on the metered value, metering mode, and the ISO Speed setting.

The camera's ideal exposure is indicated when the exposure level mark is at the center of the exposure level indicator shown on the right side of the LCD monitor.

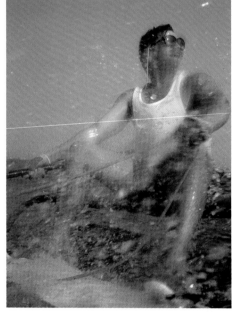

3.5 Manual mode is great for action shots, like this one of sailing enthusiast Ray Slabicki, where I know in advance what settings I want to use. The G11 was in a waterproof case and set to Manual mode at ISO 100, f/4, 1/500 second with a 6.1mm lens setting.

The exposure level meter on the LCD indicates the amount of overexposure or under-exposure from the camera's calculated ideal exposure. If the amount of under- or overexposure is +/–2 EV, the exposure level indicator turns orange to show the amount of plus or minus EV in the viewfinder and on the LCD. You can then adjust either the aperture or shutter speed until the exposure level you want is displayed on the LCD.

The same aperture and shutter speed values detailed in the preceding sections are available in Manual mode. In Manual mode, you can set the white balance, My Colors, bracketing, Flash Exposure Compensation (FEC), Neutral Density, and the drive, metering, and Image Quality modes from the Function menu.

C1 and C2 modes

The G11 expands the convenience of customizable modes by adding two to the Mode dial: C1and C2. With C modes, you can save and recall your favorite or most frequently used camera settings. These modes are ideal for photographers who routinely shoot in the same place, such as at home, a park, or an event location, and want to quickly recall the camera settings specific to that location.

Others will find it convenient to set up the C modes for specific types of shooting, such as portraits or landscapes. This way you can quickly turn the Mode dial to your favorite settings when an opportunity for that kind of shot arises.

In these modes, the camera saves and recalls many settings, including white balance, Shooting mode, My Colors, zoom position setting, My Menu items, and more.

For more on registering the C modes, see Chapter 2.

Low Light mode

The PowerShot G11 not only performs better in relation to noise levels than previous G-series cameras, but it now includes a new Low Light mode. This mode sets the ISO Speed setting automatically between 320 and 12,800 to attain optimal settings for handholding the camera in low light.

Try this mode when you need to go beyond ISO 3200 yet still don't want to use flash. Low Light mode is indicated on the Mode dial by a candle icon and enables you to shoot up to an expanded ISO of 12,800 in a reduced 2.5MP resolution at a quick 2.4fps (frames per second) capturing natural indoor shots without the need for a flash. Low Light mode is set at 1824 x 1368 resolution but this is more than sufficient for 4x6-inch prints and, in some cases, 5x7-inch prints as well.

3.6 Low Light mode yields good tonal quality and natural lighting with sharp detail in this handheld shot of a designer bedroom. Taken in Manual mode at ISO 400, f/8, 1/20 second with a 6.1mm lens setting.

Low Light mode is good for capturing some action photos in low light because of its quick 2.4 frames per second shutter, but there is a trade-off in file size and resolution, limiting your optimal printing choices to smaller prints. The Low Light file size is about one-quarter the Large JPEG image file size. In this mode, the recording pixel resolution is exactly one-half in both the horizontal and vertical directions. Each pixel in the resulting Low Light image appears to be generated from 4 pixels (2 x 2) from the image sensor.

You are limited to Auto ISO Speed settings in Low Light mode, meaning you have no control over the ISO, and the AF-assist lamp is on by default and cannot be deactivated.

Quick Shot mode

In Quick Shot mode, you compose and shoot only through the viewfinder while the LCD monitor is dedicated to displaying the main exposure controls. Indicated on the Mode dial by a flying camera icon, Quick Shot allows adjusting camera functions from the new Quick Shot screen. Once in Quick Shot mode, simply press the Function/Set button, and scroll around the controls and highlight the one that needs changing, then turn the Control dial to cycle through choices for that particular function.

3.7 The new Quick Shot screen of the G11

From these control screens, use the top, bottom, left, and right areas of the 4-Way Controller and the Quick Control dial to make your selections and press the Function/ Set button to accept all changes. The interface is elegant, the type and symbols are large and easy to see, and the 4-Way Controller button's response is fast and accurate.

I must say I was very impressed with this new display on my first outings with the G11, not only for its ability to quickly change exposure, shooting mode, image quality, and My Color settings but to be able to see a nice illuminated adjustable readout of those settings in the midst of a fast-paced shooting session.

Scene modes

The PowerShot G11 includes preset modes to cover the most common shooting situations called Scene modes. The Scene modes are accessible by turning the Mode dial to SCN next to the Movie mode camera icon. Once the camera is set to this mode, turn the Control dial with your right thumb to select the Scene mode appropriate for the situation you're shooting in.

For each specific preset mode, certain settings are locked in to produce the best picture, with more emphasis placed on exposure or color settings depending on the scene or situation. When shooting in Scene modes, images are automatically categorized for sorting later under People, Scenic, or Events. Exposure Compensation is available via the dial on the top of the camera, and drive mode and image quality are the only items changeable from the Function menu.

The Scene modes of the G11 are:

▶ **Portrait.** Portrait scene mode is best utilized when you have one, two, or three people in the shot and are taking pictures from close range. This mode selects the exposure setting with a bias toward aperture that emphasizes a shallow depth of field to make the background softer or more out of focus. Red-eye reduction is automatically turned on if the G11 determines flash is needed for the picture.

▶ **Landscape.** In Landscape scene mode, the aperture value is given more consideration to produce better depth of field, resulting in better detail in far away objects and formations. Color saturation leans toward greens and blues, and white balance is optimized for outdoor daylight.

▶ **Night Snapshot.** A companion to, but somewhat opposite of, Night Scene, Night Snapshot assumes you are not using a tripod when taking pictures at night and reduces camera shake blur by amping up the sensitivity of the image sensor so that a faster, more easily handheld shutter speed can be used.

▶ **Kids & Pets.** This scene mode optimizes the camera settings for fast focus response and quick shutter speeds to catch all the action. Red-eye reduction is turned on but can be overridden in the Shooting menu. Kids & Pets mode provides increased sensitivity and fast camera operation but may yield increased noise levels.

▶ **Indoor.** Higher sensitivity of the image sensor by way of increased ISO Speed settings to avoid camera shake in indoor images is why you'd choose Indoor scene mode. This scene mode is a good option for balancing existing ambient light with the built-in flash, which kicks in Red-eye reduction when needed. Auto White Balance is especially adept at attaining good color in tungsten and fluorescent lighting environments.

▶ **Sports.** Continuous shooting drive mode, combined with a bias toward fast shutter speeds, is the basis for the Sports mode. Choose this mode for any quick-action shooting situation that requires fast camera response and speedy autofocus results.

▶ **Sunset.** This scene mode optimizes the camera settings for a warmer color balance, with more emphasis on yellows, oranges, and reds to produce sunset or sunrise images with stunning, saturated colors.

▶ **Night Scene.** Night Scene allows you to capture better ambient lighting renditions of evening cityscapes or nighttime scenes, especially as backgrounds for portraits by slowing down the shutter speed and selecting small apertures for greater depth of field. Red-eye reduction is automatically turned on if the built-in flash is used.

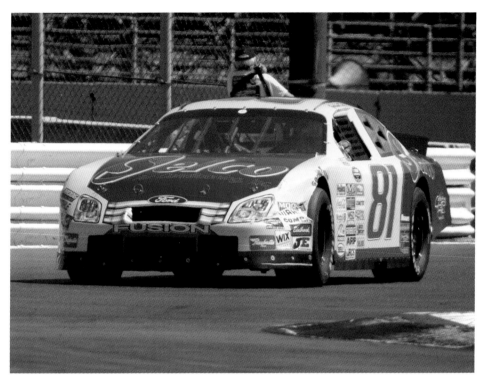

3.8 Scene modes are great for capturing images in specific situations, such as the Sports scene shot of this NASCAR race car at Portland International Raceway. Taken in Manual mode at ISO 100, f/5.6, 1/800 second with a 30.5mm lens setting.

▶ **Fireworks.** Increases saturation and utilizes smaller apertures for greater depth of field to produce vivid colors for fireworks displays.

▶ **Beach.** The Beach scene mode is geared toward minimizing overexposure and preventing your subjects faces from appearing too dark. Flash is automatically turned on if needed with the aid of Red-eye reduction.

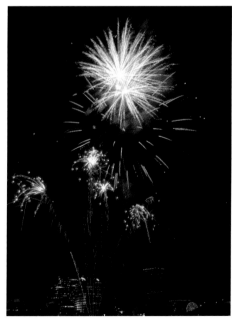

3.9 Pyrotechnic holiday display shot in Fireworks scene mode. Taken in Manual mode at ISO 400, f/8, 1.6 seconds with a 6.1mm lens setting.

▶ **Underwater.** A warmer color balance setting to counteract the overall blue/green quality of underwater scenes is the benefit of the Underwater scene mode. Flash can be utilized if needed, and Face Detection and Red-eye reduction are enabled.

 Canon offers the Waterproof Case WP-DC34 specifically for the PowerShot **CROSS REF** G11 for taking watersports and underwater photos or photos in wet conditions. See Appendix B for more information.

▶ **Aquarium.** The Aquarium scene mode setting optimizes the white balance for accurate color by reducing the blue cast and disables the flash to prevent reflection from the aquarium glass. This mode leans toward the higher ISO Speed settings to reduce camera shake and blur.

▶ **Foliage.** Foliage scene mode increases color saturation in order to produce intense, vivid colors from foliage and flowers. Foliage assumes you don't need flash, so it is disabled, and color balance is biased toward outdoor daylight.

▶ **Snow.** Because the G11 is calibrated to produce great pictures from the middle of the tonal scale, and snow scenes tend toward the brighter end of the scale, the camera often underexposes people's faces when they are photographed in these locales. Snow mode's exposure leans toward positive exposure compensation, and bluish tints are diminished from the white balance. Flash is activated automatically if need be, and Red-eye reduction is enabled.

▶ **Color Accent.** A creative Scene mode, Color Accent allows you to shoot videos with only one hue or range of color, rendering everything else in black and white. You can switch to Color Accent mode anytime while shooting by turning the Control dial while in SCN mode. This mode is handy when you want to call attention to a certain detail or subject and only want that specific color to remain in the shot.

▶ **Color Swap.** Color Swap is another interesting creative Scene mode that allows you to switch any colors of your choosing within the scene with any other color as a target. As with Color Accent, Color Swap offers limited choices when shooting stills and movies. You can swap colors by going through the simple method to switch between the chosen and desired colors using the Display button, right and left arrow buttons, and the Control dial.

▶ **Stitch-Assist.** This last Scene mode allows you to shoot panoramic images and assemble, or stitch, them together using the supplied Canon software. To shoot a panoramic series with Stitch-Assist on the G11, follow these steps:

1. **Place your camera in SCN mode.**

2. **Turn the Control dial to select Stitch-Assist.**

3. **Turn the Control dial again to select shooting the left or right side of the panorama, designated as 1 or 2.**

4. **Shoot the first image.** The exposure and white balance are automatically set and the image is displayed on the side chosen.

5. **Tap the shutter button.** The opposite side view of the panorama you started from is now live.

6. **Take the second picture.** Overlap part of the second image over the first and take the picture. The second image is displayed over the first image of the panorama.

7. **Repeat Steps 6 and 7 to take more photos for the panorama.** You can take up to 26 images for use with Stitch-Assist mode.

 Stitch-Assist mode does not work when shooting using a television as the monitor.

Movie mode

Indicated on the Mode dial by a movie camera, Movie mode allows you to take two standard resolutions of fluid video and show them on the G11's LCD monitor or standard or high-definition television. It is very convenient having a capable tool at your fingertips to capture those special moments when video and sound take center stage.

Like the G10 before it, the Canon G11 can record 30 frames per second with monaural sound at resolutions up to 640 x 480 pixels (VGA), and opts for H.264 MOV file compression. Those once-in-a-lifetime events, such as birthday parties, vacation happenings, or a child's discovery of something new, all lend themselves to priceless family memories, captured forever by your PowerShot G11 in moving imagery and sound.

 See Chapter 5 for more information on making movies with the G11.

Autofocus and selecting autofocus modes

The speed and accuracy of focusing and the ease of manually moving and resizing the AF point are as critical to camera performance as having a good on-board metering

system. The G11 autofocus (AF) performance is excellent, and AF selection is customizable. Getting tack-sharp focus, of course, depends on three factors: the resolving power of the lens (its ability to render fine details sharply), the resolution of the image sensor, and the resolution of the printer for printed images.

While the resolution of printers is beyond the scope of this book, I can address the other two factors. The G11 has excellent image sensor capabilities provided by the new 10MP sensor and DiG!C 4 processor that yields lower noise due to the new Dual Anti-Noise System.

In terms of setting focus on the G11, you have two choices: you can let the camera select the AF point automatically, or you can manually move and resize the AF frame to change it.

If you choose to have the camera automatically select the AF point and the camera is set to One-Shot mode, the G11 focuses on the subject or the part of the subject that is closest to the lens that has readable contrast, whether or not that's the appropriate point for sharpest focus. Or if you combine AF-point selection with Servo AF, the camera uses only the center AF point to identify the subject, and then subsequently uses all the AF points to track subject movement.

The G11 uses these modes to achieve accurate autofocus:

▶ **Face AiAF.** Face Artificial Intelligence Autofocus. A focusing system based on evaluating objects in the scene, Face AiAF recognizes faces in a scene and autofocuses on them first, then sets the exposure and white balance settings based on those readings.

▶ **FlexiZone.** When FlexiZone is selected, it allows you to move the focus point around inside the frame and/or resize it, making it possible to focus on off-center subjects without reframing the shot.

▶ **Face Detection mode.** When a face is detected, small white brackets appear on the screen superimposed over the face. AF is activated by pushing the Shutter Release button halfway; when focus is achieved, the box turns green and the beeper sounds. If it's a group shot and several faces are detected, a similar AF icon is displayed over a face, which can then be moved to the most important face via the 4-Way Controller. Press the Shutter Release button to focus on that face. If focus is not achieved, the AF point turns yellow with an exclamation point icon in the lower right of the AF frame.

Improving autofocus accuracy and performance

Autofocus speed depends on factors such as the size and design of the lens, the speed of the lens focusing motor, the speed of the AF sensor in the camera, the amount of light in the scene, and the level of subject contrast. Given these variables, it's helpful to know how to get the speediest and sharpest focusing. Here are some tips for improving overall AF performance:

▶ **Light.** In low-light scenes, AF performance depends in part on the lens speed and design. In general, the faster the lens aperture, the faster the AF performance. Provided that there is enough light for the lens to focus without an AF-assist beam, lenses with larger apertures will focus faster. But regardless of the lens, the lower the light, the longer it takes for the system to focus.

Low-contrast subjects that are in low light slow down focusing speed and can cause autofocus failure. With a passive autofocus system, autofocusing depends on the sensitivity of the AF sensor. Thus, autofocusing performance will always be faster in bright light than in low light, and this is true in both One-Shot and Servo AF modes. In low light, consider using the G11's AF-assist beam as a focusing aid. The AF-assist beam does double duty; it communicates focusing distance data to the camera, and it acts as a Red-eye reduction lamp.

▶ **Focal length.** The longer the telephoto lens setting, the longer the time to focus. This is true because the range of defocus is greater on telephoto lens settings than on normal or wide-angle settings. You can improve the focus time by manually focusing first in the general focusing range and then using autofocus to set the sharp focus.

▶ **AF-point selection.** Moving the AF point to match your subject may help the autofocus system work faster and the camera respond more quickly, thus shortening the shutter lag. Face AiAF will also help the system focus quicker for images with people in them.

▶ **Subject contrast.** Focusing on low-contrast subjects is slower than focusing on high-contrast subjects. If the camera can't focus, try shifting the camera position to focus on an area of the subject that has higher contrast, like the edge of a door frame or a clothing detail.

Modifying Exposure

For average scenes, using the G11's advanced exposure and shooting modes produces fine images. However, many scenes are not average due to the specifics of light in a particular scene or dramatic effects you are trying to create. In those scenes, you can

choose from any of the PowerShot G11's exposure-modification options, including Auto Exposure Lock, Auto Exposure Bracketing, and Exposure Compensation. Each exposure option is detailed in the following sections.

Auto Exposure Lock

As noted in earlier sections, Canon sets exposure to the AF point that you select. This approach is fine as long as the area of critical exposure falls within the point where you want sharpest focus. When you need to decouple the exposure from the point of sharpest focus, Auto Exposure Lock (AE Lock) is the technique to use.

Because I shoot RAW capture 99 percent of the time, AE Lock allows me to get exposures that are biased to the right of the histogram yet maintain detail in the highlights. There is a bit more latitude in raw capture because you can recover varying amounts of highlight detail during image conversion.

If you shoot JPEGs, then using AE Lock is a great way to ensure that the image retains detail in the brightest highlights.

For example, I use AE Lock in combination with Evaluative metering when exposing to maintain fine detail in the highlights of a bride's wedding dress, to retain highlight detail in macro and nature shots, and to maintain detail in skin highlights in portraits.

There are, however, some considerations for using AE Lock. First, it doesn't work in Full Auto, Special Scene, Low Light, or, of course, Manual mode. And in P, Tv, and Av modes, you have to keep holding down the Shutter Release button to take continuous shots with the AE Lock setting applied.

Before you set the AE Lock, ensure that the camera is set to Program, Aperture Priority, or Shutter Priority mode.

Follow these steps to set AE Lock:

1. **Press the Shutter Release button halfway to focus on the part of the scene that you want to meter.** For example, if you want to ensure that detail is retained in the highlight area on a subject's face, focus on a bright highlight.

2. **Continue to press the Shutter Release button halfway as you press and hold the AE Lock button on the back-right side of the camera.** This button has an asterisk above it. An asterisk is displayed in the LCD monitor indicating the exposure is locked.

3. **Release the Shutter Release button, move the camera to recompose the shot, press the Shutter Release button halfway to focus, and then make the picture.** As long as you continue pressing the AE Lock button, you can take additional images using the locked exposure settings. After you take the picture, the exposure is reset when you focus the lens again.

Flash Exposure Lock

Flash Exposure Lock allows you to lock the exposure for the flash, just as you can with exposure in AE Lock. Locking the exposure for the built-in flash provides more creative control by enabling you to fine-tune flash exposure by moving closer or farther away from the subject.

Follow these steps to set FE Lock:

1. **Turn the flash on by pressing the flash icon on the right side of the 4-Way Controller and use the Control dial to select On.**

2. **Press the Shutter Release button halfway to focus on the part of the scene that you want to meter.** For example, if you want to ensure that detail is retained in the shadow area of a scene, focus on a shadowed area.

3. **Press the AE Lock button on the back-right side of the camera.** This button has an asterisk on it. The flash fires a test flash and flash exposure is locked. An asterisk is displayed in the LCD monitor indicating that flash exposure is locked.

4. **Release the Shutter Release button, move the camera to recompose the shot, press the Shutter Release button halfway to focus, and then make the picture.** After you take the picture, the flash exposure is reset when you focus the lens again.

Auto Exposure Bracketing

Auto Exposure Bracketing (AEB) takes three exposures of the same scene: one exposure at the camera's recommended setting, an image above the recommended setting, and an image below the recommended setting. This is the traditional technique for ensuring an acceptable exposure in scenes that have challenging and/or high-contrast lighting and in scenes that are difficult to set up again or that can't be reproduced.

AEB is also used for image compositing where you take three different exposures of a high-dynamic range scene, and composite them in an image-editing program to produce a final image that offers the best of highlight, midtone, and shadow details. Using this technique, photographers can produce a final image that exceeds the range

of the camera's sensor. Additionally, AEB is a mainstay of High-Dynamic Range (HDR) imaging, which merges three or more bracketed exposures in Photoshop to create a 32-bit image with excellent rendering throughout the tonal range that has to be seen to be believed.

 For HDR imaging, it's better to bracket exposures by shutter speed rather than by aperture to avoid slight shifts in focal length rendering.

On the G11, the default exposure bracketing level is 1/3 stop, although you can set AEB captures up to +/– 2 f-stops.

Here are some things that you should know about AEB:

▶ **AEB settings remain in effect until you change them.** AEB settings are retained even when you turn the camera off and then on again, and when you change the battery or memory card.

▶ **In One Shot or Continuous mode, you do not have to press and hold the Shutter Release button to make all three bracketed exposures.**

▶ **In Self-Timer drive mode, press the Shutter Release button once to make the three bracketed images in rapid succession.**

▶ **The order of bracketed exposures begins with the standard exposure followed by decreased and increased exposures.**

▶ **AEB is available in all modes except Low Light, Special Scene, or Quick Shot, and you can't use AEB when you've mounted an EX-series Speedlite or third-party flash unit.**

▶ **You can use AEB in combination with Exposure Compensation.**

Exposure Compensation

Another way to modify the standard exposure on the PowerShot G11 is by using the Exposure Compensation dial, which enables you to purposely and continuously modify the standard exposure by a specific amount up to +/– 2 f-stops in 1/3-stop increments.

A common use is to override the camera's suggested ideal exposure in scenes that have large areas of white or black. In these types of scenes, the camera's onboard meter averages light or dark scenes to 18 percent gray to render large expanses of

whites as gray and large expanses of black as gray. You can use Exposure Compensation to override the meter. For example, snow scenes usually require between +1 and +2 stops of compensation to render snow as white instead of dull gray. A scene with predominately dark tones might require –1 to –2 stops of compensation to get true dark renderings.

Occasionally, you may notice that the camera consistently overexposes or underexposes images, and in those cases, compensation allows you to modify the exposure accordingly. (If underexposure or overexposure is a consistent problem, it's a good idea to have the camera checked by a reputable Canon repair facility.) Exposure compensation is useful in other scenarios as well, such as when you want to intentionally overexpose skin tones for a specific rendering effect.

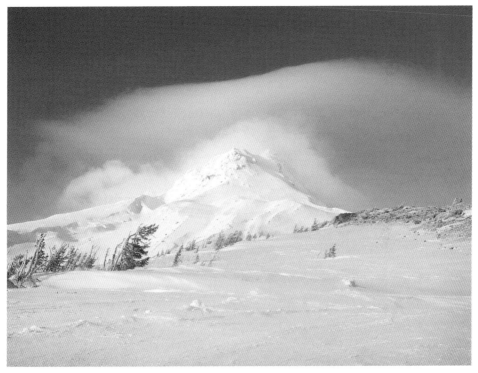

3.10 Snow-dominant scenes are a perfect example of when to use exposure compensation to counteract the camera's natural tendency to expose for middle gray. This image of Mt. Hood, Oregon was taken in Manual mode at ISO 80, f/4, 1/1000 second with a 9.8mm lens setting.

Here are some things that you should know about exposure compensation:

▶ **The amount of exposure compensation you set remains in effect until you reset it.** This applies whether you turn the camera off and back on, change the memory card, or change the battery.

▶ **Exposure compensation works in P, Tv, and Av modes, but not in Low Light or Full Auto mode.** If you are in Tv mode, setting Exposure Compensation changes the aperture by the specified amount of compensation. In Av mode, it changes the shutter speed. In Program AE mode, compensation changes both the shutter speed and aperture by the exposure amount you set.

▶ **It is annoyingly easy to inadvertently set Exposure Compensation by accidentally rotating the dial.** Because I've fallen victim to this many times, I find that the best way to avoid unintentional exposure compensation is to always check the Exposure Compensation dial's position before shooting. If the center tick mark is off-center more than the compensation that I set, or if it is off-center and I haven't set compensation, then I know to reset it.

To set exposure compensation, follow these steps:

1. **Set the Mode dial to P, Tv, Av, Scene, or Quick Shot.**

2. **Select the amount of Exposure Compensation on the dial.**

3. **Press the Shutter Release button halfway, and then turn the dial away from you to set a negative amount of compensation or toward you to set a positive compensation value.**

ND filter

The PowerShot G11 also includes a built-in 3-stop Neutral Density (ND) filter and white balance fine control that enables photographers to more accurately account for variations in natural and artificial light, such as differences in color tone across various kinds of tungsten light bulbs. The ability to make such fine adjustments in-camera can cut processing time post-shoot while enabling photographers to be more creative in the field.

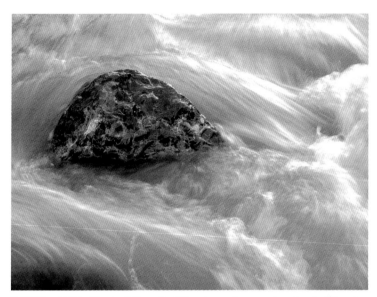

3.11 The G11's Neutral Density filter turned on and a sturdy tripod and remote switch allowed me to slow my shutter speed down to produce the silky effect of the water in this scene. Taken in Manual mode at ISO 100, f/8, 1 second with a 30.5mm lens setting.

Setting the ISO

The technology of ISO settings on digital cameras replicates the rated speeds of the films of yesteryear. In very general terms, ISO is the sensitivity to light of the sensor in the same way that film speeds were more or less sensitive to light. But there are differences between film and digital sensors; specifically, as the sensitivity setting increases on a digital camera, the output of the sensor is also amplified. This was referred to as grain when we used high-speed films. So while you have the option of increasing the ISO sensitivity at any point in shooting, the trade-off in increased amplification or the accumulation of an excessive charge on the pixels is an increase in digital noise. And the result of digital noise is an overall loss of resolution and image quality.

Partly because the G11 has relatively millions of pixels on the sensor, and because Canon has done a fine job of implementing advanced internal noise reduction processing, the PowerShot G11 stands out as a top performer even at high sensitivity settings, particularly at exposure times of 15 seconds or less.

Auto ISO

Auto ISO controls the sensitivity of your sensor automatically depending on the Shooting mode you're in. In Full Auto, Program AE, Tv, or Av, the camera selects an ISO between ISO 80 and 3200. Switch to Landscape mode and Auto ISO tops out at 400, but add a Speedlite and flash sync speed improves to 1/2000 second. Auto ISO is displayed in green on the left end of the ISO Speed dial.

Manually setting the ISO

To change the ISO setting on the G11, follow these steps:

1. **Make sure to select a Shooting mode where the ISO Speed lamp is illuminated.**

2. **Turn the ISO Speed dial clockwise to set a higher sensitivity or counterclockwise to set a lower sensitivity.** The ISO Speed setting right next to the lamp is the one selected. The ISO option you select remains in effect until you change it or change to a Shooting mode that defaults to Auto ISO.

Selecting a Drive Mode

The PowerShot G11 offers several Drive-mode options: Single, Continuous Shooting, and a 2- or 10-second-delay Self-timer, Custom timer, and a New face timer. Each mode has its uses for different shooting situations. Certainly the G11 is built for speed with a look and feel like the top guns in Canon's professional lineup, and it performs nicely in moderately fast-action scenes such as wedding processions and kids sports.

Single Shot mode

In Single Shot mode, one image is captured with each press of the Shutter button. Switching to Continuous shooting mode gives you the maximum frames to catch quick action. The actual number of frames you can capture depends on the timing of the action, shooting mode, shutter speed, focusing mode, and the space remaining on the memory cards and the type of cards you're using. The G11 is equipped to handle the latest SDHC cards, which can significantly raise writing speed.

Continuous mode

Continuous mode is where you want to be when you want to record fast action sequences at the peak of the moment. In Continuous mode, the focus and exposure

are locked when the Shutter Release button is pressed halfway down. The camera will shoot at its fastest possible speed in standard modes for up to 1.1 frames per second (fps).

To switch drive modes on the G11, follow these steps:

1. **Press the Function/Set button to access the Function menu on the LCD.** The Drive mode selection is second from the bottom in the left corner of the LCD.

2. **Turn the Control dial clockwise one click to select Continuous or two clicks to select the Continuous AF or LV drive mode.** A single rectangle denotes Single Shot mode, a tiled rectangle denotes Continuous mode, and a tiled rectangle with AF or LV in the upper-left corner denotes Continuous AF or LV mode. The Drive mode you set remains in effect until you change it or switch to a Shooting mode that changes it automatically.

Continuous AF mode

Continuous AF lowers the fps count to approximately 0.7, but that is because the G11 is continually focusing on the subject in real time. In this mode, the focus frame is automatically set to Center.

Continuous LV mode

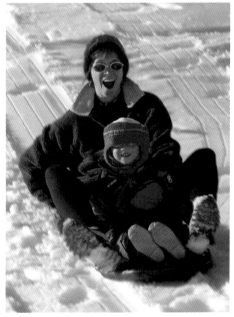

When the G11 is in Continuous AF mode and is set to Manual focus or AE Lock mode, the camera switches to Continuous LV mode. In this shooting mode, the camera shoots continuously with the focus set to the distance set in Manual Focus. In AE Lock mode, the focus is set with the first shot taken. Continuous modes cannot be used in conjunction with the Self-timer modes.

3.12 The PowerShot G11 is speedy enough for capturing the action of sledding. Taken in Manual mode at ISO 200, f/8, 1/500 second with a 15.2mm lens setting.

Self-timer modes

The PowerShot G11 includes expanded Self-timer modes that may just signal the end of running to get into the picture before the camera fires. In these modes, the shutter delays firing by 2 or 10 seconds after pressing the Shutter Release button or using the Remote Trigger. The Self-timer lamp on the front of the camera blinks and a beep is emitted slowly, for 8 seconds or 1 second, depending on the setting, and then the speed of the beep and the lamp blinking increases for the final second before the shutter fires. Ten seconds should be plenty of time to run around and get into the picture and 2 seconds allows you to get your hand down inconspicuously when triggering remotely.

This mode is useful in nature, landscape, and close-up shooting, and it can be combined with a tripod and remote switch to prevent vibration from manually pressing the shutter button.

To use Self-timer mode, focus on the subject, press the Shutter Release button completely, and then take your place in the picture, or wait for the timer to fire the shutter. Be sure that you are not standing in front of the camera when you press the Shutter Release button because it will cause inaccurate focus.

The G11 is set to Single Shooting drive mode by default.

To activate the Self-timer modes, follow these steps:

1. **Press the Self-timer clock icon on the bottom area of the 4-Way Controller.** The Self-timer menu appears in the right of the LCD for about 5 seconds.

2. **Press the Self-timer icon to select the Self-timer drive modes.** You have five options for the Self-timer modes: Off, the previously mentioned 2- and 10-second delay timers, a new Face Self-timer, and Custom timer. The Drive mode you set remains in effect until you change it.

Face Self-timer mode

Face Self-timer mode is a G11 technology that instantly recognizes when a face (ideally, you, the photographer) enters a scene, and fires the camera 2 seconds later. In this mode, you compose your group shot, aim the camera, and press the Shutter Release button. The G11 will autofocus and set exposure, and a green frame will appear around one of the faces and white frames around some others.

Press the Shutter Release button fully and the lamp blinks and the beeper sounds as the camera waits for a new face to enter the scene. When it does, the blinking and

beeping speed up and approximately 2 seconds later the camera takes three frames. When setting up the Face Self-timer mode, you have the choice of taking from one to ten images by pressing the Menu button and turning the Control dial to select the amount, although three images is the default.

Customizing the Self-timer

At the bottom of the Self-timer menu is the Custom timer mode where you can set both the delay time and number of shots taken. Choose from delay times of 0, 1, 2, 3, 4, 5, 6, 7, 8, 9, 10, 15, 20, or 30 seconds by turning the Control dial or pressing the left and right areas of the 4-Way Controller. You use the same controls to set the number of shots the G11 will take between 1 and 10.

Viewing and Playing Back Images

Image review includes magnifying the new 2.8-inch Vari-Angle PureColor II VA LCD image to check for sharpness, review the *brightness* (luminance) histogram for localized areas of overexposure, and/or review the images to check color saturation, contrast, and white-balance bias.

And with this unprecedented ability to gauge exposure and composition on the spot, image evaluation can quickly solidify the settings for vacation or event shooting, or alert you to the need for a quick exposure change before the light changes on a stunning landscape scene.

One of the first things you'll want to do is to change the default display time, which is initially set to 2 seconds, barely enough time to remove the camera from your eye or shooting position to preview the image. I understand the display time is intentionally set conservatively to maximize battery life, but given the excellent battery performance, a display time of 4 to 8 seconds is more practical and it doesn't significantly impact the battery performance. Also, if you're showing an image on the LCD to friends or subjects and you want the image to stay displayed until you dismiss it, you can set the display time to the Hold option so that the image is displayed until you dismiss the playback.

To change the length of image playback review time, follow these steps:

1. **Press the Menu button.** Unless you have selected My Menu to display first, the Shooting menu appears on the LCD. Navigate with the Control dial or the up and down areas of the 4-Way Controller to select Review.

2. **Press the left and right areas of the 4-Way Controller to select a new review time.** The Review time options, which include Off, 2, 3, 4, 5, 6, 7, 8, 9, and 10 seconds, and Hold, appear as you scroll through the choices.

3. **Press the Shutter Release button to return to shooting.** If you select Hold, the picture is displayed until you press the Shutter Release button to dismiss the display. Viewing images for a longer time depletes the battery faster. The option you choose remains in effect until you change it.

Playback display options

The PowerShot G11 offers several image playback display options including single-image display with three options for displaying or not displaying exposure information, magnified view, index display, or slide show (auto) playback.

When you press the Playback button, the most recently reviewed or shot image is displayed first, in whatever viewing mode it was left in. To move through multiple images on the memory card, turn the Control dial counterclockwise to view the previous image, or turn the dial clockwise to view the next captured image on the card.

As the name suggests, single-image display enables you to see one image on the LCD at a time. This is the default playback mode on the G11. For single-image playback, you can choose three display formats:

▶ **Single image with no shooting information.** When shooting photos of friends and family where you'll want to show them the images being captured, this is a good display option because it provides a clean, uncluttered view of the images.

▶ **Single image display with simple shooting information.** With this option, minor shooting information is displayed on the top and bottom right of the LCD. The top-right display shows the image name and the image number relative to the number of images captured (for example, 11/11, or 11 of 11 stored images) and the battery status indicator. The bottom information shows the Image quality setting and date and time the image was taken. This display option is useful during a quick image review to verify exposures for an AEB series of images, or to recall the date and time of a previous image.

▶ **Single image with detailed shooting information.** This data-rich view includes all the exposure and file information, a gray-and-white flashing display showing areas of overexposure, flash exposure, capture time, the histogram, and more. To display this amount of information, the image preview is necessarily reduced to about one-fourth of the full LCD preview size.

▶ **Focus Check Display.** This display option is invaluable at all stages of shooting so you can check the focus of a portrait, macro shot, or landscape. The LCD displays the entire shot in the top-left corner with a smaller magnified image in the lower right. Use the Zoom lever and Menu button to switch views and the up, down, left, and right areas of the 4-Way Controller to move the magnification frame around your image to check critical focus. A yellow frame in the upper-right image shows you the area being magnified.

See Chapter 2 for more information on Display modes.

Adding effects with My Colors

As described in Chapter 2, My Colors affects the way the image is processed by the camera. While you can take pictures with My Colors effects as you shoot them, you can also apply some of those effects after the image has been captured.

See Chapter 2 for complete descriptions of the My Colors options.

To apply My Colors effects to images already taken, follow these steps:

1. **Press the Playback button.** Use the Control dial to scroll to the image you want to change.

2. **Press the Menu button to enter the Playback menu.**

3. **Turn the Control dial or press the up or down area of the 4-Way Controller to highlight My Colors, and then press the Function/Set button.** The My Colors settings screen appears. Press the Function/Set button again to display the My Colors options for the image.

4. **Turn the Control dial to select a My Colors option, and then press the Function/Set button.** A screen appears asking if you want to save the new image. Choose OK to apply the effect and save the image as a new file.

Red-Eye Correction

Similar to My Colors, you can also apply Red-eye correction to an image after it's been taken or set your G11 to shoot them that way.

To set Red-Eye Correction for an image to be shot, follow these steps:

1. **Press the flash icon on the right side of the 4-Way Controller, and immediately press the Menu button.** The Built-in flash settings menu is displayed.

 If you hesitate after pressing the 4-Way Controller and then press Menu, you will be directed to the regular menu instead of the Built-in flash settings menu.

2. **Turn the Control dial to select Red-Eye Correction.**

3. **Press the left or right area of the 4-Way Controller to select On, then press the Menu button to return to shooting.**

To apply Red-Eye Correction for an image already shot, follow these steps:

1. **Press the Playback button, then press the Menu button.** The Playback menu is displayed.

2. **Turn the Control dial to select Red-Eye Correction and press the Function/ Set button.** The last image taken or viewed is displayed.

3. **Use the Control dial to scroll to the image that requires Red-Eye Correction and press the Function/Set button again.** A Busy icon and status bar appear on the LCD. If the camera found red-eye to correct, frames appear around the eye areas affected by the correction; if not, a Cannot modify message is displayed.

4. **Choose to create a New File, Overwrite, or Cancel.** I always choose New File because I want to see both versions back home on the computer and never want to degrade an original. Press the Function/Set button to correct more images or press the Menu button again.

5. **In the next screen, choose to display the new image by selecting Yes or No.** Press the Menu button again to return to the Playback mode or menu.

Correcting contrast with iContrast

Chapter 2 covered some of the benefits of shooting images with i-Contrast control turned on. You can also apply i-Contrast adjustments to images already shot.

To apply i-Contrast control to images on the memory card, follow these steps:

1. **Press the Playback button, then press the Menu button.** The Playback menu is displayed.

2. **Turn the Control dial to select i-Contrast and press the Function/Set button.** The last image taken or viewed is displayed.

3. **Turn the Control dial to select the image and press the Function/Set button.** This displays the i-Contrast screen where you choose Auto, Low, Medium, or High intelligent Contrast control. The camera shows you the effect on the image to help you make your selection.

4. **Press the Function/Set button to apply the control.** The camera asks you to Save a new image or Cancel.

5. **Use the Control dial or press the left or right area of the 4-Wat Controller to select OK and continue to add i-Contrast control to other images or press the Menu button to display the last corrected image.** Choose Yes or No. The Playback menu is again displayed. Press the Playback button to return to shooting.

Jump quickly through images

When a high-capacity memory card is full or nearly full, it's challenging to find a single image among all the images stored on the card. To make searching easier, Canon has increased your ability to jump through images by 10s or 100s, and also by First, Date, Category, or Movies to find the ones you want.

To elect how you'd like to jump through images or movies (follow these steps):

1. **Press the Playback button, and then press the Metering Light/Jump button.** The Jump menu is displayed.

2. **Press the up and down areas of the 4-Way Controller to scroll through the options for jumping, selecting the option you want.**

3. **When the option you want is displayed in the window, press the Function/Set button.** If you choose to jump by date, use the left and right areas of the 4-Way Controller to move to the previous or next dated folder and display the first image in the folder. If you choose to jump by any setting, turning the Quick Control dial will only advance or go back one frame at a time. This is handy if you want to jump quickly through a batch of images and then review a few in sequence. If there are multiple images taken on the same date, the camera displays the first image taken on that date.

4. **Press the Menu button to cancel the Jump feature and return to single image review.**

To change the method of moving through images, follow these steps:

1. **Press the Metering Light/Jump button.** The image is now displayed with a scroll bar for quickly jumping through the images based on your selections.

2. **Press the left and right areas of the 4-Way Controller to jump through the images or movies by the specification you set.** Turn the Quick Control dial to view images within those parameters one by one.

Ensuring that you have tack-sharp focus immediately after capturing an image is another advantage that Playback mode offers. This is something I do all the time and the G11 uses the actual image rather than the thumbnail for image playback and magnification. This is one of the more subtle improvements of the new camera over the old. You can magnify the LCD image display and then use the 4-Way Controller to scroll through the image to verify sharp focus.

To magnify and move within the image, follow these steps:

1. **In any Playback display mode, press the Zoom lever to the right.** A small screen with a rectangle displays the relative amount of magnification. If you are using the single-image with detailed shooting information display option, then the camera temporarily switches to the basic shooting information display and magnifies the image preview. You can magnify the image by 1.5× to 10× on the LCD.

2. **Tilt the 4-Way Controller in the direction you want to move within the zoomed image.** If you want to check other images, turn the Control dial to move to the next or previous image at the same position and magnification.

3. **Press the Zoom lever to the left to return to the original image size.** If you are in the single-image with detailed shooting information display mode, the camera switches back to that display to show the full shooting information.

Index display

In addition to evaluating individual images, you can view multiple images on the memory card as an index; essentially, this is a miniature, electronic version of a contact sheet. Index display shows 4, 9, 36, or 100 thumbnails of images at a time. This display is handy when you need to verify that you've captured a picture of everyone at a party or event, and it's a handy way to find a particular image quickly. You can use the Index display regardless of which single-image display option you're using.

To display images as an index, follow these steps:

1. **Press the Playback button.** The camera displays the last image shot or reviewed in the display mode it was left in.

2. **Press the Zoom lever to the left quickly.** If the Index display shows only one or a few images, turn the Control dial clockwise to move to the next page of images or counterclockwise to move to the previous page of images. Each time you press the Zoom lever to the left, you reduce the size of the thumbnail images, allowing more to show on the screen at one time.

3. **Use the up, down, left, and right areas of the 4-Way Controller to move among individual images on a single Index page.** The selected image is displayed with a yellow frame. To display the selected image in Single-image display, press the Function/Set button. You can press and hold the Zoom lever to the right to magnify the image. To return to Index display, press and hold the Zoom lever to the left until the full Single-image display appears, and then press the Zoom lever left again to return to the Index display.

4. **Tap the Shutter button to turn off the Index display and return to normal shooting mode.**

Viewing slide shows

The PowerShot G11 allows you to view slide shows with custom transition effects on the LCD monitor or via a standard or high-definition television set. Either way, the setup settings are the same:

1. **Press the Playback button, then press the Menu button to display the Playback menu.**

2. **Turn the Control dial to select Slideshow and press the Function/Set button.**

3. **Select the Slideshow features Repeat, Play Time, or Effects.** Repeat loops the show to play continuously, Play Time determines how long the images are shown, and Effects sets the transitions between images.

4. **Select Start to view the slide show.** During the slide show, you can still scroll through images by pressing the 4-Way Controller left or right. When you're done, the slide show resumes. This is great when you want to go back to a particular image. Grab some popcorn and enjoy the show!

Viewing images on a TV

The G11 comes right out of the box with the proper AV cables you need to view images, videos, and slide shows on a standard television set. If you think the images displayed on the back of the G11's 2.8-inch ClearView screen are impressive, wait until you see your images displayed on your TV.

To set up and view G11 images, videos, or slide shows on a standard television set, follow these steps:

1. **Make sure both the camera and the TV are off before you begin connecting them.**

2. **Plug the supplied AV cable into the G11's AV Out/Digital terminal and the other two yellow and black plugs into the TV's video input terminals.** The yellow plug is the video line and the black plug is the audio. You can skip the black plug if you are only viewing still images.

3. **Turn on the TV and use the TV's remote control to switch to the input line the G11 is connected to.**

4. **Turn on the PowerShot G11 and press the Playback button.** The G11's LCD monitor will go dark and the images will be displayed on the TV. If your images are not displayed on the TV, use the TV's remote control and press the Input button until you see your images. Use the camera to control what images, videos, or slide shows are shown on the TV.

5. **When finished, turn off the camera, turn off the TV, and then disconnect the cables.**

Viewing images on a high-definition TV

Setting up the G11 to display images, videos, and slide shows via a high-definition television is as straightforward as setting it up for a standard TV, with the exception of the cable used to connect the two. The optional HTC-100 HDMI cable is required to send the camera's signal to the high-definition TV for what's described as an enhanced viewing experience.

To set up and view G11 images, videos, or slide shows on a high-definition television set, follow these steps:

1. **Make sure both the camera and TV are off before you begin connecting them.**

2. **Plug the smaller plug of the optional HDMI cable into the G11's HDMI terminal and plug the other larger plug into the high-definition TV's HDMI input terminal.**

3. **Turn on the TV and switch it to play the HDMI input line the G11 is connected to.**

4. **Turn on the PowerShot G11 and press the Playback button.** The G11's LCD monitor will go dark and the images will be displayed on the high-definition TV. Use the camera to control what images, videos, or slide shows are shown on the TV.

5. **When finished, turn off the camera, then turn off the TV, then disconnect the cables.**

Erasing Images

Most of the time after downloading the images to my computer and burning the images to disc, I simply reformat the memory card, virtually erasing all of the images. But sometimes I just want to erase certain duplicate images to save editing time in post-production or free up some space on the card.

From experience, however, I know that some images that appear to be so-so on the LCD often can be saved with some minor image editing on the computer. For that reason, along with the difficulty to recover erased images, it pays to erase images with care. You may have some luck with image-recovery programs like PhotoRescue, but it pays to be vigilant whenever you are erasing images from the memory cards.

Of course, if you know that something is wrong with an image you just made, erasing the image helps keep the number of images on the card down and makes better use of your time when evaluating images on the computer later.

If you want to delete an image on the G11's memory card, there are now several ways to do it:

1. **Press the Playback button on the back of the camera, and then turn the Control dial to navigate to the image you want to delete.** Alternately, you can also use the left and right areas of the 4-Way Controller to move through images.

2. **Press the AF Frame/Erase button, and then turn the Control dial to select Erase.** If you change your mind, press Cancel to not erase any images.

3. **Press the Function/Set button to erase the image.** Lightly press the Shutter Release button to return to shooting.

To select more than one image to erase, follow these steps:

1. **Press the Playback button on the back of the camera, and then press the Menu button.** Use the Control dial to navigate to the Erase images menu.

2. **Press the Function/Set button.** This opens the Erase images menu and gives you three choices: Select, Select Range, or All Filtered Images.

3. **Use the 4-Way Controller or Control dial to navigate to your choice.**

4. **Press the Function/Set button to make your selection.** If you select the first option, Select, the last image you played back appears with the Erase icon and counter displayed in the top-left corner of the image. Press the Function/Set button again to select that image for erasing. An orange check mark appears next to the Erase icon and the counter has increased by one. Scroll through the images with the Control dial or left and right areas of the 4-Way Controller, pressing the Function/Set button each time an image you want to erase is displayed. After you make all your selections, press the Menu button.

5. **Using the 4-Way Controller, select OK or Stop.** A progress bar screen is displayed until all images you selected have been erased. The camera erases the image or images except those that have protection applied to them.

To erase all the images in a Range, follow these steps:

1. **Press the Playback button on the back of the camera, and then press the Menu button.** Use the Control dial to navigate to Erase images.

2. **Press the Function/Set button.** This opens the Erase images menu. Use the Control dial to choose Select Range.

3. **Press the Function/Set button to make your selection.** When you select the Range option, the LCD displays the first image in the range on the left of the LCD monitor and an empty black box is displayed on the right for the last image in the range. If that is not the first image you want to erase, use the Control dial to select the first image in the range for erasing.

4. **Press the right area of the 4-Way Controller to jump to the right image box that will be the last image in the range erased and turn the Control dial to select it.** Press the Function/Set button to choose the last image or the Menu button to cancel.

5. **Use the down area of the 4-Way Controller to select Erase and push the Function/Set button to erase the range of images.**

To erase all the images on the card, follow the same procedure except choose All Images, press the Function/Set button, and select OK. Lightly press the Shutter Release button to return to shooting.

Formatting Your Card

It's a good idea to regularly format your memory cards. I do this before every shoot. Before formatting the card, be sure to download all the images from the card to the computer. To format the memory card, follow these steps:

1. **Press the Menu button.**

2. **Press the Metering Light/Jump button until the Set-up menu is displayed.**

3. **Turn the Control dial clockwise to highlight Format, and then press the Function/Set button.** The Format confirmation screen appears.

4. **Turn the Control dial clockwise to select Low Level Format, Cancel, or OK, and then press the Function/Set button.** The camera displays a progress screen as the card is formatted.

Protecting Images

The other side of the coin from erasing images is the ability to ensure that images you want to keep are not accidentally deleted. To prevent accidental erasure, you can apply protection to one or more images.

Setting protection means that no one can erase the image when using the Erase, Erase Range, or Erase All option. However, protected images will always be erased if you format the memory card.

To protect an image, follow these steps:

1. **Press the Playback button, and then turn the Control dial to move to the image you want to protect.**

2. **Press the Menu button.** The Protect menu appears. **Turn the Control dial to highlight Protect images. Press the Fuction/Set button to select.**

3. **Press the Function/Set button again to choose Select.** The image you chose in Step 1 will be displayed. Press the Function/Set button to protect the image. A yellow key icon appears in the lower-left corner, indicating the image is protected and cannot be erased.

4. **To protect additional images, turn the Control dial to scroll to the image you want to protect, and then press the Function/Set button to add protection.** If you later decide that you want to erase a protected image, you must remove protection by repeating Steps 1 to 4 and pressing the Function/Set button to remove protection for each image.

Restoring the Camera's Default Settings

With all the different settings, you may sometimes want to start fresh instead of backtracking to reset individual settings. The PowerShot G11 offers a Reset All camera settings option that allows you to clear the function settings that you entered into the G11. This option is a good way to start fresh, but be aware that it resets all shooting and image quality settings, and My Menu, back to the factory defaults.

In addition to the fresh start advantage, I've found that a quick way out of any type of camera setting problem that you might encounter with the camera is to use the Reset All camera settings option. I was shooting a friend's wedding as a guest and I had changed a variety of camera settings and the method of AF frame functions.

As the wedding began, I immediately noticed that the AF point did not move around to match my subjects or find faces, and the autofocus confirmation beep was ominously silent. In fact, the Shutter Release button did not activate AF at all. I suspected I was in Manual focus mode with Safety MF turned off and that was the case. To keep the shoot moving, I quickly reset the camera to the defaults, and then reset the image quality and My Colors settings. Resetting the defaults solved the conflict and the camera performed great throughout the rest of the day.

If you customize the PowerShot G11 and want to restore the default camera settings, follow these steps:

1. **Press the Menu button.** Unless you have selected My Menu to display first, the Shooting menu appears on the LCD. Press the Metering Light/Jump button to quickly jump to the Set-up menu.

2. **Turn the Control dial to highlight Reset All, and then press the Function/Set button.** The Reset All settings screen appears.

3. **Turn the Control dial to select OK, and then press the Function/Set button.** A Busy icon and status bar screen appear. The camera restores settings to the camera defaults and returns to Shooting mode.

Light and Color

Getting accurate color has never been as accessible as it is now with digital photography. As digital technology progresses, the options and techniques for ensuring accurate, visually satisfying, or enhanced color become easier and more varied. Color accuracy begins by setting the color balance on the PowerShot G11 that matches your scene.

Canon's My Colors have never been easier to employ, and many photographers are beginning to enjoy the ability to set the tonal curve, sharpness, skin tones, color rendering, and saturation of images that these settings yield. You can choose among an assortment of My Colors settings that replicate the time-honored film look, render color in different ways, or create your own.

Holiday lights take on a surreal look when a shift in hue is applied in image-editing software. Taken at ISO 400, f/8, 1/4 second with a 6.1mm lens setting.

About Light

If you compare the digital photography process with the fine-art paintings by the masters, you may come up with the analogy that the pixels are your canvas, the camera is your brush, and the light is your paint. Thought of in this way, you begin to understand the relationship between these elements to help you create great images.

Light might seem like a nebulous force to wrap your brain around, but your understanding of it and your developing the ability to see light before making photographs will benefit your photography in profound ways. Professional photographers speak often about "seeing the light" or creating their own light by using flash or reflectors to match the scene in their mind's eye, regardless of the ambient light they come upon in any given situation.

Light can be better understood if you break it down to its three main components as it relates to photography: color, quality or intensity, and direction. Let's explore each of these in detail to better comprehend light and its importance in making memorable, lasting images.

4.1 Late afternoon on the banks of the Colorado River in Grand Canyon. The light's color, quality, and direction all play a part in this desert scene.

Color

The human brain/eye combination automatically adjusts to the changing colors (temperatures) of light. We see a person's white shirt as white in tungsten, fluorescent, or daylight light; in other words, regardless of the type of light in which you view a white object, it appears to be white. Digital image sensors, however, are not as adaptable. To distinguish white in different types of light, you must set the white balance to an approximate or specific light temperature.

Light temperature is measured on the Kelvin scale and is expressed in degrees Kelvin (K). Once you set the white balance to specify the light temperature, the camera renders white as white. On the G11, the preset white balance options cover a wide range of light temperatures, which is more an approximation than a specific setting. A custom white balance is a specific light temperature that renders neutral color in the image.

Custom white balance is a technique for setting the white balance to match the color temperature of a specific scene. The technique is detailed later in this section. In digital photography, color is also referred to as a color space. The Canon PowerShot G11 only records images in the sRGB color space, which is the setting most commercial color labs use to make prints. There are several other color spaces that are somewhat larger, but these are used for commercial applications, magazines, and the like. The sRGB color space is assigned to all JPEG prints produced by the G11, but if you are shooting raw images, several color space options are available during output phase in Canon's Digital Photo Professional (DPP) and in many third-party image processors like Adobe's Photoshop, Camera Raw, and Lightroom, and Apple's Aperture.

> If you shoot JPEG images, the white balance is set in the camera by the setting you choose. If you shoot RAW images, the white balance setting is only "noted," and you can set or adjust the white balance in the RAW conversion program after the image is captured.

Light, whether it be sunlight, moonlight, fluorescent light, or light from your G11's flash, has a color that can be measured using the Kelvin scale. This measurement is also known as color temperature. One of the advantages of using a digital camera is the ability to measure the color temperature of light through the lens. If your PowerShot G11 camera is set to an automatic white balance, it automatically adjusts the white point for the shot you are taking. The result of using a correct white balance setting with your digital camera is correct color in all your photographs no matter what the lighting conditions are.

Quality

By speaking about the quality of light, I'm not making a value judgment like good or bad. Quality of light refers to its properties of hard lighting and soft lighting to affect

the mood of the picture. One of the key components of any photograph — whether you're working indoors or outdoors — is the quality of light. The feel of the light in a photograph often can determine its visual impact and set the mood you want the viewer to share.

Hard light refers to light that strikes the subject directly from its source such as clear sunlight, flash, light bulb, or strobe light. Hard light can create very bright and very dark areas in the same scene and can be used effectively to show texture, contrast, and details. Hard light is most often found on bright sunny days with few clouds and is also the type of light emitted from your flash.

Soft light, on the other hand, is light that strikes the subject after passing through a diffusion material, which can be clouds, window curtains, or a sheet, or hard light that is bounced onto a nearby surface or reflector. Soft light is ideal for portraits of people, nature, and landscape scenes because it strikes the subject from many different angles and creates a lower-contrast scene that is easy for your camera to capture.

Direction

The direction of the light can add mood and drama to a scene but also controls how much detail and texture are present in the scene. As the lighting direction changes, shadows get longer or shorter or they may fall on different areas of your scene, and highlights can change shape or disappear completely. There are four basic types of lighting direction to be aware of:

4.2 Direct flash from the camera is a good example of front lighting. Jewelry artist Sander Raymond shows the effects of front lighting in this quick snapshot. It's adequate, but not very flattering. Taken at ISO 400, f/5.6, 1/100 second with a 15.2mm lens setting.

▶ **Front.** Front lighting is light that strikes the subject directly from the camera angle, whether it's ambient light or the pop of your flash. This very efficient type of lighting is good for copy work of documents, but it can be the least flattering light for portraits or any type of scene where you wish to show texture or detail, as it can result in huge highlights and a rather flat, one-dimensional-looking image.

▶ **Top.** Top lighting is light that strikes the subject directly from above, such as on a sunny day at noon when the sun is directly overhead. While not entirely undesirable for some subjects, top lighting produces strong shadows in the eye sockets and under the chins of human subjects, and adds contrast.

If the sky is clear, then strong, narrow shadows will appear, but if the sky is overcast, the clouds diffuse the top light and the effect is less harsh.

▶ **Side.** Perhaps the most flattering lighting for a scene to show highlights and shadows along with texture and detail, side lighting or modified top/side lighting is light that strikes the subject from a lower angle and skims across the subject's features.

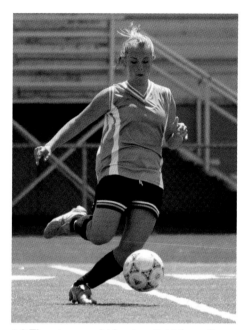

4.3 The strong midday top light from the sun produces minimal shadow areas and a shaded subject as displayed by this soccer player during a recent summer tournament. Taken at ISO 800, f/5.6, 1/2000 second with a 30.5mm lens setting.

Side lighting renders a three-dimensional look to scenes that add interest and character to the image.

▶ **Back.** Backlighting is a dramatic lighting technique where the main light is striking the back of the subject, rendering the side that faces the camera in shadow or of a darker value. Sometimes difficult to deal with, strong backlighting creates a rim of light around your subject that can add separation from the background, especially backgrounds that are darker than the subject.

Backlighting can be controlled by using a flash or a reflector to kick light back into the shadowed front of your subject, and care must be taken to always block the light source from shining directly into your camera's lens.

4.4 Beautiful morning side lighting brings out the texture of these flowers on the coast of Makapuu Point, Oahu, in Hawaii. Taken in Aperture Priority mode at ISO 200, f/8, 1/1000 second with a 7.6mm lens setting.

4.5 In New Jersey, the strong backlighting in this scene creates a rim of light around the horse and helps to separate it from the background. Taken at ISO 100, f/5.6, 1/100 second with a 21.7mm lens setting.

Understanding and Controlling Exposure

A camera is nothing more than a tool for capturing light. In fact, it is a Latin word that means lightproof chamber. You simply send light into your lightproof chamber to make pictures. You control light by making adjustments to your camera, often referred to as setting the exposure, or make changes to the light by choosing the time of day to shoot, camera angle, background selection, flash use, and so on. As a visual artist, you use light and exposure to control the viewer's experience.

Exposure is the amount of light that strikes your image sensor and is controlled by the exposure settings you have dialed in to your camera. Awareness of your subject's positioning or your camera's positioning will lead you to choose locations where you can easily control light by adding it or subtracting it. I often avoid an overly bright sky by moving my subject into soft shade and adjusting my exposure for the lower intensity of light or adding flash that fills in the new shadows caused by the shade.

Once you decide on the scene and how to handle the light, the last step is to control the amount of light that will enter the camera, pass through the lens, aperture, and shutter, and finally strike your image sensor and make the image. You do this by setting the two most creative controls the camera possesses: aperture and shutter speed.

A third method of controlling light, adjusting the ISO setting, controls how much light the image sensor needs to make a proper exposure. Correct ISO settings can determine how successful you are when shooting subjects like sports or action, close-ups, or landscapes by limiting or expanding the range of aperture and shutter speed settings available for that particular scene.

Using aperture

As the light rays pass into the camera, they travel through an adjustable opening called a diaphragm, or simply, aperture, then the shutter curtain, before striking the image sensor. The pupil in your eye is a type of aperture by opening and closing and controlling the intensity of light that hits your retina. The larger the aperture opening, the more light enters the camera, the smaller the opening, the less light enters. Aperture settings are called f-stops, a number representing a fraction, so a smaller number like f/2 is a wider opening while a larger number like f/16 indicates a smaller opening that lets less light enter the camera. On the PowerShot G11 in Manual mode, you can adjust aperture settings from f/2.8 to f/8 in 1/3-stop increments.

CROSS REF The PowerShot G11 allows you to shoot in full Manual control or Aperture Priority (Av) or Shutter Priority (Tv), along with full Program AE. Certain Scene modes offer priority of one control over other exposure controls. See Chapter 3 for more on special Scene modes.

Each aperture setting has its own strengths and weaknesses and times for choosing one over the other. Aperture settings determine the amount of depth of field in your photographs.

When you stop down your lens from f/2.8 to f/8, you let in less light but you increase your depth-of-field range. When you open up your aperture from f/8 to f/2.8, you allow more light to enter the camera but you make the focus plane shallower and create a more out-of-focus background.

 Always use aperture selection and depth of field to your advantage. To show the most detail, use a high f-number. To soften a busy background like a street scene, use a small f-number.

4.6 Aperture selection controls the amount of depth of field as evidenced by this sculpture shot. A smaller aperture was used, which renders the background more clearly defined. Taken at ISO 100, f/8, 1/15 second with a 15.2mm lens setting.

4.7 Changing the aperture to f/4.5 and refocusing shows the background more out of focus, placing more emphasis on the sculpture. Taken at ISO 100, f/2.8, 1/250 second with a 15.2mm lens setting.

Using shutter speed

You also control exposure by adjusting shutter speed. Once the light clears the aperture, the shutter speed determines how long the shutter is open and thus how much light reaches the sensor. Think about filling a bucket with water. You can turn the hose on full blast and fill it very quickly or you can let the hose drip into it until it's full. Either way, the bucket gets filled. It just takes longer with the drip method. Your shutter is very similar in the way it controls light.

The shutter speed selection also controls how motion is viewed in your photographs. An action shot or sports scene might require a fast shutter speed to freeze the action and make the image look crisp. A cascading stream or waterfall may inspire a slower shutter speed to produce silky effects in the water for that nature calendar look. Either way, the choice of shutter speed determines the look of movement in your images.

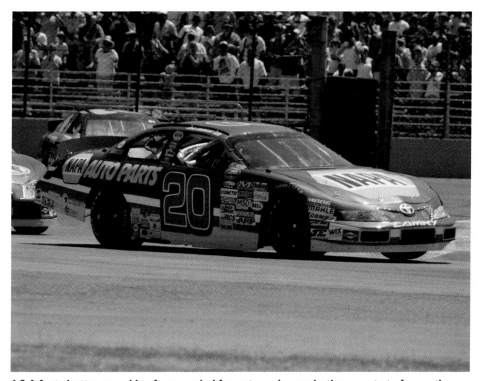

4.8 A fast shutter speed is often needed for auto racing and other sports to freeze the action for a crisp shot. Positioning myself at the slowest curve on the track also improved my rate of sharp images. Taken at ISO 200, f/.6, 1/1000 second with a 30.5mm lens setting.

Using ISO

Now that the light has passed the shutter, it is time to find its home on the image sensor and produce the picture. The CCD sensor inside your PowerShot G11 works by converting the incoming light to a small electrical voltage, which is then sent to the processor for conversion into the 1's and 0's that make up a digital image. Changing the ISO on your camera changes the light-to-voltage ratio.

The term ISO comes from the photographic film days and stands for the International Organization for Standardization. Normally, you would use a film with an ISO rating of 100 for bright and sunny days and a more light-sensitive ISO 400 or above film for shooting in low-light conditions. Each of these films had limitations. 100 speed needed a fair amount of light, which photographers didn't always have, to make a usable image, and ISO 400 pictures would show an obvious increase in grain (referred to as noise in digital images).

Similar to grain, noise is the overamplification of the electrical signal and shows up in the images as tiny bits of extraneous color, especially in areas that were meant to be dark or black. Noise can be used creatively to produce a nostalgic look, but most of the time photographers try to avoid it.

Each of the exposure adjustments will be the most important one in any given photographic situation. The trick is being able to tell which one when the opportunity arises. Keeping the ISO as low as you can to avoid noise, shooting with an appropriate shutter speed to freeze or blur the action, and selecting an aperture for less or more depth of field are all considerations to make before you press the Shutter Release button.

Understanding and Setting the White Balance

Selecting the proper light balance for shooting successful images takes time to learn, but I urge you to play with different settings and presets on the camera for creative effects. This next section, with figures 4.9 through 4.16, details what the same photograph looks like in the various preset white balance settings.

Choosing a preset white balance

You can set the white balance by choosing one of the nine preset options: AWB, Daylight, Cloudy, Tungsten, Fluorescent, Fluorescent H (daylight fluorescent), Flash, Underwater, or by setting a custom white balance preset that is specific to the scene. The G11 also offers you two custom color balance settings for you to create, use, and store until you change them again. White balance options give you a variety of ways to ensure color that accurately reflects the light in the scene.

The next series of images shows the difference in white balance settings from a photo shoot with Canon Speedlites shot in RAW format and processed following the preset's Kelvin rating. Each photo represents a different white balance setting with color temperatures ranging from 2850K to 7500K. The lower the color temperature, the more blue appears in the image. The higher the color temperature, the more red and yellow appear in the image.

> Don't fall into the habit of always relying on the automatic white balance set-
> TIP tings, especially in mixed light or other difficult lighting situations. Try some of
> the white balance presets along with AWB to see which ones you like best for that
> particular scene.

As you can see, white balance affects not only the colors of the image but also the look and feel. AWB is great in a pinch and in many picture-taking situations, but it is only making an approximate estimation in a millisecond's notice. Free yourself from always shooting in automatic white balance and experiment with the different controls and presets.

Setting a custom white balance

Setting a custom white balance is easy on the PowerShot G11, and the camera even allows you to store two different custom settings. You can create and save a custom white balance setting in Program AE, Shutter Priority, Aperture Priority, Manual, Movie, and Quick Shot modes. You cannot save a custom white balance setting in Auto, Low Light, or Special Scenes modes.

4.9 Auto white balance (AWB), 3750K. Taken at ISO 100, f/5.6, 1/100 second with a 21.7mm lens setting.

4.10 Daylight/Flash white balance, 5500K

4.11 Cloudy white balance, 6500K

4.12 Tungsten white balance, 2850K

4.13 Fluorescent white balance, 3800K

4.14 Fluorescent H (daylight fluorescent) white balance, 4000K

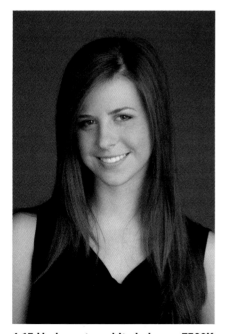

4.15 Underwater white balance, 7500K

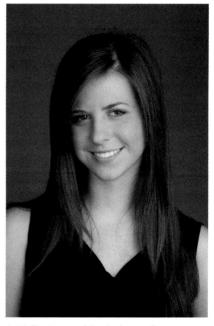

4.16 Custom white balance from a gray card, 5050K

To set a custom white balance on the G11, follow these steps:

1. **Turn your camera on and select Program AE, Shutter Priority, Aperture Priority, Manual, Movie, or Quick Shot mode.**

2. **Press the Function/Set button.** White balance is the first choice on the top left.

3. **Use the left/right areas of the 4-Way Controller to select Custom 1 or Custom 2 from the choices on the bottom of the LCD screen.**

4. **Fill the frame with a white sheet of paper or the gray card from the back of this book.** Be sure to position the target in the same quality and location of light that your subject will be photographed in.

5. **Press the Menu button to take a reading from the target and set the custom white balance.** The LCD image will go black for a second or so then return to live viewing with your custom white balance in place.

6. **Check your scene with this new setting on your camera's LCD.** It should look accurate or neutral. If not, repeat Steps 4 and 5 and make sure no extraneous light from other sources is contaminating the light on your target.

7. **Press the Function/Set button again to store your custom white balance that you can return to anytime, even after using some other white balance preset.**

Setting a white balance shift

The G11 allows you to set an adjustment to any of the presets or custom white balances settings, which is referred to as white balance shift or manually adjusting the white balance.

To set a white balance shift on the G11, follow these steps:

1. **Turn your camera on and select Program AE, Shutter Priority, Aperture Priority, Manual, Movie, or Quick Shot mode.**

2. **Press the Function/Set button.** White balance is the first choice on the top left.

3. **Use the left/right areas of the 4-Way Controller to select any of the presets or Custom 1 or 2 from the choices on the bottom of the LCD screen.**

4. **With the White Balance choice screen active, press the Display button to reveal the White Balance adjustment screen.**

5. **Press the top, bottom, right, or left areas of the 4-Way Controller to adjust the white balance to your liking.** The right and left controls change the amount of Blue or Amber that will be in a scene, while the top and bottom controls adjust the amounts of Green and Magenta.

6. **Press the Menu button to change or reset the white balance to its original setting.** When satisfied with your selections, press the Display button again to confirm your choices and return to shooting.

About My Colors

My Colors is a Canon enhancement that controls the image processing built in to your PowerShot G11. The My Colors modes are activated from the Function menu and permanently alter the way your images are processed and saved. My Colors settings may be just the ticket for you if you prefer to do your image enhancements in-camera rather than using a computer program.

 Remember too that My Colors can also be activated in Playback mode. In Playback mode, changes will apply to a copy of your image, leaving your original file intact.

The My Colors selections boast an array of image enhancements that help you create dazzling images with color that pops. Some settings change the entire look of the image, such as Black & White or Sepia, while others alter the photo in more subtle ways by making only certain colors stand out. My Colors adjustments are available in the Program AE, Shutter Priority, Aperture Priority, Manual, Movie, and Quick Shot modes and cannot be used in the Auto, Low Light, or Scene modes or when shooting RAW images. Following is the list of options available to you in the My Colors settings:

▶ **Vivid.** Boosts contrast and color saturation to make the colors and crispness of your images pop. A good setting to use in flat light or low-contrast situations where colors may be muted.

▶ **Neutral.** Reduces contrast and softly mutes the colors of your scene. Ideal for bright sunny days with lots of contrast or when you want a less intense look to the colors in a scene. Opposite of Vivid.

▶ **Sepia.** Converts your scene to black and white and adds a warm brown tint to the image. Be sure this is what you want because the image cannot be converted back to full color later.

▶ **B/W.** De-saturates your image colors completely and creates a *monotone*, or black-and-white, image. Like Sepia, this setting cannot be reversed once the image has been taken.

▶ **Positive Film.** Mixes the effects of Vivid Red, Vivid Green, and Vivid Blue to create realistic intense colors reminiscent of high saturation slide (positive) films like Fujichrome and Kodak Ecktachrome. If you miss the look of your old slide films when shooting digitally, this may be the setting for you.

▶ **Lighter Skin Tone.** Lightens most skin tones to make them appear brighter, but may have trouble with certain skin types and can also affect other areas of a scene besides skin. Experiment to see the differences for yourself.

▶ **Darker Skin Tone.** Darkens skin tones slightly to produce a normal skin tone look with subjects that have pale or washed-out skin. Can make certain skin tones too dark and may not provide the desired effect; can also affect other areas of the image besides skin.

▶ **Vivid Blue.** Punches up the blues in your photographs. Works great on oceans, skies, and any other blue objects in the photo by adding saturation and intensity to only the blue areas in the image.

▶ **Vivid Green.** Intensifies the green areas in your photograph such as grass, foliage, mountains, and any other green objects included in the frame. Fun to use on landscape photos or forest shots.

▶ **Vivid Red.** Adds depth and saturation to any red objects or areas in your photo such as lips, berries, and fall leaves. Be careful using this one on portraits as it may call attention to any reds in the face, especially the cheek areas.

▶ **Custom Color.** Allows you to adjust the Contrast, Sharpness, Saturation, Red, Green, Blue, and Skin Tone within a limited range to suit your own personal tastes. Effective when you don't feel the presets are doing the job for your scene and you want to take control yourself.

Because this section deals with color, I'll briefly recap two Special Scene modes that also deal directly with color changes — Color Accent and Color Swap — and then describe how to change them and set up your custom colors.

Color Accent

Color Accent mode allows you to shoot pictures with only one hue or range of color, rendering everything else in black and white. This selection is handy when you want to call attention to a certain detail or subject and only want that specific color to remain in the shot.

Useful for interesting images of flowers and foliage, children, celebrations, or those types of scenes that have a dominant object whose color is important to the scene. Color Accent mimics a creative technique used in advertising, movies, and print media to isolate one color in a scene, thereby calling attention to it, and can be very powerful when used to create an emotional response with the viewer. An imperfect color mode, Canon warns that scenes shot in Color Accent mode can sometimes come out garish and contrasty with unintended colors as the final result.

To use Color Accent, follow these steps:

1. **Select Scene Modes (SCN) on the Mode dial.**

2. **Rotate the Control dial until Color Accent appears on the LCD.**

3. **Press the Display button.** The image on the LCD alternates between the original scene and the Color Accent scene.

4. **Aim the center white outline on the LCD at the color you want to accent.**

5. **Press the left area of the 4-Way Controller to sample the color.**

6. **Use the up and down areas of the 4-Way Controller to adjust the sensitivity of the color selection.** A range of +/–5 is available. A +5 setting allows more of the shade of the selected color to be affected by the accent.

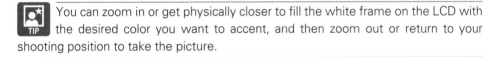 You can zoom in or get physically closer to fill the white frame on the LCD with the desired color you want to accent, and then zoom out or return to your shooting position to take the picture.

Color Swap

Color Swap is another interesting creative shooting mode that allows you to switch any colors of your choosing within the scene with any other color as a target. As with Color Accent, Color Swap offers other limited choices when shooting still images. You can swap colors by going through the simple method described in the next numbered list to switch between the chosen and desired colors using the Display button, right and left arrow buttons, and the Control dial.

In my preliminary tests, Color Swap produces images with a posterized feel to them, including lots of grain and contrast but with pleasantly unexpected results. In the example images that follow, I swapped the yellow of the foliage with a green color of a recycle bin. Notice how the camera substituted green for any of that specific color yellow it determined was in the shot.

4.17 Original afternoon scene of fall leaves shot as a baseline in Landscape mode. Taken at ISO 320, f/4.5, 1/250 second with a 25mm lens setting.

4.18 Selecting only the yellow of the leaves in Color Accent mode renders everything else in black-and-white tones. Taken at ISO 320, f/4.5, 1/250 second with a 25mm lens setting.

4.19 In Color Swap mode, I switched the normal yellow color of the leaves with a hue from a green plastic recycle bin to go back in time when the leaves were green. Taken at ISO 320, f/4.5, 1/250 second with a 25mm lens setting.

To use Color Swap, follow these steps:

1. **Select Scene Modes (SCN) on the Mode dial.**

2. **Rotate the Control dial until Color Swap appears on the LCD.**

3. **Press the Display button.** The image on the LCD alternates between the original scene and the Color Swap scene.

4. **Aim the center white outline on the LCD at the color you want to swap out.**

5. **Press the left area of the 4-Way Controller to sample the color.**

6. **Use the up and down areas of the 4-Way Controller to adjust the sensitivity of the color selection.** A range of +/–5 is available. A +5 setting allows more of the shade of the selected color to be swapped out.

7. **Aim the center white outline on the LCD at the color you want to insert.**

8. **Press the right area of the 4-Way Controller to sample the new color.**

9. **Press the Display button to accept the settings.**

10. **Press the Shutter button to take the picture.**

 Color Accent and Color Swap can only be used in JPEG capture and are not available when shooting RAW images.

Custom Colors

It is easy to set up a Custom Color profile for your G11 camera by following these steps:

1. **Turn the camera on and be sure you're in one of the modes described above.**

2. **Press the Function/Set button, then press the down area of the 4-Way Controller to select My Colors.** Press the right area of the 4-Way Controller to select the Custom Color icon.

3. **Press the Display button to enter the Custom Color selection menu.**

4. **Use the up/down areas of the 4-Way Controller to select the options available in Custom Color and the right/left areas to change their values.** Moving the indicator arrow to the right increases the effects of the control; moving it to the left decreases the effects of the control.

5. **Press the Display button again to accept the changes and return to shooting.**

Using the Onboard Flash

Early in my photography career, I felt that flashes caused just about as many problems as they solved. Even with the latest flash technology, which was auto-thyristor circuitry at the time, my results were less than stellar and often inconsistent. While attending a Dean Collins workshop about light in general, and studio flash in particular, I began to see light in a new way. Photography became less about the gear and more about the light. It was an epiphany, and it made a lasting impression on me.

Taking the time to learn about using flashes to light your photos will also benefit your natural-light outdoor photography. You'll be sensitive to the nuances and quantities of light in a brand-new way, and you'll now be positioning the camera to take advantage of it. You'll literally begin to "see the light."

The flash on your PowerShot G11 comes equipped with features to make flash photography a breeze. Experiment with these settings to find out what works best for your kind of photography. You can access all the onboard flash controls by following these steps:

1. **Turn the camera on and activate the flash by pressing the Flash icon on the 4-Way Controller.** With the Flash selection screen active, press the Menu button.

 The Flash selection screen disappears if you hesitate pressing the Menu button. The regular menu will appear instead.

2. **Press the up/down areas of the 4-Way Controller to select the control function you want to change.**

3. **Once selected, press the right/left areas of the 4-Way Controller to change the values of the functions.**

Flash Exposure Compensation

Similar to the Exposure Compensation dial on the top of the PowerShot G11, Flash Exposure Compensation (FEC) allows you to add or subtract power output from the flash to manually adjust flash exposure to suit your tastes and scenes. This is handy when you don't want the flash to dominate the lighting of a particular scene and only want to add some fill-in flash or catchlights to the eyes.

Shutter sync

Your PowerShot G11 has two moving *curtains* in the shutter mechanism. One curtain of the shutter opens, and the other closes after the correct exposure time. The first curtain opens the shutter and the second curtain closes it. The normal operation of the shutter and flash causes the flash to fire immediately when the first curtain opens. This is called 1st-curtain sync, and it is fine for most general flash applications.

So what's wrong with that?

Let's say your subject is moving and you are tracking the subject using a slow shutter speed to pick up some ambient light. You press the Shutter Release button, the shutter opens, the flash fires, and then the shutter remains open to complete its exposure. When you review the image, you see motion trails out in front of the subject you tracked and it looks like it's moving backward. The proper technique is to get the flash to fire right before the shutter closes, thereby showing the motion trails behind the subject, and this is exactly what 2nd-curtain sync does.

Red-Eye Reduction lamp

When a scene is too dark, the G11's autofocus system cannot see enough detail to work properly. When these situations arise, the Red-Eye Reduction lamp turns on to

do double duty as an AF-assist beam providing enough illumination to the AF area to allow the system to work. This feature can be turned on or off.

Safety FE

Activating Safety FE (Flash Exposure) allows the camera to take control of the shutter speed and the aperture to avoid overexposing the shot. It's called Safety because it only engages if the camera meter senses the overexposure and is only effective during flash photography.

4.20 The Red-Eye Reduction lamp is a powerful LED located above and alongside the lens on the front of the camera. This LED also works as a AF-assist beam and Self-timer warning lamp.

Making Movies with Your PowerShot G11

The Canon PowerShot G11 comes loaded with features and controls to make creating awesome still images a snap, but this powerful little camera can handily produce great movies as well. It is very convenient having a capable tool at your fingertips to capture those special moments when video and sound take center stage.

Those once-in-a-lifetime events, such as birthday parties, vacation happeings, or a child's discovery of something new, all lend themselves to priceless family memories captured forever by your G11 in moving imagery and sound.

This chapter explains the terms, controls, and options you need to be familiar with to create enjoyable video clips and memories at a moment's notice.

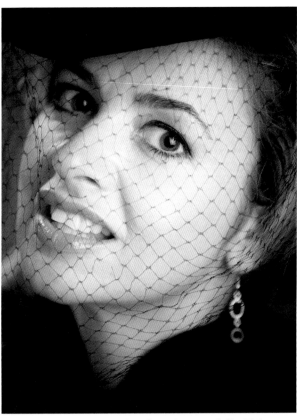

Model Cindy Jack in a shot from her portfolio. Taken at ISO 100, f/3.5, 1/125 second with a 30.5mm lens setting, illuminated with studio lighting and sepia-toned with image-editing software.

Setting Up the G11 to Shoot Movies

Before you begin creating videos with your new PowerShot G11, spend some time getting acclimated to the shooting modes and camera controls you'll most likely use when shooting movies. Familiarity with your equipment and knowing its capabilities go a long way toward your enjoyment and helping you get those cool clips and memories you look forward to capturing with your camera.

Before you press the Shutter Release button and begin recording the greatest video of all time, you have a few important decisions to make. In much the same way you set your camera up to shoot still imagery, you adjust your camera to create the look you want when shooting videos. Capture options abound on the G11 for shooting movies.

▶ **White balance.** Select a white balance preset that closely matches the existing ambient lighting conditions or select Auto White Balance (AWB) and the camera automatically adjusts the white balance as you shoot. This setting is ideal if you have subjects or action that moves into different lighting conditions through the course of the clip. If you know the lighting conditions won't change during the course of your clip, then feel free to select the white balance preset that matches the ambient lighting of the situation. Additionally, all of the My Colors options you have available in shooting stills are offered in Movie mode as well.

 See Chapter 4 for a more detailed description of white balance settings.

▶ **Exposure.** As previously discussed, exposure is made up of a combination of values involving ISO, shutter speed, and aperture. In the PowerShot G11's Movie mode, all these setting are adjusted automatically for you as you shoot. Because the camera shoots video at 30 frames per second (fps), the shutter speed never drops below 1/30 second. No matter what the ISO dial is set to, ISO defaults to Auto and the aperture value is set at the beginning of the recording and is continually adjusted during the recording.

Exposure compensation via the Exposure Compensation dial is not available in Movie mode, but you can adjust the exposure in 1/3-stop increments over a +/–2-stop range by focusing, then pressing the AE Lock button and adjusting the exposure with the Control dial.

▶ **Zoom setting.** While the zooming feature of the lens is available during video shooting, I like to set the framing beforehand and then try to use the zoom judiciously through the course of the clip. The reason for this is that I've found that even small zoom adjustments find their way into the audio portion of the scene and this can be distracting to your viewers. In situations where there is a fair

amount of ambient noise, this is not a concern, but in those quiet scenes of simple observation, the sound of the zoom can be quite apparent.

▶ **Focus.** Attaining proper focus during video shooting is just as important as when shooting stills. For better or worse, objects in your scene will move, sometimes continually. On the PowerShot G11 in Movie mode, the focus is set when the Shutter Release button is pressed halfway down, just as in shooting stills, and that focus remains for the entire video. Try to find an average focus point within your scene that works for the bulk of the action.

Also on the G11, Manual Focus (Safety MF) mode can also be employed for subjects that are difficult to autofocus on. You can also set the G11 to Macro mode or Normal mode, but keep in mind you will be in that mode for the length of the clip.

5.1 Once the camera was set to Movie mode I switched it into Macro mode to capture some close-up footage of my daughter devouring an icy treat. Taken at ISO 100, f/2.8, with a 25mm lens setting.

MOV format

The PowerShot G11generates video files in the QuickTime MOV format, which is an Apple-developed format often used on Web sites for streaming audio or video and is highly popular for its portability and nearly universal appeal. Apple distributes QuickTime Player, allowing Windows and Mac users to view QuickTime multimedia either inside or outside of their Web browsers.

 Although QuickTime Player is free, Apple also sells a professional version that supports full-screen video and other features.

MPEG-4 became an industry-standard method of defining compression of audio and visual data in 2002, when it was agreed upon by the ISO/IEC Moving Picture Experts Group (MPEG). Applications using MPEG-4 include compression of audio/visual (AV) data for streaming Web media, CD distribution, and voice or video telephone and broadcast television transmission. This collection of methods allows for faster upload/download times of large video and audio files and provides more economical storage capabilities.

Keep in mind that not all video editors support 64-bit operating systems. While Final Cut Pro, Premiere Pro, and CS4 do support a 64-bit OS, they can be a little pricey for the average user.

Shooting modes

For expanded creativity, the PowerShot G11 includes some of the same shooting modes for use in video shooting as well. The options include Standard, Color Accent, and Color Swap for creating one-of-a-kind video clips you'll enjoy for years to come. Let's look at the three modes available to you on the G11 that allow you to make video clips that will dazzle your audiences.

Standard

Standard mode is probably where you'll do the bulk of your shooting when creating videos and is the shooting mode with the greatest amount of camera setting options. Standard mode allows all ranges of presets for Auto White Balance including Daylight, Cloudy, Tungsten, Fluorescent, Daylight Fluorescent, Underwater, and two custom user-set white balances.

Standard mode also provides access to all the My Colors options such as Vivid, Neutral, Sepia, Black & White, Positive Film, Lighter Skin Tone, Darker Skin Tone, Vivid Blue, Vivid Green, Vivid Red, and a Custom Color mode where you can tweak the Contrast, Sharpness, color Saturation, Red, Green, and Blue colors or Skin Tone to suit your tastes over a five-increment range.

Standard mode offers the greatest amount of adjustments to tailor your clips just the way you want them. Say you're touring some historical landmark with character actors and you want to create a clip with a nostalgic feel. You can switch to Sepia mode and the look changes dramatically, like the image in Figure 5.2, which was taken from footage from Williamsburg, Virginia.

5.2 Evening Ceremony, Williamsburg, Virginia. We spent two days seeing the sights and living the history of our nation in Williamsburg. On the final evening, I reshot a scene I had taped the night before in color, the Evening Ceremony, a second time in Sepia for a nostalgic look. Taken at ISO 400, f/8, with a 29.4mm lens setting.

Color Accent

The Color Accent mode is a creative shooting mode with limited options. Color Accent mode allows you to shoot videos with only one hue or range of color, rendering everything else in black and white. You can switch to Color Accent mode anytime between clips by turning the Control dial while in Movie mode. This mode is handy when you want to call attention to a certain detail or subject and only want that specific color to remain in the shot.

This mode is useful for interesting footage of flowers and foliage, children, celebrations, or those types of scenes that have a dominant object whose color is important to the scene. Color Accent mimics a creative technique used in advertising, movies, and print media to isolate one color in a scene thereby calling attention to it, and it can be very powerful when used to create an emotional response with the viewer. An imperfect color mode, Canon warns that scenes shot in Color Accent mode can sometimes come out garish and contrasty, with unintended colors as the final result.

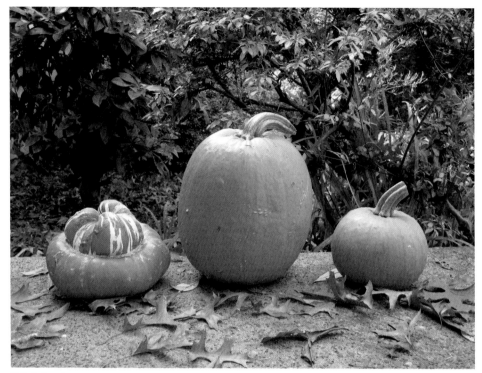

5.3 Color Accent mode can be set before shooting videos to render only one color in a scene, converting everything else to black and white. It's one of those settings that you may not use very often but can be very powerful and have strong emotional appeal. Taken at ISO 80, f/3.2, with a 8.1mm lens setting.

Color Swap

Color Swap is another interesting creative shooting mode that allows you to switch any colors of your choosing within the scene with any other color as a target. As with Color Accent mode, Color Swap mode offers limited choices when shooting still images and movies. You can swap colors by going through the simple method described previously to switch between the chosen and desired colors using the Display button, right and left arrow buttons, and the Control dial.

In my preliminary tests, Color Swap mode produces images and video with a poster-ized feel to them, including lots of grain and contrast but with pleasantly unexpected results. In the example image, I swapped the orange of the center pumpkin with a patch of clear blue sky. Notice how the camera substituted blue for any of that specific color orange it determined was in the shot, as evidenced by the blue tinges on the leaves.

5.4 Color Swap mode can give you surreal color relationships that upend what you think is true. Like Color Accent mode, you may not use it very often but the effects can be very intriguing and entertaining. Taken at ISO 80, f/3.2, with a 8.1mm lens setting.

Sound

When shooting movies, sound is recorded by the on-board microphone located on top of the camera just to the left of the ISO dial. It is the only way to capture sound as no other microphone input jack exists on the PowerShot G11. While this microphone does a good job handling the audio capture in many everyday situations, with its small size and proximity to other camera controls used during shooting movies, it does have its limitations and considerations.

The microphone picks up any camera operational sounds like zooming with the zoom lever or rough handling of the camera, so be sure to start with a comfortable grip or use a tripod to keep extraneous sound to a minimum. As previously discussed, the G11 includes a user-set Wind Filter, which is found in the Shooting menu for use when shooting videos in windy locations, but be aware that this control can also create unnatural sounds when left on when shooting in nonwindy locations.

Image quality

The PowerShot G11 gives you the option of shooting movies in two resolution settings, depending on your intended use. Choose the best setting for your video considering quality and portability and how you want to output it.

- ▶ **640.** This is the largest size for video recorded with the PowerShot G11. At 640 x 480, it is similar in size to standard-definition video and displays well on a regular television set. Although it's usually too large for e-mailing and can be uploaded only on the fastest Internet connections, if you are not sure where it's going to go, start with this size. You'll have recorded the video in the highest quality the G11 can produce and this footage can always be scaled down on a computer for e-mailing or Web usage later on.

- ▶ **320.** The standard size for Internet usage is 320. With dimensions of 320 x 240, it is nearly half the image size of regular video but extends the shooting time almost three times longer. Considering the video's length, this resolution should be reduced for e-mailing purposes, but it's the most common size used for video-sharing sites such as YouTube.

 For comparison of video sizes, standard definition television is usually 720 x 486.

To set the video resolution on the PowerShot G11, make sure the camera is set to Movie mode and follow these steps:

1. **Press the Function/Set button and then the Down button to select the last menu choice, Image Quality.**

2. **Turn the Control dial or press the right arrow to select 640 or 320.**

3. **Press the Function/Set button to confirm your selection.** Once you select the desired resolution, the maximum amount of recording time left on your card appears in the lower right of the LCD monitor.

In either 640 or 320 mode, the PowerShot G11 is set to record video at 30 fps. This speed of frames per second is pleasing to the eye and mimics a film camera's frame-by-frame image capture that gives clarity for high-speed subjects and a cinematic-like appearance. Shooting at 30 fps also provides video with no interlace artifacts.

Maximum file size and runtime

The PowerShot G11 records video up to 4GB per continuous QuickTime clip or a maximum continuous video capture time of 59 minutes and 59 seconds, whichever comes first. Depending on the amount of detail in a scene, an 8GB SD memory card

can record a QuickTime format .mov file approximately 1 hour and 4 minutes long at standard-definition resolution and approximately 4 hours and 16 minutes in low definition. Canon recommends memory cards with at least an SD Speed Class Rating of 4 or higher for smoother transfer of video images.

Because it's always a good idea to replace your memory cards every few years, now might be a great time to upgrade to faster and higher-capacity cards. You can edit and create any length movie you want by using third-party software such as Adobe Premiere Pro or Apple Final Cut Pro and editing sequences together, but it's only the individual continuous clips that are limited to these times.

5.5 Although the PowerShot G11 accepts several different types of memory cards, SD (Secure Data) and SDHC (Secure Digital High Capacity) cards shown here are the most popular.

After you begin shooting a movie, the shooting stops automatically once the file size reaches 4GB or if the runtime exceeds 1 hour. This may seem like a limitation, but in reality, it's not. If you think of your favorite movies, it's extremely rare an uncut scene would run continuously for 12–60 minutes.

SDHC

Digital photographers know memory cards can never be too large or hold too many digital files. That's why they continue to demand faster, higher-capacity media in which to store their digital images and videos. Initially, there was only one type of Secure Digital (SD) card, but now there is another type of media that photographers are raving about: SDHC, which stands for Secure Digital High Capacity. The cards are identical visually in size and shape, and the media slot of the PowerShot G11 accepts and uses both. SDHC cards feature a Class Speed Rating that specifies the card's minimum sustained write speed. There are three classes of cards — Class 2, Class 4, and Class 6 — that represent a minimum sustained write speed of 2MB, 4MB, and 6MB, respectively.

Though it's not an issue with the G11, SDHC cards are not backward-compatible with SD cards, meaning if you have an older digital camera that uses SD cards, the newer SDHC cards may not work in them. The same goes for card readers and internal drives. Once I picked up the 8GB Class 4 SDHC card shown in the previous image, I had to replace my computer's internal 5-in-1 card reader with the current version reader because it could not read the SDHC cards' higher-capacity file structure.

Shooting Movies

Now that you have gone over some of the preliminary setup you need to consider when getting ready to shoot videos, you should be ready to jump in and give it a try. Perhaps you're thinking that you only purchased the camera to take still images. When you see the awesome results you can get shooting movies with the PowerShot G11, you will find yourself in Movie mode more often than you think.

While I believe passionately in the power of a still image whether it be in color, black and white, or anywhere in between, I can't help but be swayed emotionally when viewing moving images mixed with sound and/or music. Take a bunch of fantastic stills, add some appropriate audio and/or music, and the whole feeling and ambiance changes. Camera-wise, shooting video is no more difficult than shooting stills on the PowerShot G11, so let's get to it.

To record a video, follow these steps:

1. **Turn the camera on and set the Mode dial to Movie mode.**
2. **Turn the Control dial to select a Shooting mode.**
3. **If available, press the Function/Set button to select a white balance preset.** If unsure, or if the lighting conditions will change during your clip, select Auto White Balance.
4. **Compose your scene using the Zoom lever to adjust framing.**
5. **Press the Shutter Release button halfway to set focus and initial exposure settings.**
6. **Press the Shutter Release button all the way down to begin recording audio and video.**
7. **Press the Shutter Release button again to stop the recording.**

Composition

Composition skills are just as important when shooting moving images as when shooting stills, perhaps even more so because they may remain on the screen longer. You needn't learn any new techniques for movies that you don't already employ compositionally when shooting single images. Considerations such as clean backgrounds devoid of visual clutter that can steal attention away from your intended subject or scenes, being aware of colors and how they relate to each other on-camera, and keeping the camera steady during shooting can go a long way toward making your videos memorable.

Lastly, as a gentle reminder, don't make the same mistake I did many years ago when I shot my very first video with a digital camera in vertical format. The PowerShot G11 can only play back movies in horizontal format!

TIP If you do happen to shoot a vertical scene, you can rotate the clip during your editing process. You will lose some of the clip if you keep it at full size after rotation, but just resize the clip to fit the screen to see it in its entirety.

Zooming

Zooming during shooting can be a visually stimulating sensation for your audiences, forcing them to get closer to the scene or subject as the action unfolds by editing out extraneous details. Too much of a good thing, however, can leave them feeling drained by excessive camera movement, swings, and zooms.

Consider holding the camera with a very firm but gentle grip when shooting videos and try to avoid any quick, drastic movements in any direction, or better yet, use a tripod with a fluid three-way pan/tilt head for smooth movements of the camera during shooting. Too much zooming in and out can be unsettling to an audience and give the impression you have no idea what is important in your clip. Be deliberate in your framing and compose your scenes just as you would with your favorite still images.

One final note of caution that may not be apparent when you first begin shooting videos: My older brother Kevin had been shooting videos, mostly of his kids, for years before I started shooting digital videos, and his videos always entertained. My initial attempts were less than stellar, and the more I thought about it, the difference was in the audio not in the video. My voice was plainly obvious throughout most of my clips, yet he barely spoke in any of his; he just let the action unfold and didn't try to direct while shooting. In my videos, my voice was so overbearing! As I held the camera, the small on-board microphone was very close to my voice and picked it up over most other ambient sounds. Remember this the next time you're shooting videos, and let the action speak for itself.

Playback

Once you finish recording your movie, you can edit the files in several ways, but the most common methods are to edit in-camera, use the Canon-supplied image-editing software, or use third-party applications like Apple's iMovie or Final Cut Pro, Sony's Vegas Movie Studio 9, or Adobe's Premier Pro.

On the PowerShot G11, you can modify each video clip in the camera by using the Playback function. In-camera editing offers you the choice of saving a copy of the

edited file, which is a good idea, so make sure you have enough room left on the memory card to do so.

To play back the video and make edits to the files, follow these steps:

1. **Make sure the camera is turned on and push the Playback button.**
2. **Turn the Control dial to select the video to play back or edit.**
3. **Press the Function/Set button to display the Movie Player controls.**
4. **Select the Play icon and press the Function/Set button to play the movie.**

Use the previous procedure to play back any movie contained on the card. If you want to edit your movie, continue with the following steps:

5. **Select the Scissors icon (edit) and press the Function/Set button to enter the editing mode.** The Movie Player controls are replaced on the LCD monitor with a timeline and timer count that represent the entire length of your movie.

 - To trim the beginning of your video, select the Scissors icon to the left of the film frame.
 - To trim the end of your video, select the Scissors icon to the right of the film frame.

6. **Use the left and right arrow controls to scroll through your video and find the frame where you want to begin your movie.** Right goes forward, left goes backward. Each press of the control moves one frame. Press and hold the control to jump through the movie 1 second at a time. An orange indicator toward the left of the scale indicates your current position on the timeline. The footage to be trimmed is indicated by dark gray on the timeline.

7. **Select the Play icon to preview your edit.**
8. **If your edit points are acceptable, select the Save icon to save a New File with the edits you've selected.**

Editing on the computer with any of the previously mentioned third-party software is much more involved, but the results are well worth it. They provide the ability to add music, sound effects, or remotely recorded audio to create a totally sensory viewing experience.

My videographer friends and colleagues would be disappointed if I didn't include these important tips before moving on to the next chapter:

▶ **Try to tell a story.** Remember the commercial films you've seen that had a lasting impression on you? They all used story-telling elements in the framing and laying out of scenes. Consider your audience: Will it know what is going on or where the attention should be? Start off shooting a wide shot to establish the scene, then get physically or optically closer to home in on the details.

▶ **Use a tripod for stable shooting.** Whenever possible, use a tripod for your movie shooting. A jumpy, blurry video is just as disconcerting to view as a blurry, crooked still image. Use a tripod or the Self-timer when you can to minimize camera shake and create smoother-flowing video.

▶ **Be frugal with camera movement and zooming.** Remember where the camera's microphone is located and that excessive camera handling will seriously degrade the audio portion of your movie. This will help you make smooth camera movements and transitions. Of course, you have some leeway here depending on the subject matter and emotional response you seek to elicit from your audiences, but smooth video imagery should always be the goal.

▶ **The importance of audio.** Audio is likely one of the most overlooked parts of shooting movies — especially by beginning photographers. I recommend you put some time into learning about it and experimenting. Several videographers mentioned to me the fact that quite often, great audio can carry mediocre video for a compelling show, but it never works the other way around.

No matter how great the scene is, if the audio doesn't create the proper mood or support the visuals, it's going to fall flat. When creating your memorable movies, always consider the importance and quality of sound in your projects.

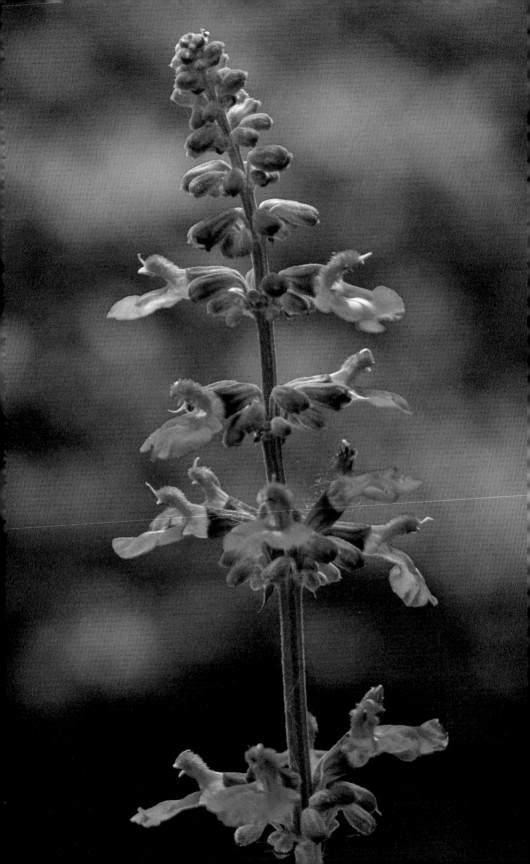

Everyday Picture-taking Situations with Your PowerShot G11

The first five chapters of this book dealt with introducing you to the operational modes of your Canon PowerShot G11, choosing Shooting modes or Scene modes, and getting them set up for different shooting situations.

We've discussed the principals of photography, how to set up your camera to get the most from natural light and flash work, and some ideas for creative use of your digital camera's awesome capabilities.

This final chapter applies those techniques to situations you'll find in the real world. I discuss some of the common problems encountered in several shooting locations and situations, as well as some practical advice for solving them and going beyond the ordinary in your everyday photography.

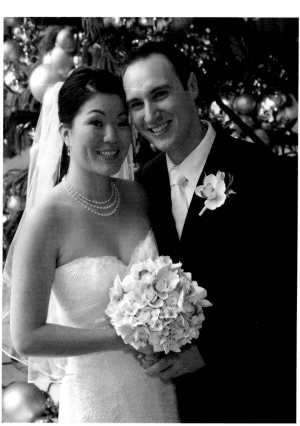

Cydelle and Levi on their wedding day in Honolulu, Hawaii. Taken at ISO 500, f/3.2, 1/640 second with a 15.2mm lens setting.

Action and Sports Photography

Today's active digital shooters are well poised to get fantastic images of a public happening, an epic moment, a memorable performance, or your child's game with the G11. Also, there's the possibility of creating content images for blogs, school Web sites, or a host of other media outlets. Knowing the G11 and what its strengths and weaknesses are is never more necessary than when shooting sports and action photos.

With the added challenge of shooting in somewhat unfamiliar surroundings, sports and event photographers grapple almost constantly with limited access, unflattering lighting, uncooperative venues and subjects, weather, and a host of mechanical problems that the casual shooter may never encounter.

6.1 As night fell, having a powerful flash like the Canon Speedlite along saved the day for this shot of Neil Wolfson, motorcycle racer. Taken at ISO 400, f/3.2, 1/80 second with a 27.2mm lens setting.

On the plus side, the low-light focusing and processing speed of the G11 is faster than its predecessors, and you can position the higher-resolution LCD screen at various angles that allow you to view images faster with stunning clarity. Highly personal satisfaction

awaits the moms, dads, and sports and action photographers who continuously hone their craft — on the sidelines, in the pits, or at the ballpark.

The G11's Sports Scene mode is a great place to start taking action pictures. It gives more importance to shutter speed to ensure you get a sharp shot, and the image stabilization in the lens further aids getting tack-sharp images from the day's events. Faces are very important in action and sports pictures, and you always want to get them as sharp as possible.

You can also utilize a number of other techniques besides the ones in-camera to further decrease motion blur with your moving subjects. A very common camera technique is *panning*. Panning refers to tracking the moving subject with your camera lens as it moves horizontally across your field of view. When done correctly, the subject should be in sharp focus while the motion of the camera blurs the stationary background. This effect is great for showing the illusion of motion in a still photograph. While panning, you can also use a slower shutter speed to exaggerate the effect of the background blur. With panning, it can be a little difficult to nail tack-sharp images, so shoot lots of images. With a little bit of practice, your number of keepers will rise substantially.

6.2 Deciding to practice my technique for images with a moving background, I had no other model but myself. I clamped the camera to the merry-go-round handrail and jumped on the other side, using the self-timer to trigger the camera. Since I was using a slower shutter speed and moving with the camera, the background became a blur. Taken at ISO 100, f/9, 1/200 second with a 6.1mm lens setting.

Flash in Action Photography

Using flash for action/sports photography is often inadvisable. Sometimes you are so far away from the action that your flash won't be effective, or you may be in a situation where flash is not allowed because it's distracting to the participants. In these cases, just make sure you use a fast-enough shutter speed to freeze the motion. Remember to use as fast a shutter speed as you can, depending on your ISO setting. You can also use a wide aperture in Manual or dial up your ISO setting to be sure you get a workable shutter speed.

Preparation and considerations

For many photographers, the need to shoot at fast shutter speeds produces incredible images of moderately paced action successfully. The PowerShot G11 responds quickly to your touch, and AF is adequately fast to capture that shot at the peak of the action.

In addition, when you shoot in Continuous mode, you'll be better positioned to capture the decisive moment of the play over several frames. Top-of-the-line pro cameras are renowned for their faster frames-per-second rates, and the G11 fires approximately 2.4 frames per second, which is still fine for lots of sporting events. By cramming more images into that 1-second time frame, the odds are higher you'll yield far more keepers of the peak action.

For anyone who appreciates fast action, shooting sports can be one of the more exciting and rewarding genres of photography. Sports photography also comes with its own set of challenges that must be met if you are to produce images you'll be proud to share. We have all seen sports photos that make us stop and simply marvel at human achievement, power, or grace. To be able to produce such arresting imagery requires some special considerations to be sure, but also a certain sensitivity for the sport at hand and an ability to think on your feet while working your peripheral vision, too, in order to see it all and capture it.

Preparation is key to being able to capture the shots you want to come away with, images that define the sport, the players, or the moment. Getting close to the action requires access that you'll need to set up beforehand by talking with the coaches, officials, or location staff. A friendly smile can go a long way toward getting you where you need to be. Sports photography is really no different than portraiture in the sense that you want to fill the frame with your subject, which is not an easy task when that subject is engaged in competition or streaking toward the basket, goal, or finish line at top speed.

When deciding what equipment I'm going to bring to a sporting event, my main consideration is mobility — quickly getting to where I need to be to make the shot. You want to able to relocate to the other side of the court, field, or track when the action moves there.

Here are some general suggestions for shooting sports and other events, as well as a look at some of the gear you may want to consider bringing along for more involved events:

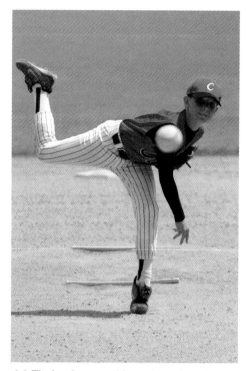

▶ **One or more PowerShot G11s.** The best-case scenario is having two G11s, one zoomed wide and one zoomed to telephoto, depending on the event. For most beginning photographers, that might be impractical, but I would still bring along the point-and-shoot camera that the G11 replaced in case something goes wrong with your primary camera.

▶ **Waterproof case or other camera protection.** A large majority of sports and action photos I make are in outdoor locations, often in uncooperative weather.

6.3 Timing is everything when shooting sports, and fast-breaking action will test your reflexes and the inherent lag before the camera fires when you press the Shutter Release button. Aiming the camera through a link in the chain-link fence, I had to make many exposures before I captured this one with the ball superimposed over the pitcher, my preconceived idea. Taken at ISO 400, f/5.6, 1/3200 second with a 30.5mm lens setting.

That does not stop me from taking pictures of these events. I simply make sure to keep my camera dry and dust free at all times. For certain events, where dust or moisture could be an issue, such as motorsports, beach volleyball, or surfing, be sure to also have lens cleaner, a towel, or cleaning cloths handy.

▶ **Tripod and monopod.** Whether you are shooting stills or video, having a lightweight but sturdy tripod is indispensable, particularly when you shoot in low light. In addition, a versatile ball head with a sturdy quick-release plate allows you to remove the camera quickly to take shots you don't need a tripod for. A monopod is a necessity when shooting sideline sports because tripods are usually not allowed.

▶ **SD/SDHC cards sufficient for the duration.** The number of memory cards that you carry depends on how many images you typically shoot and the length of the shooting session. It is very easy to shoot over 100 photos at my daughter's soccer games, and I don't want to run out of storage space and miss getting shots of the high-five appreciation lineup after the game.

▶ **Spare camera or flash batteries.** Live by the battery, die by the battery. If your battery gives out, you're sunk. For cameras, I usually have one or more charged NB-7L batteries in my gear bag as insurance. Also, if I'm going on an extended trip, I bring along the battery charger for when the batteries become exhausted.

▶ **Personal amenities.** During sporting events, there are often periods of down-time where you'll need to take a break from shooting. Having a snack, drinking a bottle of water, and wearing comfortable clothing and shoes all deserve a men-tion here as ways to stay loose and be ready to shoot at a moment's notice.

▶ **Laptop computer or portable storage device.** Backing up images on-site is an essential part of the workflow, and if you're traveling for an event, you'll want to back up the shoot on a laptop or portable storage device. A laptop is also conve-nient if you upload images to a client server, blog, or Web site and/or print images on-site.

▶ **Plastic sheets or drop cloths.** For outdoor shooting, large plastic sheets come in handy for a variety of unexpected situations, including offering protection from a rain shower or wet grass, protecting camera and lighting equipment, or serving as a diffuser for shooting portraits.

▶ **Universal 5-in-1 tool.** This tool can solve all kinds of unexpected problems, from fixing cameras or flash gear to repairing sports equipment. Don't laugh, it's happened!

As with many types of photography, choosing what will be the background is often my first consideration. For outdoor events, you'll want to avoid shooting angles that show cars in the parking lot, portable toilets, or those orange event cones. Indoors, watch out for illuminated exit signs, trash cans, and vast sections of empty grand-stand. This is not as easy as it sounds when shooting less-than-professional sports. Start at this point and your photography will immediately improve. Try to choose angles where your background "holds" or at least complements your subject in a clean, nonobtrusive way. Shooting at your widest f-stop will aid you in your endeavors, allowing you to also do this as well as affording you the ability to shoot at the fastest possible shutter speed for your chosen ISO.

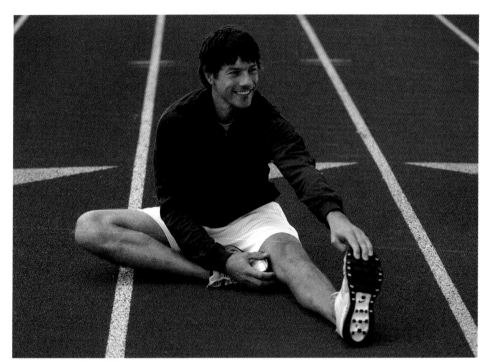

6.4 In many venues, uncluttered or smooth backgrounds are hard to find. I decided to use a camera angle that diminished the background and used the striped track lines to frame my subject, long-distance runner Ian Reschke. Taken at ISO 500, f/2.8, 1/4000 second with a 15.2mm lens setting.

Learning all you can about your particular sport before you begin to shoot can pay huge dividends later. Think about it. If you have a sport you love, you know the intricacies of play and all the nuances of the rules. That special knowledge of the sport will become evident in your photographs. All sports have downtimes and peak moments. Having the skill to predict these times will help keep you sharp and focused on the action, or send you off looking for unique compositions of the gear, players, location, or setting.

Successful sports photography is all about timing and anticipating the action before it happens. There's a saying among sports photographers that "If you saw the play, you missed the shot," meaning that if you saw that split-second action in your viewfinder, you probably missed getting a shot of it.

Getting into the flow of the game helps to anticipate what may happen next. Keeping the camera nearby, ready to shoot, and your other eye open and watching the scene unfold will speed up your reaction time. Because your subjects are often human — and humans are vertical subjects — you should change up your compositions and shoot vertical images of players along with horizontal images of the field or court. You don't want to be a pitcher who only throws fastballs!

6.5 In order to get the least distracting background for these quarter-midget racers, I needed to move up into the bleachers and shoot down on the track near the finish line. After following this side-by-side battle for a few laps, I panned my camera to make this shot. Taken at ISO 400, f/8, 1/800 second with a 30.5mm lens setting.

Action tips and advice

Keep these techniques in mind when shooting sports and action events:

▶ **Know your fundamentals.** There are no retakes, and second chances are rare when shooting many types of sports and action events. Know your equipment thoroughly before you begin to shoot, so you are not messing around with buttons and dials trying to figure out how your camera works on-site instead of concentrating on the action in front of you.

▶ **Do your homework.** Know the key participants, know the rules of the game, know the schedule of events, know if the event is being videotaped and how that affects your ability to move around the field or venue, know if any areas of the location are off-limits, know where the best action might happen, and, of course, have a general idea of the shots you want to make beforehand.

▶ **Shoot both traditional shots and creative variations.** You don't want to take the same photos over and over, so avoid shooting from the same place or with the same zoom setting every time. Moving around the action can provide ideas for more interesting camera angles, backgrounds, or compositions.

▶ **Look for small stories within the larger one.** Many events produce lulls when it seems like nothing is going on. Let your vision wander beyond the sidelines.

These are great times to look for the details of the sport or action you're cover-
ing. Close-ups of the gear, faces, or hands of the competitors, and the outfits or
face-painting of the fans, all make great subjects that tell a smaller story.

▶ **A monopod can be your best friend.** Once you shoot sports or action with a
monopod, you'll be hard pressed to do it any other way. Using the LCD monitor
to frame and compose your shots can strain your neck muscles after a while.
Use the viewfinder or switch to using a monopod to help keep your camera
steady for tack-sharp images, even when panning. They are lightweight and eas-
ily attach to your camera, bag, or backpack. Many small, lightweight monopods
suitable for the G11 can also double as walking sticks.

▶ **Scope out the area to find where the action is.** Getting a great action shot is
being at the right place at the right time. Before you break out your camera and
start shooting, take some time to look around to see what's going on.

▶ **Stay out of the way.** Be sure you're not getting into anybody's way or in the
sight line of the judges. It can be dangerous for you and the participants. Be
aware of the field boundaries and know where you can and cannot go. Be very
careful at track events where discus, shot put, and javelins are all flying through
the air, and because timing equipment may be in use, avoid walking across fin-
ish lines, even during lulls between races.

▶ **Lock in your settings.** Part of the lag time between pressing the Shutter Release
button and the G11 capturing the image is caused by the camera having to set
exposure, white balance, and focus each time you take a shot. Minimize this delay
by avoiding Auto White Balance and locking in exposure and focus when you can.

CROSS REF See Chapter 3 for instructions for setting focus and Auto Exposure Lock.

▶ **Practice your technique.** Action photography requires a skill set that is different
than that of a portrait photographer. Be prepared to shoot a lot of images. After
you get comfortable with the type of event you're shooting, you'll learn to antic-
ipate where the action will be and anticipate the peaks.

▶ **Experiment with different shutter speeds.** Sometimes slowing down the
shutter speed and using the on-board flash can freeze the action and result in
unique, one-of-a-kind images.

▶ **Don't stop shooting.** There are great moments to be captured after the play is
over, and the photographer who keeps looking and shooting will get those shots.
Stay focused on the participants for that emotional response after the play that
can sum up the whole game in one shot. As Yogi Berra used to say, "It ain't over
till it's over!"

Obtaining Permission

When photographing people, it's generally a good idea to ask if they mind if you take their pictures. This is especially true when photographing someone's children other than your own. You should always find a parent or guardian and ask permission before photographing their kids.

Generally, I keep a pad and paper in my camera bag, I ask for a mailing or e-mail address, and I offer to send the family a copy of the photo, either in print form or as an electronic file.

If you're planning to publish your photographs or use them on the Web, it's also mandatory to have secured a photo release, also known as a model release form. Depending on the language on the form, when signed by the person you photographed, this document allows you to use the image for publication and any other legal use that you wish.

If your subject is under the age of 18, you must have the parent or legal guardian sign the release form.

Many sample photo release forms are available on the Internet. Read them carefully or have an attorney do it for you to choose the right one for you.

Concert and Event Photography

Concert and event photography can be an extremely rewarding photographic endeavor, especially if you're a music fan, but it's not without its own set of unique difficulties. If this particular area of photography appeals to you, a good start is attending small concerts or music clubs where local bands perform to perfect your skills. It's here that you can experiment with mixed light sources, slower-than-normal shutter speeds, flash, zooming in, or panning the camera. Providing images you shot of the performers may endear you to the band or entertainers and provide more opportunities or other performance situations to shoot.

Preparation and considerations

As with sports and event shooting, I begin by trying to find a clean background and shooting position where I am not blocking anyone's view. I try to get as close as possible to maximize my G11's zooming range.

For smaller venues, there may be no choice of background, so I try to shoot from both sides of the stage. Performers with guitars present the photographer with a nice triangular composition that looks good when shot in tight.

 Some venues or performers do not allow flash photography at all. In these situations, use the widest aperture you have and try to use the lowest ISO possible while still maintaining a shutter speed that keeps up with the performer.

The biggest challenge I find is establishing a base exposure that still retains detail in the highlights of performers as they move in and out of the strong spotlights on the stage. To this end, I also experiment with white balance settings even though I might be getting good results with AWB. In the past, I've gotten great results with Tungsten and custom white balances, so I alternate among the three as stage lighting changes to establish which is best. A lot of times the stage lighting is warm, and a Tungsten white balance cools things off a bit yet still produces pleasing skin tones.

At concerts, I use the Auto Exposure Lock button, setting the exposure on the hottest highlight area of the performer's body. Alternately, you can use the Spot meter to determine the exposure of the face.

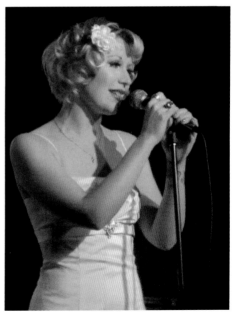

For all indoor events on a stage, I shoot wide open at the lowest ISO that I can set and still get 1/60 second or slower at f/2.8 with my built-in IS lens. With the high ISO range of the PowerShot G11, I'm excited about shooting concerts now at exposure combinations and low noise levels not previously possible.

6.6 Cafes, small clubs, and coffee houses are perfect venues for testing the performance of your PowerShot G11, such as this shot of Tana and the Fascinators performing at Dante's. Taken at ISO 1600, f/4.5, 1/20 second with a 30.5mm lens setting.

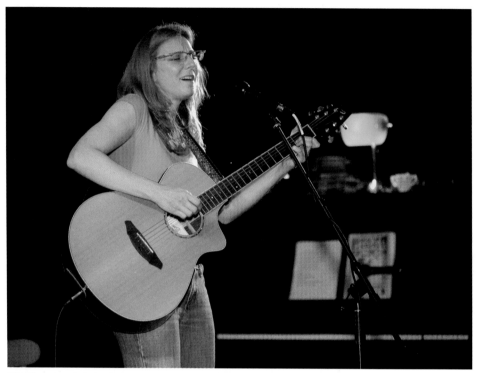

6.7 Changes in stage lighting can produce interesting results when shooting performances. Tungsten white balance combined with colored stage lighting gave surprisingly good results in this shot of singer-songwriter Connie Pazienza. Taken at ISO 1000, f/2.8, 1/125 second with a 21.7mm lens setting.

Concert tips and advice

Depending on the type of show or band you expect to photograph, it's helpful to know the music, story line of the musical, or lighting changes so you're ready to effectively capture definitive images when the lights come up or go down. This is easy if you get to shoot the same show twice or follow the band to another venue the next day, but many times that's not feasible. You are pretty much at the mercy of the lighting or stage designer, but you can learn a lot about lighting for your photography by attending shows. Fog and theatrical smoke may set a mood and look great onstage, but it robs you of contrast if your subject or performers are enveloped in it. Behind them, it looks awesome.

Try looking for angles where the performers are looking good and fit the rectangular frame even if you have to crank the camera sideways. It adds to the dynamic. Musicians move around a lot into good and bad backgrounds, and lighting conditions change constantly. Similar to shooting pictures of kids, shoot a lot of pictures and let go of reviewing images after you check those first few exposures. Keep your eye to

the viewfinder or LCD screen and keep shooting. A memorable image can happen in a fraction of a second.

Another consideration is file size. You may be generating more than 100 images from a single show. I shoot just about everything now in RAW mode. There was a time when I thought RAW meant "really awful workflow," but I converted to RAW shooting once I saw the amount of detail and sharpness I gave up for convenience. Many photographers still prefer to shoot JPEG at events for the faster write speed and workflow that it offers, and this approach makes sense for shooting scenarios when you may be displaying and printing images on-site. In other cases, it makes sense to shoot RAW+JPEG, particularly if you anticipate that you'll want to spend some time editing selected images after the event for a portfolio, Web site, or blog.

 Remember, shooting RAW+JPEG images can really use up storage space on **CAUTION** your memory card rather quickly, so be sure to have plenty of cards on hand for the duration of the event.

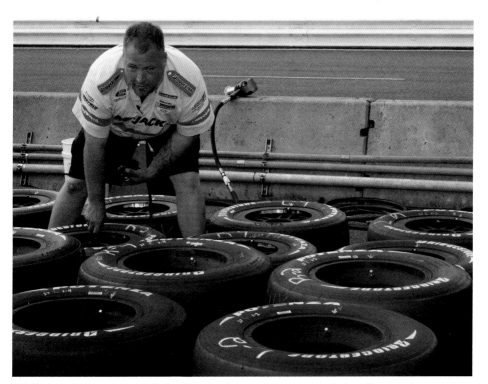

6.8 An IndyCar crewman inflates tires to the proper pressure during the opening ceremonies of a Champ Car race at Portland International Raceway. Taken at ISO 400, f/8, 1/250 second with a 10mm lens setting.

I often prefer to have the latitude that RAW offers in post-processing, particularly in changeable light, such as on a stage or outdoors, as when participants move in and out of bright sunlight to overcast or shaded areas. I know that even if the images are slightly overexposed, I can pull back a minimum of 1 f-stop of highlight detail during RAW image conversion.

Here are some things to consider the next time you plan on shooting a concert or event:

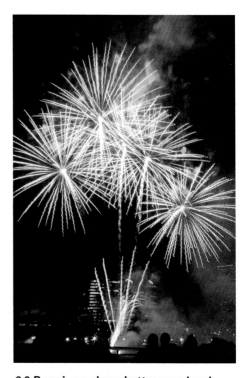

▶ **Experiment.** Don't be afraid to try different settings and long exposures. Long exposures enable you to capture much of the ambient light while freezing the subject with the short bright flash.

▶ **Call the venue before you go.** Be sure to call the venue to ensure that you are allowed to bring your camera in. If it does allow photography, ask about using flash. Today, almost

6.9 By using a slow shutter speed and timing it just right, I was able to capture these "palm trees" during a city fireworks celebration. Fireworks can also provide a one-of-a-kind backdrop for musicians and festival performers. Taken at ISO 400, f/8, 1.6 second with a 6.1mm lens setting.

always it's up to the band. Know what time the concert starts, if there's a warm-up band, intermission for the main act, and so on. Details count, so make sure you have as many details as you can get.

▶ **Put the camera in Manual mode.** Depending upon the intensity of the music being performed, some performers move around more and faster than others. I typically start out with the lens on the G11 wide open at f/2.8 and pick a shutter speed around 1/30 or 1/60. If these shots look good, I may switch to Aperture Priority and keep it on f/2.8 and let the camera pick the shutter speed. Oftentimes, I'm pleasantly surprised by the look of the shots.

Using 2nd-Curtain Sync

Second-curtain sync, also known as Rear-curtain sync, allows the flash to fire at the end of the exposure. When photographing moving subjects, if the flash fires at the beginning of the exposure, the ambient light being recorded causes a blur in front of the subject, which can look unnatural. Using 2nd–curtain sync causes the motion blur to lead up to or follow the subject. Second-curtain sync is most effective when using a long shutter speed and shooting against a dark background.

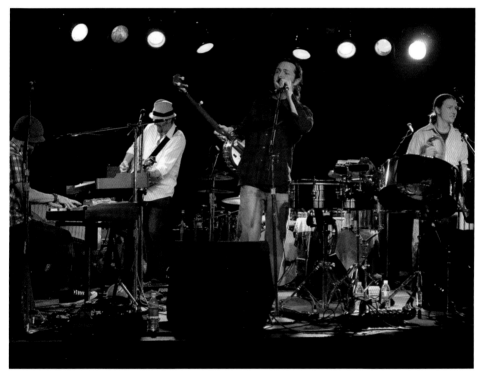

6.10 Some clubs, concert halls, and bands don't allow photography. The ones that do are usually pretty lenient about where you can shoot from. TapWater, shown here, is a band that doesn't care if you take pictures as long as you remember to send them a copy. Taken at ISO 3200, f/3.5, 1/60 second with a 10.8mm lens setting.

Landscape and Travel Photography

Photographers have no greater challenge than leaving their comfort zones behind, rising early in the morning, setting off looking for beautiful light in all its many moods,

and submerging themselves in new surroundings, cultures, and climates in pursuit of meaningful images that tell a story. Such is the life of a landscape, nature, or travel photographer who relishes getting out there and returning with images that shape public opinion, focus the world's attention on an urgent issue, or simply convey the beauty of the land.

People with a creative eye and a passion for travelling gravitate naturally toward landscape, nature, and travel photography. Starting at an early age, many were probably exposed to the *National Geographic* magazine and the beautiful, well-crafted images of foreign cultures and land formations.

At some point in the process, the financial burden of extended travel becomes evident, and so photographers seek ways to share and license their images with agencies, magazines, and book publishers as a way to cover their travel expenses and create careers for themselves.

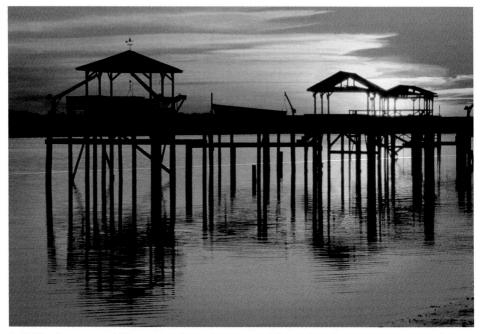

6.11 The Intracoastal Waterway along the coast of North Carolina was the setting for this sunset shot. I purposely dialed in –2 on the Exposure Compensation dial to render these boat docks as silhouettes against the beautiful sky and water. Taken at ISO 100, f/8, 1/30 second with a 10.8mm lens setting.

Preparation and considerations

Landscape and nature photography is one of the best ways to bring many shooting disciplines together to come back with the best images you can. The wide array of subject matter, the unpredictability of what weather you many find, and the simple pleasure of being able to immerse yourself in nature are irresistible lures.

Here's my list of recommendations for packing gear for shooting when airline travel isn't involved:

▶ **One or two PowerShot G11s.** Ideally, you should have a backup camera with you in case anything goes wrong. This is especially important in inclement weather and in locations where the camera is exposed to blowing dust, sand, rain, or heavy moisture — all of which can wreak havoc with cameras. You may, of course, eschew the second body for local shooting. But if you spend any time backpacking, driving, and/or hiking to a location only to experience a problem with your gear, your time and the trip are wasted.

▶ **Weatherproof camera case.** Keeping your PowerShot G11 warm and dry will benefit you in many shooting situations. Moisture and condensation can wreak havoc with your camera's ability to focus or get a clear shot especially when coming inside after skiing, snowboarding, or photographing a swim meet. Keeping the camera warm or in a weatherproof case until it warms up keeps condensation from forming inside the camera.

▶ **Tripod and monopod.** A lightweight but sturdy tripod such as those from Manfrotto, Gitzo, and Cullman are indispensable. In addition, a versatile ball head with a sturdy quick-release plate increases the steadiness and speed of shooting, and is mandatory for long exposures.

▶ **Tele Converter TC-DC58D.** To increase the range of my G11's lens, the TC-DC58D allows me a narrower field of vision that results in a more magnified subject. Just the ticket for images of buffalos or snakes where I don't want to get too close!

▶ **Circular polarizing filter.** Polarizing filters select which light rays enter your camera lens. They can remove unwanted reflections from nonmetallic surfaces such as water or glass, and can also saturate colors, providing better contrast. The separation effect on blue skies and clouds for landscape work can be stunning. The effect can be seen through the viewfinder and changed by rotating the filter. The filter factor varies according to how the filter is rotated and its orientation to the sun. (A circular polarizer reduces the light entering the G11 by approximately −1.3 stops.) Circular polarizers are specifically designed for use with autofocus cameras and usually come with an adapter ring included with the filter to secure the filter to the camera.

Aside from the Canon lens adapter LA-DC58K, which fits both the G10 and the G11, many third-party manufacturers market adapter rings for the PowerShot cameras that accept 58mm and 72mm filters.

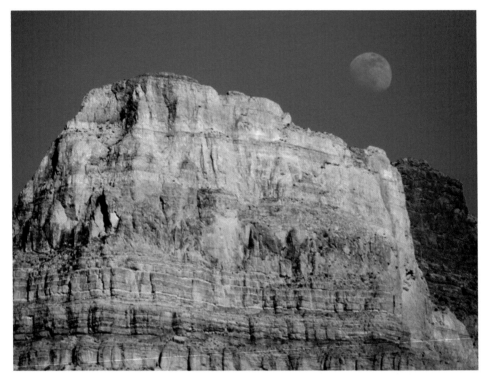

6.12 The benefits of using a polarizing filter are evident in this image of cliffs in the Grand Canyon. The polarizing filter, when rotated properly, yields deep blue skies, reduces reflections from surface glare of foliage, and saturates landscape colors. Taken at ISO 200, f/8, 1/200 second with a 28.3mm lens setting.

▶ **SD/SDHC cards.** The number of memory cards that you carry depends on how many images you typically shoot and the length of the shooting session. I usually carry a variety of SanDisk or Lexar SD or SDHC cards in sizes ranging from 2GB to 8GB.

▶ **Spare camera batteries and battery charger.** Live by the battery, die by the battery, especially in cold weather. The cold reduces the shooting time for the battery, and it's important to have plenty of power available in the form of one or multiple spare, charged, camera batteries. Keep the batteries covered with the supplied cover; there's even a neat little window in the cover to show whether the battery is charged or exhausted.

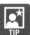 In cold weather, place fresh batteries inside your jacket and near your body to keep them warm.

▶ **Remote Switch RS60-E3.** A good companion tool when using a tripod, the Remote Switch RS60-E3 replicates all functions of the camera's AF/Shutter Release button to ensure vibration-free operation for macro or timed exposure work. Identical to the Shutter Release button on the G11, you press the remote button halfway down to focus, then all the way down to take the picture. The Remote Switch also works with the camera to keep the shutter open for even longer time exposures of up to 15 seconds for subjects such as star trails and nighttime cityscapes.

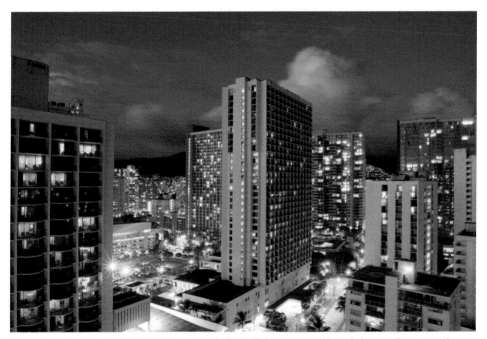

6.13 Time exposures like this 15-second shot of downtown Honolulu require a sturdy tripod and a remote switch to trip the shutter for sharp exposures. Taken at ISO 1000, f/8, 15 seconds with a 6.1mm lens setting.

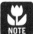 Bulb photos, where the shutter stays open as long as you want it to, are not available with the G11.

▶ **Laptop computer or portable storage device.** Backing up images on-site — either to a laptop or to a handheld hard drive — is an essential part of the work-flow throughout the day. Unless I have to, I won't delete images from the memory cards after loading them onto the computer or handheld device so that I have two copies of the images at all times.

For vacation, travel, and landscape work, some additional items to consider include:

▶ **Cell phone and/or location device.** If you're hiking in mountain areas, check in with the ranger station to see if it has GPS location devices or electronic signal devices you can borrow that will enable rescuers to more easily find you in case of an emergency. Your cell phone may also have a GPS system installed.

▶ **Passport, driver's license, or other identification.** If you're staying in a hotel, be sure to carry the hotel's phone number or business card with you.

▶ **Notebook and pen.** Write down your impressions of the area, especially first impressions that can help you define your creative inspiration of the place and, subsequently, your approach to shooting. You can also add lighting setups (if any), shooting settings, date and time, and so on. A small video clip could also be shot to complement your notes.

6.14 The Astoria/Megler Bridge spanning the great Columbia River, with the camera set to Tungsten white balance to add to the blue, lonely feeling. Taken at ISO 800, f/8, 15 seconds with a 6.1mm lens setting.

▶ **Plastic bags.** These are useful for storing anything and everything in inclement weather and keeping your sensitive electronic gear dry.

▶ **Universal 5-in-1 tool.** This valuable tool can solve all kinds of unexpected problems in the field, from camera repair to fixing clothing or camping gear malfunctions.

Landscape tips and advice

Tips and techniques for nature, landscape, and travel images abound. Here are some of the techniques that you can use when shooting outdoor images:

▶ **Focus one-third of the way into the scene.** This technique approximates *hyper focal focusing*, and although it's not as accurate, it works reasonably well. For sweeping landscapes where there's no obvious center of interest — such as a person, an object, or an animal — focus the lens approximately a third of the way into the scene. The depth of field for distant subjects extends approximately twice as far beyond the point of focus as it does in front. At close-focusing distances, however, the point of focus falls approximately in the center of the depth of field.

6.15 Fannette Island through the trees, Emerald Bay, Lake Tahoe. Stepping back a few feet, I used some foreground pine trees and branches as framing elements around the island. Taken at ISO 100, f/2.8, 1/1000 second with a 15.2mm lens setting.

► **Previsualize the image.** If you're shooting a sunset scene, decide if you want to capture foreground detail or show trees, hills, and buildings as silhouettes. If you want to show foreground detail, meter the foreground directly by excluding the sky and sun from the viewfinder. If you decide to let the foreground go to silhouette, include less foreground in the frame by tilting the camera upward slightly to feature more sky. Or zoom to a telephoto setting to pick out one or two elements to silhouette, such as trees or a building.

► **Research before you go.** Most landscape photographers agree that you can never do too much research on the place you're traveling to. The more you know about an area, what its defining characteristics are, and what areas the locals frequent, the better the chances that you can come away with distinctive images that capture the spirit of the locale.

► **Use side-, back-, or cross-lighting.** Frontal lighting is often chosen by inexperienced photographers but creates images that lack texture and depth because the shadows fall away from the camera and out of view. Instead, shoot so that the sun is on one side of the camera, with light striking the scene at an angle. Sidelighting provides the strongest effect for texture and detail when you are shooting at right angles to the sun.

► **Use Self-timer mode or the remote switch.** For low-light and night scenes, you can use the Self-timer mode or remote switch to ensure that there's no camera shake as a result of pressing the Shutter Release button with your finger.

► **Photographing rainbows.** To capture the strongest color of a rainbow, position the rainbow against a dark background, such as stormy clouds, a hill, or trees. You can underexpose the image by about −1/3 or −1/2 f-stop to increase the intensity of the colors.

6.16 Halloween jack-o'-lantern. Showing some noise due to the maximum ISO setting on the camera affording a higher aperture to retain detail, I used a slow shutter-speed to expose for the candle. Taken at ISO 3200, f/2.8, 1/4 second with a 20.1mm lens setting.

▶ **Include people in travel images.** People define the locale, and the locale defines the people. As a result, it's difficult to capture the spirit of a place without including people in your images. I also make a point of using people in my landscape images to provide a sense of scale to natural land formations. Silhouetting people against a landscape or nature shot can add mood and drama. If you don't speak the language, use hand gestures to ask permission before you photograph people.

▶ **Find new ways to capture iconic landmarks.** Some landmarks, such as the Empire State Building, have been photographed at every angle, with every lens, and in every light possible. Spend some time thinking about how to get a fresh perspective on iconic landmarks to make your images distinctive.

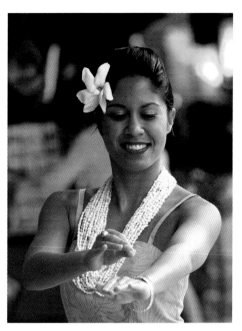

6.17 A hula dancer gave lessons every morning at our hotel. After asking her permission during a break, I made this portrait. Taken at ISO 400, f/3.5, 1/400 second with a 25.0mm lens setting.

▶ **Use a Stitch Assist mode for panoramic images.** For beautiful panoramic photos you can assemble on your computer using the supplied software that comes with the G11, use the Scene mode Stitch Assist to make your original images. This cool mode allows you to see the merge in-camera as you shoot the photos and can merge a total of 26 images for a large-scale panorama.

▶ **Use selective focusing for creative effect.** The opposite of maximum depth of field is choosing to render only a small part of the scene in sharp focus by using limited depth of field. This technique is effective with any lens set to a wide aperture with a close subject as the point of focus while the rest of the scene is thrown well out of focus. The fall-off of sharpness is increased as the focal length increases and the aperture gets wider.

▶ **Use silhouettes as design elements.** Be on the lookout for interesting silhouettes as graphic elements of your photograph. They can be employed when the subject of the silhouette has detail, coloring, or some other feature that would

detract from your composition but has a powerful shape. When creating silhouette images, it's often beneficial to underexpose the image slightly from 1/2 to 1 1/2 stops.

6.18 Returning to camp dog-tired after a long, hot hike in the Utah desert, I noticed these interesting shadows on the desert floor. Taken at ISO 100, f/8, 1/400 second with an 8.2mm lens setting.

Macro and Close-Up Photography

The closer you look, the more there is to see. There is perhaps no area of photography more set up for failure and surprise than macro photography, double that when you add flash. The PowerShot G11 excels at shooting close-up macro images. With a working macro range of just 0.4 to 1.6 feet, the G11 is much more adept at shooting macro than a normal dSLR with a standard lens where the minimum focusing distance is usually around 2 feet. Macro subjects can be anything around you, such as flowers, insects, reptiles, and water droplets. The possibilities are truly endless.

Macro offers you the opportunity to shoot when the light isn't exactly right for nature pictures because your subject matter is so small. While most people think of nature pictures when they think of macro work, I use everyday macro techniques at weddings to shoot the rings, flowers, and other details, and I often photograph circuit boards and product details in my commercial work.

 When shooting macro images with the G11, you can physically get very close to the subject being photographed. Be careful that the lens doesn't touch anything, especially if the subject is wet.

You don't need any other special equipment to take stunning macro shots with your PowerShot G11 like you do with larger dSLRs — it comes ready to go, right out of the box. DSLRs require extension tubes or close-up filters to get you into the close-up range that the G11 handles

6.19 While hiking in the Grand Canyon, I came upon this lizard that was darting in and out of the shade of trees. With a little patience and making slow, stalking movements to get into position and fill the frame, I was able to make this detailed portrait. Taken in Macro mode at ISO 400, f/3.5, 1/100 second with a 13mm lens setting.

with ease. Macro photography can be a great avenue for learning about light and the world around you, but be warned — it can be very habit forming. The more you do it, the more you begin to see macro possibilities everywhere.

While the PowerShot G11 can handle a large variety of macro images all on its own, for most of my macro work I prefer to work with flash, or more specifically the Canon Speedlite system. The G11's on-board flash works well in many shooting scenarios, and I often use it in tandem with external Speedlites as my main or fill light.

6.20 Overhead fluorescent room light was all I needed to make this detailed shot of the wedding rings just before the ceremony. To offer a wide variety of images for my bridal clients, I always provide several macro shots of the details. Taken in Macro mode at ISO 800, f/5.6, 1/100 second with a 15.2mm lens setting.

Canon's ETTL system is surprisingly adept at figuring out which objects are more important and balancing the light output for perfect exposures. Although any of the Speedlites can be used for macro photography, Canon markets two specifically for that reason.

The MR-14EX Ring Lite is a journeyman flash for stunning close-up images of small objects. The lighting is soft and produces no shadows on the subject. This can work to the photographer's advantage, or the subject can look flat and lifeless because the lighting is so even. Dental offices have used the Canon MR-14EX ring lite for years to produce visual records of work done on clients' teeth and gums.

Preparation and considerations

Because macro work is so dependent on small apertures to provide the much-needed depth of field, it is ideally suited for small flash photography. When moving the camera's flash close to a small subject, it in effect becomes a soft light source. Anytime

Photo courtesy Dr. Ryan Mueller

6.21 Macro photography is an everyday occurrence at Dr. Ryan Mueller's dental office. The Canon MR-14EX Ring Lite produces well-lit images of the before and after status of patient's teeth.

the light source is bigger than or as big as the subject, you will have soft light. That is one of the reasons why the design of the G11 and Canon's macro Speedlites is so effective at creating awesome close-up imagery.

6.22 Using the MR-14EX Ring Lite flash on flowers produces stunning color but little depth and some surreal results depending on the camera's proximity to the subject. Taken in Macro mode at ISO 200, f/8, 1/125 second with a 21.7mm lens setting.

Many photographers use a tripod for macro work; this is great in the studio but not always workable in the field. As long as the light is sufficient and there is no wind, a tripod will keep the camera rock solid for sharp images.

However, even a slight breeze will blur certain elements if the shutter speed is way down there to compensate for the smaller f-stop selected. A not-so-obvious work-around for this is to use a handheld small flash. This way you can move around with the flower swaying in the breeze or freeze that insect as it scurries about.

The MT-24EX Macro Twin Lite addresses these concerns in a compact and balanced unit. Two small flash heads connect to a mount ring that attaches directly to the front ring of the PowerShot G11 via the Conversion Lens Adapter LA-DC58K. These flash heads can be positioned, locked in place, turned off, or even removed from the mount ring and repositioned for greater creative control.

The MT-24EX incorporates many of the features of the top-of-the-line Canon flashes such as Flash Exposure Compensation, Flash Exposure Bracketing, high-speed synch, and adjustable output rations between the two flashes by a 3-stop range in 1/2-stop increments.

6.23 A caterpillar sporting cocoons of parasites. A common problem with macro work is the black background produced by the use of smaller apertures and the limited distance range of onboard flash. Taken in Macro mode at ISO 100, f/8, 1/100 second with a 21.7mm lens setting and a 580EX II Speedlite.

6.24 One Speedlite on a flash bracket created soft light for this macro image of as spider. Taken in Macro mode at ISO 400, f/8, 1/125 second with a 21.7mm lens setting.

Both flash heads are fully positionable around the lens ring or can be removed from the ring and placed elsewhere, say to light up the background to keep it from going black, for example. Since macro work requires such small apertures for even limited depth of field that the background will be out of focus by a considerable amount. Point one flash head at the subject and one at the background, and you totally change the feel of the photo. Look around for background elements and colors you can render as soft, out-of-focus shapes to add a sense of place to your image.

6.25 The MT-24EX Macro Twin Lite Speedlite provides soft light for this macro image of a common honeybee. Taken in Macro mode at ISO 2000, f/8, 1/100 second with a 21.6mm lens setting.

If you plan to do a lot of macro work, adding these tools to your close-up kit will give you wide latitude for the macro subjects you can capture. Additionally, you'll need to purchase the Conversion Lens Adapter LA-DC58K, Off-Camera Shoe Cord OC-E3, and Bracket BKT-DC1 which is described in Appendix B in order to properly attach and use this macro flash with the G11.

Macro tips and advice

While it is possible to use a Speedlite for macro photography while mounted on the camera, it's usually not the best way to go about it. The flash of the camera can be very effective depending how close you are to the subject; you may not get even coverage, and the corners of your image may be darker when moving in really close. Also, when shooting extremely close up, the lens may block the light from the flash, resulting in a dark cusp on the bottom of the image.

In order to get the flash off-axis and closer to the subject when shooting insects or other small live creatures, I use an external flash with the ST-E3 cord and handhold it next to the front of the lens. I can now position it where I want it and shoot handheld. You can position the flash near the top of the subject to achieve an overhead studio lighting effect.

In normal shooting modes on the PowerShot G11, it can sometimes be difficult to reduce the depth of field of the background to isolate your macro subject. The G11's Macro mode reduces your focusing range in a snap, allowing you to focus on your compositions and not just trying to get in close.

6.26 When you decide to pursue macro flash photography, you don't leave natural light behind. You need to be ready to shoot at a moment's notice. This praying mantis actually allowed me to pose its arms with a blade of grass to separate them from appearing as one from the camera's point of view. An incredible experience afforded by macro photography. Taken in Macro mode at ISO 100, f/8, 1/100 second with a 13mm lens setting.

Besides using a Speedlite for macro work, these other items find great appeal in the field for close-up photographers:

▶ **Tripod.** Working with a tripod for macro work can be a pure joy, and having a lightweight but sturdy tripod is indispensable, particularly when you shoot in low light. Having the camera securely mounted on a tripod allows a more contemplative approach to your image and gets you out of the run-and-gun mode that other photographic genres require. In addition, a versatile ball head with a sturdy quick-release plate allows you to remove the camera quickly to take other shots that you may not need a tripod for.

▶ **Remote Switch RS60-E3.** Any time you use a tripod for macro work, you should use the Remote Switch to trigger the shutter to get the crispest images possible. Identical to the Shutter Release button on the G11, you press the remote button halfway down to focus, then all the way down to take the picture. The close proximity of the subject to the camera can change with a slight breeze depending on the subject matter, and using the two-step switch on the Remote Switch allows you to refocus quickly and nail the shot.

▶ **Close-up diopter.** If the close-up capabilities of your PowerShot G11 require a little assistance for extreme close-up images, several third-party manufacturers, such as Lensmate, offer close-up diopter kits specifically for your camera. These often come as an assortment of +1, +2, +4, and +10 power diopter filters and require an adapter ring that usually comes with the kits.

In addition to these tools to aid your macro work with the G11, keep these ideas in mind no matter what equipment setup you work with:

▶ **Use the Self-timer in lieu of a Remote Switch.** If you don't have a Remote Switch, use your camera's Self-timer to trip the shutter to avoid any camera shake when depressing the Shutter Release button with your finger. Macro photography magnifies any unintentional camera movement, so do everything you can to keep the camera rock steady.

▶ **Check the composition.** Remember to compose for the entire frame, not just the subject. Macro photography is about more than just getting as close as you can to a subject. Frame the subject, but be aware of any background elements that may be distracting. Press the Shutter Release button halfway to check the focus, and back the camera off the subject if it's having trouble auto-focusing.

6.27 Macro work does not always have to be super close up. Morning light graces this leaf in Portland's Hoyt Arboretum. Taken in Macro mode at ISO 100, f/8, 1/60 second with a 21.5mm lens setting.

▶ **Check the focus.** Macro images may look sharp on the LCD but can ultimately be unsharp when you review them on your computer after download. Review the image and zoom in during playback to check the details. The eyes should be the sharpest part of any macro shot of animate subjects. Use Continuous mode for uncooperative subjects that move around a lot to increase your yield of sharp images.

▶ **Use the adjustable LCD monitor.** Many macro subjects are framed best with the camera at or near ground level. If you are not dressed appropriately to get down on the ground in these situations, place the camera there and use the adjustable LCD to view, frame, and capture your subjects.

▶ **Use body focus technique.** Focus is so critical to macro work that any quick movements by your subject can result in a blurry shot due to lost focus, even when you are using flash. The fastest shutter speed cannot overcome this because the blur is often focus blur, not motion blur. Try using your body to help focus the camera. Check the LCD and focus by moving your body and camera closer or farther away from the subject until sharp focus is achieved.

Portrait Photography

Perhaps no other genre of photography can be quite as personally and spiritually rewarding to the photographer as the art and craft of portrait photography. The ability to create a memorable portrait of a person in a certain time and place can be a very powerful, motivating endeavor. Photographers approach portrait photography for any number of reasons, but the bottom line is almost always about capturing a spirit and vitality

in an image that will stand the test of time and be remembered by loved ones for years to come.

Using the time-honored tools of lighting, posing, and connection with the subject, photographers create lasting images that have the potential to convey these inner feelings.

Here are some basic equiptment recommendations for shooting portraits, mostly the gear you'll want to have available to make the shoot go smoothly:

▶ **PowerShot G11 in Portrait mode.** Most of the features packed into the G11 are designed for pictures of people, and the G11 will probably be used for these images more than any other subject matter. Special features such as Red-eye reduction, Portrait mode, and the various Face Detection modes are all there to make people look good when having

6.28 A cool, windy day did not stop family friend Erin Harroun from posing for some portraits to test drive the new G11's Portrait mode. The Face Detection software locked in on her face and the mode setting selected an aperture that kept the background slightly out of focus. Taken at ISO 500, f/5.6, 1/80 second with a 30.5mm lens setting.

their picture taken. Use the technologies to capture great portraits of your family and friends.

▶ **External Speedlite.** An external secondary Speedlite is a great addition to your kit when shooting portraits because of the flexibility and versatile shooting looks it affords the photographer. Fire the flash by connecting it to the G11's hot shoe or use it wirelessly triggered by a camera-mounted ST-E2 Transmitter. The on-board flash of the G11 is great for times when you are fairly close to your subject but an external Speedlite will help you with the heavy lifting when you are shooting zoomed all the way out or with larger groups.

Zooming your G11 lens out to its telephoto setting is an ideal way to start a shooting session because, depending upon your subject, it keeps you a respectful distance away from the person you're photographing, who may feel uncomfortable with a closer approach. As you begin to build a rapport with your subject and make her feel more comfortable with you and your abilities, she'll loosen up and allow you to move in closer.

▶ **Tripod and monopod.** A lightweight but sturdy tripod is essential. In addition, a versatile ball head with a sturdy quick-release plate increases the steadiness of shooting stills or videos of people.

▶ **Secure Digital (SD/SDHC) cards.** The number of memory cards that you carry depends on how many images you'll typically be shooting and the length of the shooting sessions. I carry a variety of fast Lexar or SanDisk cards in sizes ranging from 2GB to 8GB.

▶ **Silver and gold reflectors.** Collapsible reflectors of various sizes or a piece of foamcore or white cardboard are great for filling shadow areas and adding a sparkle to the eyes when shooting individual portraits.

▶ **Spare camera and flash batteries.** Even with the healthy life of the camera and rechargeable batteries, I still have one or more charged sets in my gear bag as insurance.

▶ **A laptop computer or portable storage device.** Backing up images on-site either to a laptop or to a handheld hard drive is an essential part of the workflow. If you're traveling for an extended vacation, you'll want to back up the shoot on a laptop or portable storage device. The laptop also allows you to review the day's images or provide impromptu slide shows for your subjects.

Additional handy items include brushes, combs, cosmetic blotters, lip gloss, concealer, clothes pins, and safety pins. Particularly for model or senior photo sessions, touch-ups of hair between shots are often necessary. Cosmetic blotters come in handy to reduce the shine from facial oil, and a neutral-tone lip gloss adds shine to the lips while concealer hides blemishes and dark circles under the eyes. It's a lot easier to apply a dab of makeup under each eye than spend time on the dark circle in post-processing, retouching it out.

Outdoor portraits

My first concern with nearly any portrait is what the background is going to be. From there, I build my shot forward to the camera. I create portraits for a wide range of final

uses and am always mindful of what that is before I even take the first frame. For personality shots, I might try to capture a look or mannerisms that friends of theirs would say embodies their spirit and then choose an uncluttered background that complements that feeling. For a business portrait where I may want to imply strength, power, and control, I might opt for starker lighting and a more polished background.

Outdoor lighting presents as many challenges as creating your light from scratch in the studio. At any rate, the lighting must provide beautiful facial illumination and be appropriate for the subject's face, skin tone, and personality. Midday direct sunlight is harsh light to work in and is guaranteed to produce dark shadows under the eyes, nose, and chin.

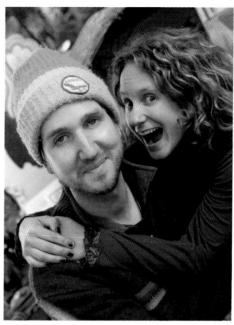

6.29 Overcast light and a small, collapsible reflector set the scene for this casual portrait of husband-and-wife writers Dave and Courtney Jarecki. Taken at ISO 100, f/5, 1/100 second with a 12.4mm lens setting.

I use a 42-inch round diffusion panel to soften the light when I have no alternative but shooting in bright sunlight because of location or scheduling, or I try to find an area where the subject is shaded from above such as by the roof of a building, awning, alleyway, or tree. These locations soften the light on the face and keep the subject from having to squint into the bright sun light. For fill, I'll use a silver reflector to bounce a little edgier light back into the face.

Backlighting is a look I love as the sunlight creates a fine rim of light that encompasses the subject and really separates it from the background. You can position the subject so the sun strikes from behind, throwing faces into shadow, then use a silver or white reflector to bounce soft light back up into the subject's face at the angle that's most pleasing. For softer light in this situation, I use a white reflector or piece of foamcore, which softens shadows and reduces contrast. If this isn't enough to balance my backlighting, I add a small amount of on- or off-camera flash.

6.30 Backlighting your portrait subject is a great technique to separate her from the background and create a pleasing rim of light around clothing and hair. Special care must be taken that you are not shooting directly into the sun and that the face does not expose too dark. Taken at ISO 1250, f/2.8, 1/30 second with a 7.6mm lens setting.

Group portraits

Part cheerleader, part showman, and part herder are all skill sets called upon by the successful group photographer. Group photography can mean taking pictures of couples, families, or entire companies. With more subjects to arrange comes more responsibility to make everyone look good. Added to that is the challenge of getting everyone's attention, balancing the pose, and shooting quickly. Nobody likes to stand around for a group photo while the photographer messes around with the gear.

When setting up for groups, it's advisable to show up early, look for a good background, and shoot some tests before anyone arrives so you'll be ready to go when they do. It's a good idea to be really clear on where the pictures are supposed to be taken and make sure you have permission to be at the location. I can't tell you the number of times I have been all set up to shoot a team portrait and sprinklers came on automatically, soaking everything, or a few ball teams showed up at the last minute demanding to use the field for their scheduled game. Plan ahead.

Geometric patterns, such as a diamond or triangular shape, work well when shooting a few people, but after that it's a challenge to be creative with lots of bodies in the picture. Depending on the end result for the photo's use, I have staged pyramids of cheerleaders, pig piles of soccer and volleyball players, and goofy shots of softball and basketball teams after the standard vanilla pictures were taken, to the great delight of the participants.

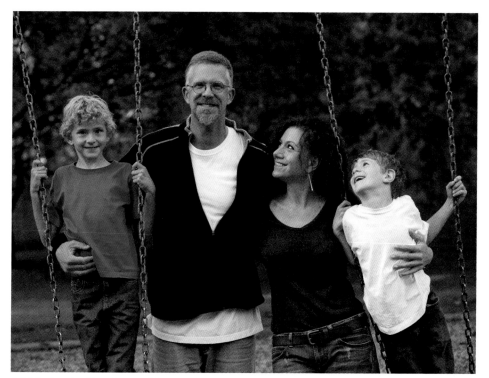

6.31 A simple direction — "Look at Dad" — prompted the warm expressions in this family portrait. Taken at ISO 400, f/5.6, 1/200 second with a 26.1mm lens setting.

As I'm staging the shot, I try to have the most important person relating to the intent of the group, front and center in the first row, whether it's grandparents on their anniversary day, a child on his birthday, or a CEO at the year-end board meeting. I then attempt to position the others so they fall into *windows*, the cavity of space between two people standing shoulder to shoulder. This creates a pattern much like musical notes on a scale, giving each person some space around his or her face, and makes the eye dance around the image rather than zipping down a row of faces.

My intent in a group portrait is to make everyone an individual and appear that way in the picture.

Night portraits

Once the sun goes down, you don't have to put your PowerShot away and quit shooting. The evening palette of colors constantly changes, and as city lights come on, many different light sources come into play affecting the color balance. Urban street

scenes and especially neon make great backgrounds for nighttime portraits rich with out-of-focus lights and colors.

When photographing portraits at night, remember that while the camera's on-board flash is used to illuminate your subject, it will not have enough oomph to illuminate the background. In order to get enough light to raise the background value, you may need to use a slower shutter speed than normal or switch to Low Light mode on the Mode dial, Slow Synchro flash mode, or use the Scene modes, Indoor and Night Portrait.

These PowerShot G11 modes produce natural-looking pictures by slowing down the shutter speed to pick up more ambient light and adding flash to illuminate the subject. The G11 has a maximum flash sync speed of 1/2000 second (which is incredible if you think about it) to prevent blowing out faces when your subjects are close to

6.32 For a more professional look to your nighttime portraits, use Low Light or any one of the special flash or Scene modes when shooting after hours. Or you can take it a step further and switch to an external Speedlite and wireless transmitter to fire the flash. Taken at ISO 1600, f/2.8, 1/60 second with a 19.6mm lens setting.

the camera. As you can see, the G11 takes nighttime photography seriously and is loaded with features to make beautiful evening portraits.

When using any of these modes to shoot night portraits, using a tripod is a good idea. Look around for a railing, sign post, or some other structure to steady the camera or just make sure to hold the G11 securely. The flash from your G11 has a short duration of around 1/1000 second, which effectively becomes the shutter speed for your subject. The background, which is probably soft anyway due to a larger aperture being used, won't suffer terribly from any motion blur.

For a higher-quality look to nighttime portraits, I deactivate my on-camera flash and switch to using an external Speedlite and illuminate my subject from an angle that produces highlights and shadows that translate into depth in the photo. This way, I either use the Speedlite bracket to attach the flash to the camera or trigger the Speedlite wirelessly by mounting the ST-E2 transmitter on the G11.

6.33 The speed at which the PowerShot G11 can capture great night portraits is simply amazing. Jim McCord listens to after-dinner conversation in this low-light image. Taken at ISO 400, f/3.5, 1/60 second with a 9.4mm lens setting.

Portrait tips and advice

Here are some of the techniques that I've found most useful in shooting successful individual and group portrait images:

▶ **Focus on the eyes.** They say the eyes are the windows to the soul, but if not, they sure are the most dramatic feature in portraits. With any animate subjects, as long as the eyes are in focus, the photo registers as a sharp photo. Using a shallow f-stop and focusing on the eyes causes what's in front and behind the eyes to go slightly soft focus, which can be a great thing when you want to diminish skin texture in elders, kids, or babies.

▶ **Maintain proportions for kid shots.** Keeping with the eye thing, compose shots of kids from their eye level, which means you have to get down there on the ground to shoot. This keeps their heads in perspective and places them in their environment the way they see themselves. This is true with nearly every

pet or critter or any living thing. If you get down to their view of the world, your images will become more realistic and resonate so much more.

▶ **Pose groups of people as you'd arrange music.** In this easy-to-remember analogy, you begin by placing the first person and then the next with an eye toward creating a pleasing blend of shapes and sizes within the frame. Create a natural flow from person to person in the group, as if the viewer is following a visual map. Use hands and arms to connect subjects, and use classic shapes, such as the S-curve and triangle. Remember your hyper focal principles, and focus 1/3 into the group with a smaller aperture than you'd use for individuals. Try to keep the subjects as close to the same plane as possible — perpendicular to the lens axis — to maintain the greatest sharpness.

▶ **Use contrast for composition strength.** The viewer's eye is always drawn to areas of greater contrast — a light subject against a dark field and vice versa. In addition, the sense of sharpness of a photograph is increased by the skillful use of contrast. In other words, place the subject against a complementary background tone with good separation.

▶ **Engage with the subject(s).** A primary means of human communication is with the eyes. If you're buried behind the camera, you run the risk of losing the connection with the subject. I get the shot set up, sometimes employ a tripod, and then step from behind the camera to show the subject what I have in mind or just to chat a bit to help the subject loosen up and become more comfortable. Most people are a little nervous under the big studio lights, so you need to be aware and sensitive to this and do all you can to get natural looks from your subjects.

▶ **Remember that kids rule.** The wise photographer works with the mood, energy, and flow of young subjects rather than against them. Children can often have short attention spans. Work quickly but be flexible and engage them in the picture-taking process. They are naturally curious about our adult stuff, and I'm sure my PowerShot G11 must look incredibly desirable to them. Use it as a learning opportunity to your advantage.

▶ **In group shots, position the children last.** As mentioned before, many kids have short attention spans, especially around large family groups where there's lots of activity. I save the kids for last and usually have them in the front, because anything closer to the camera appears larger, and anything farther away appears smaller, and this technique spatially balances them with adults.

▶ **Show instead of tell.** Directing people how to pose is hard work. Instead of describing what you want them to do, move to their position and assume the pose or position that you want them to mimic. Portraits are best when the effort becomes a two-way street, so as you demonstrate, talk about your ideas for the session and also ask for the subjects' ideas as well. Be supportive. Smile. Listen.

Wedding Photography

Wedding photography has seen a dramatic shift in styles, techniques, and creative challenges in recent years, resulting in a large number of photographers who are entering the field, lured to the field by relative ease and workflow benefits that a digital capture camera can provide. The wedding day itself presents photographers with a huge array of lighting conditions, locations, and subjects and can also be a good test for their equipment and personal temperament.

Today's brides and grooms are also savvier clients because they're aware of popular trends and looks, having grown up with more music, video, and media influences than their parents could have ever dreamed. As such, they are better-educated clients who require a photographer who can produce the images they desire on their special day. A person with a creative eye and superior people skills couldn't find a more satisfying career than that of a wedding photographer.

Preparation and considerations

Wedding clients spend a lot of time looking for just the right person to capture the special moments of their day, and they expect a photographer who's knowledgeable about all the latest trends and styles and who's competent to produce images that render both your clients and the newest fashions creatively. That's why many wedding photographers I know keep up with the latest news by attending seminars, joining online forums and associations, and reading bridal magazines. There's a vast array of educational sources and inspirations out there, and the field has grown to produce celebrity icons that travel the country to conduct seminars and workshops in the art and marketing of digital wedding photography.

Wedding tips and advice

When wedding photographers get together, stories are told about cameras that stop working for no apparent reason, cameras that freeze up, autofocus that won't work, cameras being dropped, tripod legs that stick fast, and flashes that just won't fire. The only way around these dilemmas is to have backups of everything. Although this may be impossible when you're just starting out, the option to rent has vast appeal. The ability to try out equipment with possibly rent-to-own arrangements can be an invaluable way to gain experience with new gear and build up your photographic arsenal.

When I am invited to a wedding instead of being hired to shoot one, I don't leave my cameras at home but am very respectful to stay out of the hired gun's way. It's his show when the formals are being taken and he needs to make a lot of images in a very short amount of time. I often make acquaintances with other wedding photographers and ask if I may shoot pictures when they do, and they almost invariably say yes.

Because I'd rather not be messing around with my G11's buttons, dials, and menus and possibly missing a key shot, I set my camera up beforehand, taking into consideration white balance, exposure, and mode settings. If I am using more than one camera, I make sure to synchronize the cameras' internal clocks before I start shooting. This way, it makes the chronological sorting of images in my image browser later on that much easier.

6.34 Grand locations, such as Oregon's Multnomah Falls Bridge shown here, make for fantastic memorable wedding photos, which the PowerShot G11 handles flawlessly. Taken at ISO 500, f/4, 1/320 second with a 15.2mm lens setting.

What you decide to pack in your gear bag and how many cameras you bring depend on many factors, including the location and duration of the wedding, how well you know the couple, and your budget. Here are my minimum recommendations for shooting a candid wedding:

▶ **Set two Creative modes.** The Creative modes on the G11, C1 and C2 on the Mode dial, are great for setting up your camera ahead of time for the shooting needs of different situations such as an outdoor wedding and an indoor reception. This way, you can easily switch between two entirely different camera setups and not have to delve into the extensive menu system at all.

▶ **Focus on the details.** With so much going on during a wedding day, it's easy to get overwhelmed by it all and miss the details that have such great story-telling potential. Hands, rings, flowers, expressions, kisses, and hugs are all on my list of things to watch out for that make great photos happen.

▶ **Tripod and monopod.** Have both a tripod and monopod with the same quick-release plates. A tripod with a three-way pan head will allow you to shoot photographs in low light, and a monopod is invaluable as a secondary flash or remote camera grip, often referred to as a *stick*. I use this with a ball head and zoom out for one-of-a-kind aerial shots of the ceremony and dancing.

▶ **Flash units and brackets.** I typically bring an external Speedlite like the EX580 II and plenty of spare AA rechargeable batteries. A better solution would be to use the Compact Battery Pack CP-E4, which shortens flash recycle times and provides more firings before batteries need to be replaced. The flash bracket allows you to get the flash unit off the axis of the camera lens and gives you more flexibility and dramatic lighting options. Using a flash bracket allows the flash to stay above the lens for both horizontal and vertical shooting.

6.35 A wedding day is alive with rich, vivid details that allow you to practice your macro shots, at which the G11 excels, like this image of the cake topper.

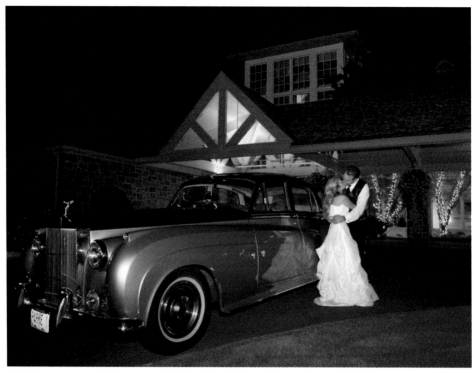

6.36 In our pre-wedding consultation, the bride told me about this Rolls Royce that would whisk them away to the airport for their honeymoon, so I knew this photograph would be an important storytelling image. Taken at ISO 1600, f/5.6, 1/6 second with a 6.1mm lens setting.

▶ **Memory cards sufficient for the duration.** The number of SD/SDHC cards that you carry depends on how many images you typically shoot and the length of the wedding. I usually carry a variety of cards in sizes ranging from 2GB to 8GB, and I transfer full cards to another pouch in my bag to safely store them until later review.

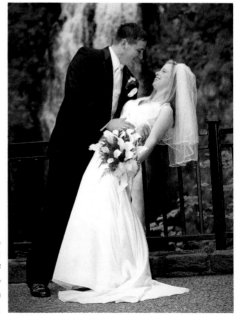

6.37 Slow Synchro flash, moving the camera, and an external Speedlite all combine to make this dynamic shot of Christina and Bill having fun at their wedding. Taken at ISO 1600, f/5.6, 1/20 second with a 7.2mm lens setting.

▶ **A laptop computer or portable storage device.** Backing up images on-site, either to a laptop or to a handheld storage drive, is a great idea. Unless I have to, I don't erase images off the memory cards after loading them onto the computer or handheld device until I get home and burn a disc so that I have two copies of the images at all times. If you plan to do on-site slide shows, which are always a hit, the laptop is necessary.

Wildlife and Pet Photography

Wildlife and pet photography can be an immensely pleasurable and satisfying pastime for those photographers who possess a love for nature and the many species that roam this earth. Nothing beats the thrill of finding animals in their natural habitat or in a picturesque setting and nailing the shot.

For many of us, our first foray into wildlife photography may be taking pictures of our pets: The family dog, cat, or goldfish all make great subjects. A photo of your pet already has an emotional response built in because you love and care for it. Is there anything that tugs on your heart more than a photo of your child or pet? When we begin to look for images where there is more going on in the frame, perhaps some sort of behavior or ritual that we never noticed before, memorable image ideas can be revealed.

6.38 At a friend's house on the Columbia Gorge, I stopped to take a few photos of her horse with the Columbia river in the background. Taken at ISO 100, f/4, 1/160 second with a 17.4mm lens setting.

Preparation and considerations

Photographing your pet is a great way to get started in the realm of animal photography. Your little friend already is comfortable with you and you are both able to read each other's moods. Engage your pet or have someone else do it as you start noticing backgrounds that will work for portraits. Have treats and snacks available and always reward good behavior.

If you have a photo trip or vacation coming up where there stands a good chance of seeing some major wildlife, I always recommend a trip to a zoo or wildlife reserve to hone your skills and get you in the mental zone of photographing animals. Zoos are a great resource for practicing your wildlife photography skills and to make decisions on exposure and white balance, to check on an animal's reaction to flash, and also to practice other skills that may need to be addressed before you take a big trip.

6.39 A couple of alligators cool off on a hot day in North Carolina. Taken at ISO 800, f/8, 1/60 second with a 25.4mm lens setting.

A trip to the zoo will clue you in to how your camera technique is working for this particular genre of photography. Shooting in Continuous mode improves the chances of getting a great shot of some animal behavior or activity that will result in a lot more keepers when a real situation arises.

Depending on the size and nature of the game you will be photographing, you have the option to dress in camouflage, sit quietly in a blind or tree stand, or rig up remote cameras that are triggered by motion or sound detectors.

6.40 A little onboard fill flash really pops the colors of this peacock at the Oregon Zoo. Taken at ISO 100, f/8, 1/100 second with a 30.5mm lens setting.

Wildlife tips and advice

Much of the same gear I use for travel and landscape photography goes with me on wildlife shoots or shooting pet portraits for friends. Keep these ideas in mind the next time you're stalking big game — photographically, of course!

▶ **Zoom your lens.** Whenever possible, zoom out to the telephoto setting. This allows you to remain inconspicuous to the animal, enabling you to catch it acting naturally.

▶ **Tripod and monopod.** Having a lightweight but sturdy tripod such as those from Manfrotto, Gitzo, and Cullman is indispensable. In addition, a versatile ball head with a sturdy quick-release plate increases the steadiness and speed of shooting.

▶ **Polarizer and neutral density filters.** A circular polarizer can enhance the saturation and color of certain types of skins and fur as well as reduce reflections on reflective surfaces. Circular polarizers are specifically designed for use with autofocus cameras and usually come with an adapter ring included with the filter to secure the filter to the camera.

▶ **Remote Switch RS60-E3.** A good companion tool when using a tripod, the Remote Switch RS60-E3 replicates all function of the camera's AF/Shutter Release button to ensure vibration-free operation for macro or timed exposure work. Identical to the Shutter Release button on the G11, you press the remote button halfway down to focus, then all the way down to take the picture. The Remote Switch is great when shooting animals because often you want to be aware of your surroundings shooting wildlife and make eye contact with your pets to get their best expressions when photographing them.

▶ **Sound-maker or whistle specific to the animal.** Lots of outdoor stores have bird whistles or sound-makers that attract a wide variety of wildlife. Use sparingly to attract them, and then put them away so as not to confuse your subject into thinking there is food or a mate close by.

▶ **Be careful.** Know the behavior patterns of the animals you're photographing and always be aware of their proximity to you. Even domesticated animals like horses and dogs can be intimidating if they do not know you. Keep your peripheral vision on alert and never get into situations without an escape plan.

6.41 Shoebill posing at the Philadelphia Zoo. This fellow was being ignored by the zoo guests, which allowed me plenty of compositional options by being able to move around and not bump into anyone. Once I set up my tripod, we soon drew a crowd that wanted to see what was going on! Taken at ISO 100, f/5.6, 1/15 second with a 30.5mm lens setting.

Rules of Composition

By this time, I sincerely hope you have learned a little about photography in general and your Canon PowerShot G11 in particular. Ideally, you have now learned how to begin photographing your subjects and scenes in new and more visually interesting ways. You can now turn your attention to the rules of composition. Granted, *rules* is a pretty strong word for creative types to mess with, so I prefer to think of them simply as visual guidelines for more well-constructed images.

At first, these concepts might seem strange and uncomfortable, like holding your camera a different way or composing scenes through a new lens, and you may struggle a bit with applying these rules to your kind of photography. Just know that these are the foundations your best shots are built upon, and a working knowledge of them is essential to creating more dynamic, compelling images.

I consider these concepts as tools and techniques I turn to when a situation or location is not working or has been exhausted photographically. Mentally going through the list of ideas presented here can often yield new ways of looking at things such as camera angles, lens choices, and the like.

Keep It Simple

Keeping your compositions simple is probably the easiest yet most important rule in creating powerful, memorable images. In today's image-rich world, you have a very limited time to gain your viewer's attention.

We are bombarded by images more and more every day for myriad reasons: to sell us products, relate current events, and share family milestones. Eventually, image overload can set in. You want your images to be clear and on point. Keeping your compositions simple can go a long way toward this goal.

Ideally, your subject should be immediately recognizable to your audience. When considering a subject to photograph, I rarely come upon a scene wholly formed. This is why photographers make such a distinction, which may seem semantic or petty, between *taking* a photograph and *making* a photograph. It takes careful consideration of all the elements to make a truly memorable image.

AA.1 At a balloon festival in Quechee Gorge, Vermont, I was initially attracted to the shape and sound of these propane jets but realized the background was lacking any visual interest. I began to search for a better background. Taken at ISO 100, f/5.6, 1/320 second with a 28.3mm lens setting.

Once you realize what your subject is, the next task is to locate a background that holds or complements that subject. This often involves walking around the subject if possible and observing what happens to the background as you move. Suddenly, new ideas form, and you may feel like you are looking at a totally different picture than the one you first imagined. Famed photographer Edward Weston once remarked, "My own eyes are no more than scouts on a preliminary mission, for the camera's eye may entirely change my idea."

To create better photographs, it's helpful to learn to see the world and the events before us as our camera does. When conducting classes in the film days, my students would often complain that the cost of film and processing was preventing them from shooting more. When I suggested they just go out and shoot without film, they'd look at me like I was crazy. My intent was that they just spend more time seeing through the camera, looking at subjects they liked, and learning the visual language and interpretations of their lenses.

AA.2 As I considered improving my background, I noticed another balloon inflated and ready to go aloft, and knew I'd found a great option. Peripheral vision is a great thing! Taken at ISO 100, f/5.6, 1/250 second with a 28.3mm lens setting.

That disconnect between what the photographer sees on the spot and the final photograph is where many photographers stumble. Learning to see as our cameras and lenses do can go a long way to improving our photography. Spend the time with your camera to learn the way it sees the world; once you do, you'll be rewarded with spectacular, compelling imagery.

Try to come up with a background that has a different color or texture than your subject does so as not to camouflage the subject by blending in. Having a brighter toned subject against a darker background, or vice versa, is another way to make your subject command more attention. A simple background allows the eye to linger on the photographer's subject and provides the time to make an emotional connection with the viewer.

Composition

Composition is the plan, placement, or arrangement of the elements in a photograph to produce the photographer's desired effect. The general goal is to select and place the appropriate elements within the scene in order to communicate your ideas and feelings with the viewer on an emotional level to produce a desired response.

The photographer determines what the points of focus of the image will be and composes the image accordingly. The eyes of the viewer then tend to linger over these points of focus. The photograph can now be arranged in a harmonious whole that works together to produce a statement, and several camera techniques can be utilized to achieve this ideal.

Silhouettes

Whether conscious of them or not, many people respond emotionally to silhouettes in photographs. An implied empty shape that only delivers minimal information about that shape adds mystery and often stark contrast to the background. The basic approach is to find a really dynamic background and then underexpose the shot by 1 to 2 f-stops or shutter speeds. The following two examples I encountered describe how silhouettes can add visual power and punch to your images.

AA.3 Backlighting on these buds really make them stand out from the background. Underexposing by 2/3 stop also removes detail and helps unify the background.Taken at ISO 100, f/4, 1/320 second with a 30.5mm lens setting.

Shooting photos of dragonflies in the Grand Canyon recently, I found a dragonfly that was attracted to a certain branch. I was shooting with my Speedlite quickly, and eventually my flash started taking longer to recycle. A few of the frames were shot when the flash didn't fire, and this produced the silhouette shot in Figure AA.4.

AA.4 In this scene, backlighting helps yield the rich, saturated colors and added contrast obtained when underexposing. Select –2 on the Exposure compensation dial to create a silhouette. Taken at ISO 80, f/7, 1/320 second with a 5.8mm lens setting.

I often employ silhouettes when I have a great background but my subject has too much detail that detracts from the scene or contains information I don't want in my scene. Such was the case photographing these boys in Trenton, New Jersey, enjoying an open fire hydrant on a hot day.

Silhouettes can be a powerful, graphic way to add punch to your images. If you've never attempted silhouettes before, consider giving them a try.

AA.5 This late-summer river scene focused on the Talmadge Memorial Bridge in Savannah, Georgia by underexposing by 2 f-stops. Taken at ISO 400, f/4, 1/80 second with a 7.6mm lens setting.

Limiting focus

Another way to simplify your images is to limit the focus range in the photo to only cover the subject, rendering any elements in front of or behind the subject as out of focus. This is achieved by using smaller number apertures (f-stops), all the way down to your smallest, to reduce the amount of depth of field the image yields. A setting of f/2.8 on the PowerShot G11 fits this bill.

By shifting the plane of focus this way, more time is spent looking at the photographer's intended subject and less on the background. This is a great technique to employ when you are stuck with a busy background, such as when items like architecture, trash cans, and signage all conspire to steal attention away from your subject.

As you consider lenses, the term *bokeh* is important. The term *bokeh* is derived from the Japanese word *boke* and means fuzzy. The term refers to the way an out-of-focus point of light is rendered in an image.

AA.6 By focusing on the flowers, the bride is rendered softly out of focus by using a wide aperture. Taken at ISO 400, f/4, 1/200 second with a 29.4mm lens setting.

Obviously, bokeh can make the out-of-focus areas aesthetically pleasing or visually obtrusive, and the interpretation is almost entirely subjective.

In general, you want the out-of-focus points of light to be circular in shape and blend or transition nicely with other areas in the background, and the illumination is best if the center is bright and the edges are darker and blurry.

AA.7 This shot of the groom features pleasing, out-of-focus background elements, indicative of a large aperture. Taken at ISO 800, f/2.8, 1/200 second with a 30.5mm lens setting.

In general, lenses with normal-aperture diaphragms create polygonal shapes in the background. On the other hand, circular-aperture diaphragms optimize the shape of the blades to create a circular blur pattern because the point source is circular. Canon lenses that feature circular aperture diaphragms use curved blades to create a rounded opening when the lens is stopped down and maintain the circular appearance through all f-stops.

The Rule of Thirds

One of the easiest ways to start on the path of better compositions is to move away from centering all of your subjects within the frame all the time. We've all seen unremarkable horizontal photos where one person's face is dead center in the picture, leaving lots of unused visual real estate on the top and sides. The face appears to float there in the picture. This can easily be solved by switching to a vertical composition and moving in, or left- or right-comping the subject to bring in more of the background or to imply the subject's movement. I often do this with my travelling companions when I want to make a portrait of them along with some interesting location detail.

Perhaps the most well-known principle of photographic composition is the *rule of thirds*. This tenet is a guideline commonly followed by other visual artists as well. The basic principle behind the rule of thirds is to imagine breaking your image down into thirds (both horizontally and vertically) so that you have nine sections or boxes with two lines vertical and two lines horizontal, each a third of the way across its dimension.

The resulting lines and intersections are your *sweet spots*. The objective is to keep the subject(s) and areas of interest (such as the horizon) out of the center of the image by placing them on or near one of the lines that divide the image into three equal columns and rows, or on or near the intersection of those lines.

Two things I've found to be helpful when utilizing the rule of thirds are worth noting here. The first is to try to have any implied subject motion moving toward the center of the frame. This adds balance and a direction for the viewer's eye to follow. The opposite approach may weigh the image down in that direction and give the photo an unbalanced feel.

The second applies when shooting landscapes with the sky as an element of the scene. If I have an incredible sky, I place the horizon on or near the lower horizontal line. If I have a blah sky but very good light, I move the horizon up to the higher horizontal line and search out some interesting element in the good light for my foreground.

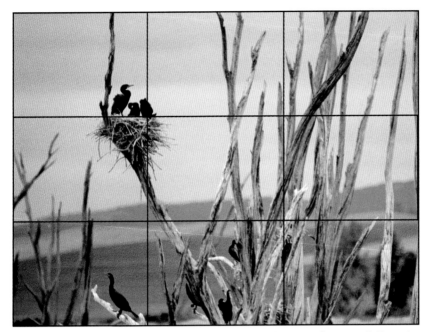

AA.8 Cormorants in Napa, California. The nest and mountain range fall on the vertical and horizontal lines of the Rule of Thirds grid. Taken at ISO 100, f/8, 1/125 second with a 30.5mm lens setting.

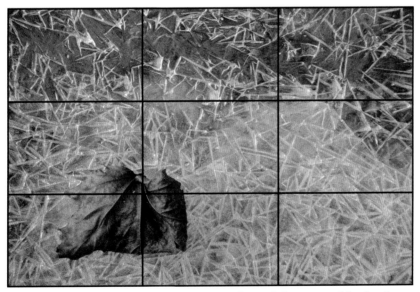

AA.9 Purposely placing this dried leaf in the lower-left corner adds visual interest and allows the ice to share importance with the leaf. Also, the cool tones of the ice contrast and set up a visual tension with the warm tones of the leaf. Taken at ISO 100, f/5.6, 1/250 second with a 28.3mm lens setting.

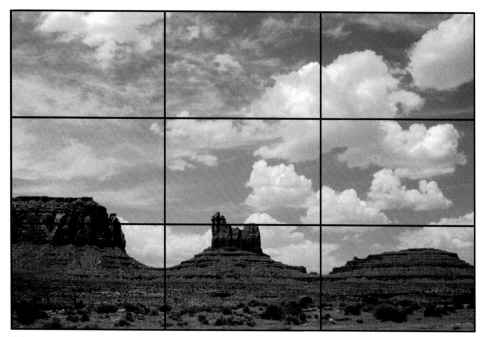

AA.10 Monument Valley, Utah. Lowering the monuments to just below the lower horizontal line in the frame brings more of this dramatic sky into the picture and conveys the sense of wide-open space the desert is famous for. Taken at ISO 100, f/8, 1/500 second with a 21.7mm lens setting.

Field of View

Many times, better compositions can be achieved by merely moving the camera slightly up, down, left, or right. Distracting elements can be eliminated by taking a step or two to either side of the subject. By altering the position of the camera, the background can be changed so that the subject has fewer distractions to compete with. This could be achieved by getting closer, moving laterally, or moving the camera vertically.

Controlling the field of view can also mean getting closer to your subject either optically by changing lenses or physically by moving in. Getting closer to flowers and inanimate objects might be easy, but doing so with other people may make some of us uncomfortable. This is when it's advisable to switch to a longer focal length lens to tighten up the frame.

AA.11 This potentially busy background was controlled by filling the frame with the umbrella when photographing this track athlete. Backlighting also helps pop the colors in the umbrella. Taken at ISO 100, f/4.5, 1/125 second with a 30.5mm lens setting.

Also, try not to fall into the habit of shooting all your images standing up at your eye level. Children and other animate subjects look much more realistic when photographed from their eye level, not yours, capturing them in the environment from their point of view. Also, remember anything closest to the camera appears larger and any elements farther away appear smaller. That's the reason why many family portraits are often composed with the children in front and the adults in the back.

In order to get more heroic shots of people, I like to frame them up with the camera about waste high, making them seem more towering and statuesque. By contrast, in tight situations where space is limited, such as a wedding cocktail hour, I'll use a wide-angle lens setting and try to shoot down on the bride and groom on the dance floor to show the setting and the decorations. Unique, interesting images are always the goal.

After getting the safe shots, go for the more interesting, offbeat camera angles. Don't be afraid to stand on a table or chair (with permission, of course) or get down on your stomach to create a more interesting camera angle for your subject. Any personal embarrassment you may feel will easily dissipate in a few minutes, and that great shot will live forever.

AA.12 Getting right down on the ground for this portrait of our kitty, Mica. Taken at ISO 400, f/3.2, 1/60 second with an 11.5mm lens setting.

Leading Lines and S-Curves

Leading lines create an illusion by means of linear perspective and can create a feeling of depth by merging at what is called the vanishing point. Oblique and angular lines convey a sense of dynamic balance and a sense of action. Lines can also direct attention toward the main subject of the photograph or contribute to the photograph's organization by dividing it into compartments.

A straight, horizontal line, commonly found in landscape photography, gives the impression of calm, tranquility, and space. An image filled with strong vertical lines tends to have the classical impression of height, power, and/or grandeur. Tightly angled diagonal lines give a dynamic, lively, and active feeling to the image, a stylistic approach very common in contemporary wedding and portrait photography today.

Curved lines or S-curves are generally used to create a sense of flow within a photograph. The eye generally scans these flowing lines with ease and enjoyment as it follows it throughout the image. Compared to straight lines, S-curves provide a greater

dynamic influence in a photograph. When paired with soft, directional lighting, curved lines can give gradated shadows, which usually results in a very harmonious line structure within the image. Perspective is also important with S-curved lines; generally speaking, the higher the viewpoint the more open the lines tend to be.

AA.13 Train tracks create an S-curve and appear to disappear into the vanishing point in this scene from the Delaware Water Gap in Pennsylvania. Taken at ISO 100, f/5.6, 1/100 second with a 17.4mm lens setting.

Symmetry

While I advise you to let go of the urge to always center your subject in the frame and to employ the rule of thirds when possible instead, there are those times when the old center-comp does indeed work best. This occurs when I shoot a business portrait or I want to just capture a person's expression or some other element for the strongest effect. I'll look for balancing colors in the background or some architectural items I can use to frame my subject. Balance is what you're striving for and sometimes putting the subject smack dab in the middle does have the most powerful impact.

The *rule of odds* further suggests that an odd number of subjects in an image is more interesting than an even number. An even number of subjects produces symmetries in the image that can appear unnatural and difficult to balance visually. When shooting engagement sessions or couples, I often compose the shot in such a way as to create visual diagonals, balancing the shot by having one person slightly higher than the other or farther away.

AA.14 I found this interesting structure for the background on a downtown walk during Cydelle and Levi's engagement session. Taken at ISO 400, f/5.6, 1/60 second with a 22.8mm lens setting.

Finally, pay close attention to the edges of your frame. Avoid having bright colors or sharp focus directly on the edges of your picture. Areas like these give the viewer's eye an easy way out of the photo and are the main reason many digital photographers today add slightly darker or lighter vignettes to their images to contain the edges of the frame.

Some of the best photography advice of all time was dispensed when baseball great Yogi Berra once said, "You can observe a lot by just looking around."

Accessories

Your PowerShot G11 comes with everything you need to begin creating awesome images with low noise and high resolution right out of the box. As you become more accustomed with all the dials, buttons, and menus, and as the camera feels more intuitive to you, you may feel the desire to expand on some of your camera's limitations. This is a good time to consider the many accessories available to you that add to your photographic experience.

Accessories for the PowerShot G11 are vast and include such items as external Speedlite flash units and transmitters and waterproof cases and bags that allow you to take your camera underwater and across the desert safely and easily. Macro Speedlites enable you to take close-up photographs with stunning detail and color. This section highlights some of the specific Canon accessories for the PowerShot G11 along with some items to consider adding to your photographic arsenal to expand your creativity and produce imagery way beyond the ordinary.

External Speedlites and Flashes

Just take a look at some of the cool features that are available with the Canon Speedlite System:

▶ **E-TTL II.** Canon's most advanced flash metering system uses preflashes and flash-metering algorithms to determine the proper flash exposure. The E-TTL II system reads information from all metering zones before and after the preflash. Areas with little change in brightness are then weighted for flash metering. This is done to prevent a highly reflective surface or overly bright area from creating a false reading, thereby causing underexposure.

▶ **Flash Exposure Lock (FEL).** FEL enables you to pop the flash to meter the subject, get a reading for the proper flash exposure, and lock in that information. Pressing the FEL button enables you to meter the subject via a test flash and then recompose the shot while maintaining the proper flash exposure for that subject.

▶ **High-speed sync.** This feature allows you to use your flash at higher shutter sync speeds than your camera is rated for. This setting is often used when you want to freeze action or when you want to shoot outdoor images that require a wide aperture and higher shutter speed.

▶ **Flash Color Information Communication.** As flash duration increases, the color temperature changes slightly. The Canon Speedlites transmit this change to the camera, ensuring a more accurate white balance.

▶ **Wireless lighting.** This feature allows you to use your Speedlites wirelessly. When using wireless lighting, you need to have either a 580EX II, either of the Macro Speedlites, or an ST-E2 wireless transmitter set as a master unit. A master unit fires a preflash, which then transmits information back and forth between the camera and the flash. The master unit can control multiple Speedlites wirelessly, allowing for more creative lighting setups.

EX Speedlites

Adding an EOS Speedlite to your arsenal of photography gear can open a whole new way of seeing and rendering the world around you. Speedlites are available for all ranges of budgets and shooting requirements, and because of the camera's sophisticated circuitry, getting spectacular flash-lit images has never been easier.

AB.1 The Canon 580EX II Speedlite

▶ **580EX II.** This is the flagship Speedlite for all-around general photography. The 580EX II offers a metal foot for reliability and rigidity, a 20 percent improvement in recycling time, and more weatherproofing than its predecessor, the 580EX.

It also features a 180-degree swivel in either direction, white balance informa-tion communication with compatible cameras, and it includes an external meter-ing sensor for non-TTL automatic flash exposure control and a PC socket for use with nondedi-cated slave triggers.

▶ **430EX II.** The 430EX II features the same basic appearance and layout as the 430EX, but adds a metal shoe with the same lock-ing mechanism as the 580EX II and 1/3 EV step output control in Manual mode.

The 430EX II can also be fully configured via the rear LCD menus of recent Canon cameras as well as from its own LCD con-trol panel. The recycling time of the 430EX II is 20 percent faster than the 430EX, and recycling is much quieter. Like the 430EX,

AB.2 The Canon 430EX II Speedlite

the 430EX II can act as a wireless slave, but not as a wireless controller.

▶ **270EX.** Released in May 2009, the new Speedlite 270EX replaces the 220EX as Canon's entry-level Speedlite. Compact and lightweight, the 270EX expands your camera's capabilities over the on-board pop-up flash in a highly portable unit that fits in a shirt pocket.

The 270EX is powered by two AA batteries instead of four like almost all other Speedlites, and this seriously lightens the weight of this flash.

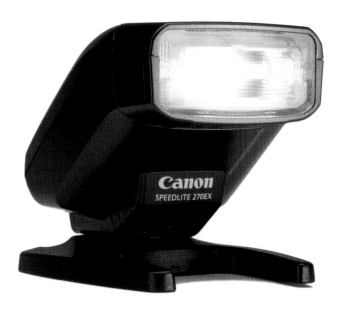

AB.3 The Canon 270EX Speedlite

Speedlite Bracket SB-E2

The Canon Speedlite Bracket SB-E2 allows side mounting of the Speedlite 580EX II. Three levels of height adjustment are available to help prevent unnatural shadows on the sides of objects when shooting from a vertical position. It is extremely useful for shooting portraits and other verticals where you want the flash higher than the subject. Depending on the angle and the close proximity of the flash, the bracket may sometimes prevent opening the LCD monitor. In these instances, I revolve the LCD around so it faces me flat against the camera back before I attach the bracket.

The Canon Speedlite Bracket SB-E2 is also compatible with two older Speedlites, the 580EX and the 430EX.

Speedlite Transmitter ST-E2

For the ease of controlling multiple wireless Speedlites, or when the OC-E3 off-camera shoe cord is just not long enough, the Speedlite Transmitter ST-E2 is an attractive option. Attached to the camera's hot shoe, the ST-E2 is an infrared wireless master control unit for the Canon Speedlite system. It functions in much the same way as the 580EX II does in master mode. This wireless flash controller transmits an infrared

trigger, exposure information, and flash ratios to all EX-series Speedlites. The ST-E2 also includes a powerful infrared AF-assist beam, a welcome feature in nighttime shooting or for EOS cameras that lack an AF-assist beam.

Here are some of the features of the ST-E2:

▶ **Control of up to three groups of Speedlites, with the ability to control the slave unit's' IDs.**

▶ **An AF-assist beam compatible with 28mm and longer focal lengths.** The AF-assist beam has an effective range of approximately 2.0 to 16.5 ft/0.6 to 10 m along the periphery (in total darkness).

▶ **Flash ratio control as well as adjustment and channel control.** The flash ratio control for the A:B ratio is 1:8 to 8:1, in half- step increments or 13 steps.

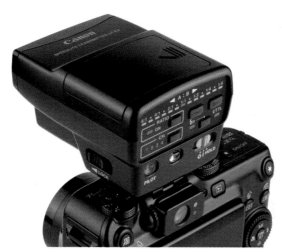

AB.4 The Canon Speedlite Transmitter ST-E2 mounted on the PowerShot G11

▶ **FE Lock, Flash Exposure Bracketing, Flash Exposure Compensation, Stroboscopic flash, and high-speed sync (FP flash) in High-speed sync mode for flash synchronization at all shutter speeds.** Flash exposure confirmation during FE Lock is indicated when the flash exposure level icon is lit in the viewfinder. If the flash exposure is insufficient, the icon blinks. After the flash fires, the ST-E2's flash confirmation lamp lights in green for 3 seconds.

▶ **Infrared pulse transmission system with a range of approximately 39.4 to 49.2 ft/12 to 15 m indoors, and approximately 26.2 to 32.8 ft/8 to 10 m outdoors.** The flash transmission coverage is +/–40 degrees horizontal and +/–30 degrees vertical.

AB.5 Control panel of the Canon Speedlite Transmitter ST-E2

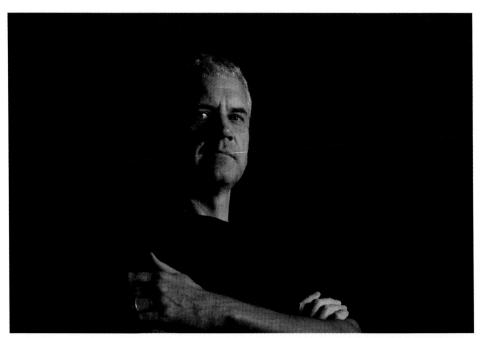

AB.6 Off-camera flash controlled by the camera-mounted Speedlite Transmitter ST-E2 can provide dramatic lighting effects, like this portrait of artist and video producer Lyle Morgan. Taken at ISO 400, f/5.6, 1/200 second with a 18.5mm lens setting.

Macro Speedlites

When choosing a Speedlite, it's important to evaluate your objectives. How do you intend to use the flash unit? Questions that you might ask yourself include: Do you want to enhance macro and other nature shooting? Do you need a Speedlite only for occasional use? Macro Speedlites open up a world of shooting possibilities you may not have imagined.

▶ **Macro Twin Lite MT-24EX.** This dual-light macro unit alleviates the flat lighting look that a single-ring light flash can create by providing two separate flash heads that you can move around the lens, aim separately, or remove from the holders and mount off-camera.

The MT-24EX is E-TTL-compatible with the PowerShot G11 and allows wireless flash with one or more 580EX II, 580EX, 550EX, 430EXII, or 430EX Speedlites as slave units. You can also control the lighting ratio of each flash head's output for more than a 6-stop range.

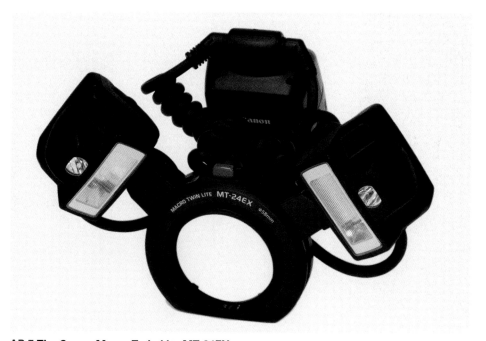

AB.7 The Canon Macro Twin Lite MT-24EX

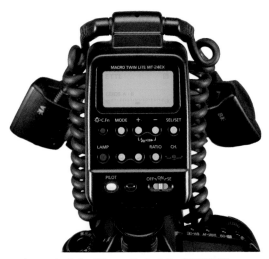

AB.8 Control panel of the Macro Twin Lite MT-24EX

▶ **Macro Ring Lite MR-14EX.** For shadowless illumination during macro work, this flash unit is compatible with E-TTL and features two circular flash tubes that can fire at even power or be varied between them over a 6-stop range. You can use compatible nonmacro Speedlites, such as the 550EX, as wireless slaves. The controller has an illuminated LCD panel and accepts optional high-capacity battery packs.

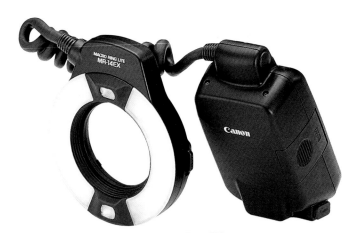

AB.9 The Canon Macro Ring Lite MR-14EX

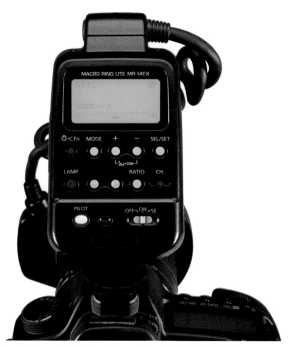

AB.10 Control panel of the Macro Ring Lite MR-14EX

Off-Camera Shoe Cord OC-E3

The Canon Off-Camera Shoe Cord OC-E3 supports all Speedlites. It also maintains all on-camera flash functions, including E-TTL II for Canon Speedlites used off-camera at distances up to the length of the cord, which is 2 feet.

It is compatible with all Canon G Series cameras that have hot shoes.

**AB.11 The Canon Off-Camera
Shoe Cord OC-E3**

The Off-Camera Shoe Cord allows you to use your flash either handheld or with a flash bracket. Using the cord with a flash bracket allows the flash to stay above the lens axis and communicate with the camera whether the camera is in a horizontal or a vertical position.

Shooting flash off-axis from the lens allows you to light your subject directionally and adds three-dimensionality to your flash photos by having the light come from the side, thus creating more interesting highlights and shadows.

Remote Switch RS60-E3

A good companion tool when using a tripod, the Remote Switch RS60-E3 replicates all function of the camera's AF/Shutter Release button to ensure vibration-free operation for macro or timed exposure work. Identical to the Shutter Release button on the G11, you press the remote button halfway down to focus, then all the way down to take the picture.

The Remote Switch also works with the camera to keep the shutter open for even longer time exposures of up to 15 seconds for such subjects as star trails and nighttime cityscapes. Bulb photos are not available with the G11.

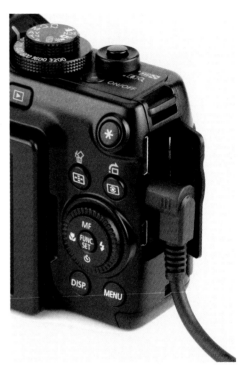

AB.12 The Canon Remote Switch RS60-E3 connected to the PowerShot G11

Tele Converter TC-DC58D

The Canon Tele Converter TC-DC58D converts the focal distance of the body lens by a factor of approximately 1.4x when attached to the PowerShot G11. It is designed specifically for the G10 and G11, and requires the Conversion Lens Adapter LA-DC58K, which is sold separately, to attach the teleconverter to the camera.

By adding a supplementary lens assembly, the Tele Converter TC-DC58D multiplies the focal length of the camera's lens throughout its zooming range by 1.4x, making it

a perfect addition for sports and wildlife photography, where you are limited by access or safety concerns as to how close you can get to the subject and want to extend the telephoto reach of the existing lens. Regular users note the lack of front threads on the teleconverter's front edge, necessitating other methods of attaching filters.

Conversion Lens Adapter LA-DC58K

The Conversion Lens Adapter LA-DC58K is a simple lens adapter needed to attach the Tele Converter TC-DC58D to the PowerShot G11. Because this is another set of optics between the sensor and the subject, be sure to keep it clean for maximum resolution and clarity.

I suggest using the teleconverter with the camera's lens zoomed out near its maximum focal length setting to avoid having parts of the frame vignette by using these attachments. Because the attachments stick out so far, I use the LCD monitor to compose and shoot because the viewfinder image is slightly blocked by the teleconverter and I need to see the entire frame before I shoot.

Waterproof Case WP-DC34

Canon offers the Waterproof Case WP-DC34 specifically for the PowerShot G11 for taking photos underwater down to a maximum depth of 40 meters or 140 feet. These cases or housings have sealed buttons that give you access to all the camera's controls, so that even underwater, you can make adjustments to your exposure, shooting modes, white balance, and more. It's also ideal camera protection in unforgiving environments such as in the rain, at the beach, while whitewater rafting, or on the ski slopes.

HDMI Cable HTC-100

The HDMI Cable HTC-100 enables you to connect the PowerShot G11 to a high-definition TV for enhanced viewing of still photos and videos. The mini HDMI plug connects to the G11's HDMI terminal (see figure AB.14), and the larger plug connects to your high-definition TV's HDMI input terminal.

AB.13 The Canon HDMI Cable HTC-100 for the PowerShot G11 showing the two different-sized plugs

AC Adapter Kit ACK-DC50

The Canon ACK-DC50 AC Adapter Kit is designed to supply uninterrupted power for your camera while down-loading pictures to your computer, working in a studio, or while viewing images when connected to your TV or VCR.

The AC adapter coupler takes the place of the G11's battery in the bat-tery compartment and the cord exits the camera via the DC coupler cable opening on the right side of the cam-era just under the handgrip. The adapter kit is compatible with both the Canon PowerShot G10 and G11 cam-eras.

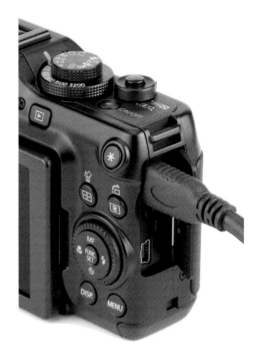

AB.14 The Canon HDMI Cable HTC-100 plugged into the HDMI terminal on the PowerShot G11

Resources

At no other time has there been more information available on the Internet for photographers and photographic and business education. With the vast amount of knowledge to be found on the Web, it can be frustrating sometimes to know where to begin or even where to look. On the Web, you'll find conflicting or contradictory information on every topic from alchemy to Zen meditation about "the right way" to do a certain thing.

My approach is to look for experts on the topic, and once I find someone who makes sense to me, I take that advice and run with it. If it works for me, then that becomes my method of working. Find what works best for you. While this is not an exhaustive list, I offer here a selection of my favorite resources to help you learn more about the digital camera, photographic lighting, photography, and the photography business in general.

Informational Web Sites and Blogs

As digital photographers, it seems we all spend an inordinate amount of time on computers these days. Turn that time into productivity and advancement by checking in to these Web sites and blogs often, as their news changes rapidly. Or better yet, create RSS feeds for each of these sites for your feed reader or e-mail client, and get updated content delivered right to your computer on a daily basis.

▶ **Canon Digital Leaning Center (www.usa.canon.com/dlc/).** The Canon Digital Learning Center and Explorers of Light program group is a broad-ranging initiative for photographic education and inspiration. Today, the group is comprised of 60 of the most influential photographers in the world, each a master of his or her own creative specialty. Find tips, how-to's, and techniques on exposure, workflow, getting the best color, and more.

▶ **Canon Rumors (www.canonrumors.com/).** Want to stay up on the latest rumors revolving around all things Canon? Then check into this Web site for all the latest, juiciest gossip totally unaffiliated with Canon Inc. Where there's smoke, there's fire, so be in the know and be the first to know.

▶ **Flickr (http://flickr.com).** Flickr is Yahoo's photo-sharing Web site that allows uploading of photos and sharing in its broad photographic community. Join Groups, create sets and collections, and add your photo locations to its world map.

▶ **Kodak Easyshare Gallery (http://kodakgallery.com).** The Kodak Easyshare Gallery was one of the first photo-sharing Web sites. It offers online sharing, special photo-printed products, and print orders that can be picked up at many chain camera stores and chain pharmacies.

▶ **Phanfare (http://phanfare.com).** Phanfare is a membership-based site and offers both monthly and yearly fees. It offers unlimited storage of images and videos. A wide array of photo Web pages and photo albums are available to display your images.

▶ **Photo.net (http://photo.net).** The Photo.net site is an enormous Web site containing equipment reviews, forums, tutorials, galleries, sharing spaces, communities, learning centers, and more. If you are looking for specific photography-related information or are new to photography, this is a great place to start.

▶ **PhotoShelter (http://photoshelter.com).** Stock photography from all over the world and a redundant storage solution to store, manage, and sell your own stock photography collection.

▶ **Picasa (http://picasa.com).** Totally integrated into the Google world, Picasa is a free photo-editing program that allows you to create albums with Picasa Web Albums to share with family and friends on blogs and Web sites and even add geo-tags to your images by using Google Maps.

▶ **PixSylated.com (http://pixsylated.com).** Created by California commercial shooter Syl Arena, PixSylated is a high-octane Web site devoted to the trends, tools, and techniques that are shaping the world of digital photography today, especially high-speed sync, other creative flash techniques, and color management.

▶ **Shutterfly (http://shutterfly.com).** Shutterfly offers a full range of products from free online storage to prints that can be picked up at Target stores. You need to keep your account active by making a purchase annually to qualify for the free storage.

▶ **Snapfish (http://snapfish.com).** Owned by Hewlett-Packard, this site offers online sharing and digital printing. You need to keep your account active by making a purchase annually to qualify for the free storage.

▶ **Strobist.com (www.strobist.blogspot.com).** David Hobby has created a groundswell movement of small flash devotees, the Strobist Nation, with his

highly informative blog on small flash use. This site has lots of tips and tutorials on how to effectively use shoe-mounted flashes on- and off-camera. It's loaded with lighting ideas and DIY projects for making light modifiers for your small flash. Start with the Lighting 101 section and continue from there. It can be habit forming. Be prepared to stay up for some very late nights!

Online Photography Magazines

Many print photography magazines also have Web sites dedicated to photography articles and other information not found in the pages of the magazine. When I was starting out, I could not wait for my new issues of some of the magazines to arrive in my mailbox and would scour them for hours, picking up tips and techniques to use in my beginning photo business. Now, the latest info is just a mouse click away, and these are some of the best. Again, subscribing to the RSS feeds of the sites that offer them speeds delivery of the latest content to your e-mail inbox.

▶ **Digital Photo Pro (www.digitalphotopro.com).** One-stop Web site for the latest gear reviews; profiles of the best in the business; technique, software, and business news; and contests.

▶ **Digital Photographer (http://digiphotomag.com).** Great online resource offering articles, hardware and camera reviews, features, how-to's, photo essays, reader photos, tips, and more.

▶ **National Geographic (www.nationalgeographic.com).** Over 120 years old, Big Yellow is still going strong and supports critical expeditions and scientific fieldwork, encourages geography education for all, promotes natural and cultural conservation, and inspires audiences through new media, vibrant exhibitions, and live events. The redesigned Web site features sections on Photo of the Day, Editor's Choice, Daily Dozen, and Your Shot, where you can upload a photo to the National Geographic editors for review.

▶ **Nature Photographers Online Magazine (www.naturephotographers.net).** An online resource for nature photographers of all skill levels from beginner to professional, with a focus on the art and technique of nature photography as well as the use of photography for habitat conservation and environmental photojournalism.

▶ **Outdoor Photographer Magazine (www.outdoorphotographer.com).** Provides a host of how-to articles, gear reviews, contests, a forum community, and monthly columns by the best nature photographers working today.

▶ **Photo District News (www.pdnonline.com).** The online business journal of the photo industry. Originally based in New York City, PDN offers insight into running your photography business in a profitable manner. It includes news, features, gear, contests, resources, community, multimedia, and much more.

▶ **Shutterbug (www.shutterbug.net).** Much like the favorite magazine that comes packed with information and equipment reviews and news each month, the Web site is chock-full of a huge array of information about digital imaging, techniques, forums, galleries, links, and more.

How to Use the Gray Card and Color Checker

Have you ever wondered how some photographers are able to consistently produce photos with such accurate color and exposure? It's often because they use gray cards and color checkers. Knowing how to use these tools helps you take some of the guesswork out of capturing photos with great color and correct exposures every time.

The Gray Card

Because the color of light changes depending on the light source, what you might decide is neutral in your photograph, isn't neutral at all. This is where a gray card comes in very handy. A gray card is designed to reflect the color spectrum neutrally in all sorts of lighting conditions, providing a standard from which to measure for later color corrections or to set a custom white balance.

By taking a test shot that includes the gray card, you guarantee that you have a neutral item to adjust colors against later if you need to. Make sure that the card is placed in the same light that the subject is for the first photo, and then remove the gray card and continue shooting.

 When taking a photo of a gray card, de-focus your lens a little; this ensures that you capture a more even color.

Because many software programs enable you to address color correction issues by choosing something that should be white or neutral in an image, having the gray card in the first of a series of photos allows you to select the gray card as the neutral point. Your software resets red, green, and blue to be the same value, creating a neutral midtone. Depending on the capabilities of your software, you might be able to save the adjustment you've made and apply it to all other photos shot in the same series.

If you'd prefer to made adjustments on the spot, for example, and if the lighting conditions will remain mostly consistent while you shoot a large number of images, it is

advisable to use the gray card to set a custom white balance in your camera. You can do this by taking a photo of the gray card filling as much of the frame as possible. Then use that photo to set the custom white balance.

The Color Checker

A color checker contains 24 swatches which represent colors found in everyday scenes, including skin tones, sky, foliage, etc. It also contains red, green, blue, cyan, magenta, and yellow, which are used in all printing devices. Finally, and perhaps most importantly, it has six shades of gray.

Using a color checker is a very similar process to using a gray card. You place it in the scene so that it is illuminated in the same way as the subject. Photograph the scene once with the reference in place, then remove it and continue shooting. You should create a reference photo each time you shoot in a new lighting environment.

Later on in software, open the image containing the color checker. Measure the values of the gray, black, and white swatches. The red, green, and blue values in the gray swatch should each measure around 128, in the black swatch around 10, and in the white swatch around 245. If your camera's white balance was set correctly for the scene, your measurements should fall into the range (and deviate by no more than 7 either way) and you can rest easy knowing your colors are true.

If your readings are more than 7 points out of range either way, use software to correct it. But now you also have black and white reference points to help. Use the levels adjustment tool to bring the known values back to where they should be measuring (gray around 128, black around 10, and white around 245).

If your camera offers any kind of custom styles, you can also use the color checker to set or adjust any of the custom styles by taking a sample photo and evaluating it using the on-screen histogram, preferably the RGB histogram if your camera offers one. You can then choose that custom style for your shoot, perhaps even adjusting that custom style to better match your expectations for color.

Glossary

AE Automatic Exposure. A general-purpose shooting mode where the camera automatically sets the aperture and shutter speed using its metered reading. On some cameras, the ISO settings are also automatically set.

AE Lock Automatic Exposure Lock. A camera setting that allows you to lock the current exposure setting prior to taking a photo. After the exposure is locked, you can recompose the image and shoot.

AF Lock Autofocus Lock. A camera setting that allows you to lock the focus on a subject prior to taking a photo. After the focus is locked, you can recompose the image and shoot without the focus changing.

AF-assist beam In low light and low contrast shooting situations, the AF (autofocus) assist beam automatically illuminates to aid the camera's autofocus system to focus properly in poor light.

AiAF Artificial Intelligence Autofocus. A focusing system based on evaluating objects in the scene.

ambient light The natural or artificial light within a scene. Also called *available light*.

angle of view The amount or area seen by a lens or viewfinder, measured in degrees. Shorter or wide-angle lenses and zoom settings have a greater angle of view. Longer or telephoto lenses and zoom settings have a narrower angle of view.

aperture Also referred to as the diaphragm or f-stop setting of the lens. The aperture controls the amount of light allowed to enter through the camera lens. The higher the f-stop number setting, the smaller the aperture opening on the lens. Larger f-stop settings are selected by lower numbers, such as f/2 or f/1.2. The wider the aperture, the less depth of field the image will possess. The smaller the aperture, the more depth of field you'll have, and more of the background will be in focus. See also *f-stop*.

Aperture Priority mode A camera setting where you choose the aperture and the camera automatically adjusts the shutter speed according to the camera's metered readings. Aperture priority is often used by photographers to control depth of field.

artifact An unintentional or unwanted element in an image caused by an imaging device or appearing as a byproduct of software processing such as compression, flaws from compression, color flecks, and digital noise.

artificial light The light from a camera flash, electric light, or other man-made source.

Auto ISO Considering the lighting, lens used, and exposure settings, the camera automatically selects an appropriate ISO for handheld shooting from ISO 80-3200.

automatic exposure The camera meters the light in the scene and automatically sets the shutter speed, ISO, and aperture necessary to make a properly exposed picture.

automatic flash When the camera determines that the existing light is too low to get either a good exposure or a sharp image, it automatically fires the built-in flash unit.

Av Abbreviation for Aperture Value. A camera setting where you pick the aperture and the camera picks an appropriate shutter speed. See also *Aperture Priority mode*.

AWB Automatic White Balance. A white balance setting where the camera determines the color temperature of the existing scene automatically.

backlighting Light that is positioned behind and pointing to the back of the subject, creating a soft rim of light that visually separates the subject from the background.

bokeh The shape and illumination characteristics of the out-of-focus areas in an image, depending mainly on the focal length and aperture blade pattern of the lens.

bounce light Light that is reflected off of or bounced off of a surface, thus softening the light falling on the subject. Bouncing the light often eliminates shadows and provides a much smoother light for portraits.

bracketing To make multiple exposures, some above and some below the average exposure calculated by the light meter for the scene either by flash output or exposure settings. Some digital cameras can also bracket white balance to produce variations from the average white balance calculated by the camera.

Bulb A shutter speed setting that keeps the shutter open as long as the Shutter Release button or cable release is fully depressed.

cable release An accessory that connects to a port on the camera and allows you to activate the shutter by using a remote switch instead of pressing the Shutter Release button to take the photo thereby reducing camera/shutter vibrations over slow or timed exposures.

catchlight Reflected light, usually from a flash that is needed to create sparkle in the portrait subject's eyes.

color balance The color reproduction fidelity of a digital camera's image sensor and of the lens. In a digital camera, color balance is achieved by setting the white balance to match the scene's primary light source. You can adjust color balance in image-editing programs using the color Temperature and Tint controls.

colorcast The presence of one color in other colors of an image. A colorcast usually appears as an incorrect color shift, often caused by an incorrect white balance setting.

color/light temperature A numerical description of the color of light measured in degrees Kelvin. Warm, early, and late-day light have lower color temperatures. Cool, shady light has a higher temperature. Midday light is often considered to be neutral light (5500K) and flash units are often calibrated to 5500–6000K.

daylight balance General term used to describe the color of light at approximately 5500K, such as midday sunlight or an electronic flash.

dedicated flash A flash unit designed to work with one particular camera system that can operate in conjunction with the camera's internal metering. Dedicated flash units exchange information with the camera via a proprietary digital data line. These lines require small data pins on the flash hot shoe to communicate.

depth of field The distance in front of and behind the subject that appears to be in acceptable focus.

DiG!C Digital Integrated Circuit. A proprietary computer chip manufactured by Canon to process images coming from the image sensor and to also control various camera functions.

digital zoom A method of making a subject appear closer by employing software within the camera rather than the optical elements of the lens. See also *optical zoom*.

dynamic range The difference between the lightest and darkest values in an image. A camera that can hold detail in both highlight and shadowed areas over a wide range of values is said to have a high dynamic range.

EXIF Exchangeable Image File format. A file structure used in digital cameras to allow the standardization of metadata and common exchange of files among different hardware systems.

exposure The amount of light reaching a light-sensitive medium, such as film or an image sensor that is the sum of the intensity of light controlled by the aperture, multiplied by the amount of time the shutter is open, controlled by the shutter speed.

exposure compensation Allows you to adjust the exposure in 1/2 or 1/3 stops from the metered reading of the camera to achieve correct exposure under mixed or difficult lighting conditions.

exposure modes Camera settings that allow you to take photos in a variety of specific modes such as full-auto, Aperture Priority, Shutter Priority, or Manual for specific situations. See also *Scene mode.*

f-stop Expresses the diameter of the entrance pupil in terms of the focal length of the lens; in other words, the f-number is also the focal length divided by the effective aperture diameter. See also *aperture.*

FE Lock Flash Exposure Lock. The FE Lock feature allows you to obtain the correct flash exposure and then lock that setting in by pressing the FE Lock button. You can then recompose the shot and take the picture with the camera retaining the proper flash exposure for the subject, no matter where the subject is in the frame.

file format The data structure in which digital still images and videos are stored. The Canon Powershot G11 allows RAW and JPEG formats for still images and MOV format for movies.

fill flash A lighting technique where the Speedlite provides enough light to illuminate the subject in order to eliminate, reduce, or open up shadowed areas. Using a flash for outdoor portraits often brightens up the subject in conditions where the camera meters light from a broader scene.

filter An accessory, usually made of glass or plastic that attaches to the front of a lens to change the color, intensity, or quality of the light that enters the camera. Filters are used to reduce glare and haze, change the color of a scene, or add a special effect like soft focus or star points to an image.

flare Undesirable light reflecting and scattering inside a lens that causes a loss of sharpness, contrast, or color fidelity to an image.

Flash Exposure Bracketing FEB. Taking a series of exposures while adjusting the Flash Exposure Compensation up and/or down to ensure capturing the correct flash exposure.

Flash Exposure Compensation FEC. Adjusting the flash output by +/– 3 stops in 1/3-stop increments. If images are too dark *(underexposed)*, you can use Flash Exposure Compensation to increase the flash output. If images are too bright *(overexposed)*, you can use Flash Exposure Compensation to reduce the flash output.

Flash Sync mode Set in conjunction with camera settings, you can take flash photos in either Front-curtain or Rear-curtain sync. For most flash photos, the default is Front-curtain sync. When using Front-curtain sync, the flash fires right after the shutter opens completely. In Rear-curtain sync, the flash fires just before the shutter begins to close. Using Rear-curtain sync in low-light situations avoids unnatural-looking photos due to subject or camera movement.

FlexiZone An autofocus camera feature that allows you to move the focus point around inside the frame making it possible to focus on off-center subjects without reframing the shot.

front light Light that comes from behind or directly beside the camera to strike the very front of the subject.

Front-curtain sync Default setting that causes the flash to fire at the beginning of the exposure when the shutter is completely open. See also *Rear-curtain sync*.

grain See *noise*.

gray card A card that reflects a known percentage of the light that falls on it. Typical grayscale cards reflect 18 percent of the light. Gray cards are standard for taking accurate exposure-meter readings and for providing a consistent target for color balancing during the color-correction process using an image-editing program.

highlight A term describing a light or bright area in a scene or the lightest area in a scene.

histogram A simple bar graph that shows the distribution of tones in an image.

hot shoe A camera mount that accommodates a separate external flash unit. Inside the mount are contacts that transmit information between the camera and the flash unit and that trigger the flash when the Shutter Release button is pressed.

image stabilization IS is a family of techniques used to reduce blur in an image caused by camera shake. Motion sensors in the camera or lens detect tiny movements and create error-correction signals that are applied to the optical elements in the lens resulting in a sharply focused photo.

ISO sensitivity The ISO (International Organization for Standardization) setting on the camera indicates the light sensitivity setting. In digital cameras, lower ISO settings provide better-quality images with less image noise; however, the lower the ISO setting, the more exposure is needed.

JPEG Joint Photographic Experts Group. A lossy file format that compresses data by discarding information from the original file in order to reduce file size.

Kelvin A scale for measuring temperature based around absolute zero. The scale is used in photography to quantify the color temperature of light.

leading line An element in a composition that leads the viewer's eye toward the subject or deeper into the scene. See also *S-curve*.

Manual exposure In Manual mode, the photographer adjusts the lens aperture and shutter speed to achieve the desired exposure. Many photographers need to control aperture and shutter independently because opening up the aperture increases exposure but also decreases the depth of field, and a slower shutter speed increases exposure but also increases the opportunity for motion blur.

memory card Removable media that is used to store images from a digital camera such as the Secure Digital (SD) and Secure Digital High Capacity (SDHC) cards the PowerShot G11 uses.

metadata Data about data, or more specifically, information about a file. The extra information captured by your camera is called Exchangeable Image File Format (EXIF) data. While most current photo manipulation software supports the reading of this information, there are many specialized tools for reading, editing, extracting, and converting EXIF information.

midtone An area of medium brightness; a medium-gray tone in a digital image or photographic print. Midtones are usually found halfway between the darkest shadows and the brightest highlights.

noise Extraneous visible artifacts that degrade digital image quality or are creatively added in post-production for effect. In digital images, noise appears as multicolored flecks, also referred to as grain. Noise is most visible in high-speed digital images captured at high

ISO settings and in RAW and fine JPEG capture using the digital zoom feature.

optical zoom Subject magnification that results from adjusting optical elements in the lens. See also *digital zoom.*

overexposure Exposing an image with more light than is required to make an acceptable exposure. The resulting image is too light.

panning A technique of moving the camera horizontally to track a moving subject, thereby keeping the subject sharp and adding a creative linear blur to the background details.

panorama A wide-angle view of a scene made up of several images shot in sequence either horizontally or vertically, then stitched together in the computer by software.

Quick Shot mode A Scene mode that displays all the camera's settings on the rear LCD monitor and forces you to use the viewfinder to compose and shoot images. In this mode, the camera continually activates the focus and exposure systems allowing the photographer to shoot moving subjects quickly and successfully.

Rear-curtain sync Camera/flash setting that allows the flash to fire at the end of the exposure, right before the second or rear curtain of the shutter closes. With slow shutter speeds and flash, this feature creates a blur behind a moving subject, visually implying forward movement. See also *Front-curtain sync.*

Red-eye reduction A flash mode controlled by a camera setting that is used to prevent the subject's eyes from appearing red in color. The Speedlite fires multiple flashes just before the shutter is opened. As a general rule, the farther the flash head is located from the axis of the camera lens, the less chance of getting the red-eye effect. You can combine Red-eye reduction with slow-sync in low-light situations.

S-curve A serpentine line within the frame that draws the viewer's eye into a scene. See also *leading line.*

Scene mode Available on the PowerShot G11, these are automatic modes in which the settings are adjusted to predetermined parameters, such as a wide aperture for Portrait scene mode and high shutter speed for Sports scene mode. See also *exposure modes.*

Shutter Priority A semiautomatic camera setting where you choose the shutter speed and the camera automatically adjusts the aperture according to the camera's metered readings. Shutter Priority is often used by action photographers to control motion blur.

shutter speed The length of time the shutter is open to allow light to fall onto the imaging sensor. The shutter speed is measured in seconds or, more commonly, in fractions of a second.

side lighting Light that strikes the subject from the side, often utilized to show the texture of a subject.

silhouette A view of an object or scene consisting of the outline and a featureless interior, with the silhouetted object usually being black. The term has been extended to describe an image of a person, object, or scene that is backlit and appears dark against a lighter background.

sync speed Most flashes are limited to only being able to be used up to a certain shutter speed. This top speed is called the sync speed. The camera and the type of shutter mechanism being used limit the sync speed.

telephoto A lens with a long focal length or zoom setting that narrows the field of view and makes objects appear larger in the frame.

telephoto effect The visual effect a telephoto lens creates that makes objects appear to be closer to the camera and to each other than they actually are.

tonal range The range from the lightest to the darkest tones in an image.

top lighting Light, such as sunlight at noon, that strikes the subject from directly above.

tungsten lighting Common household lighting that uses tungsten filaments. Without filtering or adjusting to the correct white-balance settings, pictures taken under tungsten light display a yellow-orange colorcast.

viewfinder A viewing system that allows the photographer to see all or part of a scene that will be included in the final image.

vignette/vignetting Darkening of edges on an image that can be caused by lens distortion, using a filter, or using the wrong lens hood. Also used creatively in image editing to draw the viewer's eye toward the center of the image.

white balance Use white balance to compensate for the differences in color temperature common in different light sources. For example, a typical tungsten light bulb is very yellow-orange, so when adjusted properly, the camera's white balance setting adds blue to the image to ensure that the light looks like standard white light.

wide angle A lens or zoom setting that produces a field of view that is wider than you would normally see with your eyes.

Index